# Cultural Insurrection

ALSO BY JONATHAN NOSSITER

BOOK

*Liquid Memory: Why Wine Matters*

FEATURE FILMS

*Resident Alien*
*Sunday*
*Signs & Wonders*
*Mondovino*
*Rio Sex Comedy*
*Natural Resistance*
*Last Words*

# Cultural Insurrection

A MANIFESTO FOR THE ARTS,
AGRICULTURE, AND NATURAL WINE

Jonathan Nossiter

OTHER PRESS / NEW YORK

Originally published in French as *Insurrection culturelle*
in 2015 by Éditions Stock, Paris.
French edition coauthored by Olivier Beuvelet.

*Production editor: Yvonne E. Cárdenas*
*Text Designer: Jennifer Daddio / Bookmark Design & Media Inc.*
*This book was set in Bembo and Helvetica Neue by*
*Alpha Design & Composition of Pittsfield, NH*

1 3 5 7 9 10 8 6 4 2

Library of Congress Cataloging-in-Publication Data

Names: Nossiter, Jonathan, author.
Title: Cultural insurrection / Jonathan Nossiter.
Other titles: Insurrection culturelle. English
Description: New York : Other Press, [2019] | "Originally published in
French as Insurrection culturelle in 2015 by editions Stock, Paris. "
| Includes bibliographical references.
Identifiers: LCCN 2018044922 (print) | LCCN 2018046776 (ebook)
| ISBN 9781590518274 (ebook) | ISBN 9781590518267 (pbk.)
Subjects: LCSH: Art and popular culture. | Organic viticulture.
| Wine and wine making.
Classification: LCC N72.S6 (ebook) | LCC N72.S6 N67513 2019 (print)
| DDC 701/.03—dc23
LC record available at https://lccn.loc.gov/2018044922

*For my children Miranda, Capitu, and Noah*
*and for our farm, Fattoria La Lupa . . .*
*may they all have thriving futures*

# Contents

# Preface

THIS BOOK is intended for those who never considered wine of any remote interest.

But it's intended equally for wine lovers.

If you're among the former, then I'll ask you to imagine wine simply as a radical (that is, deeply rooted) metaphor for culture, art, and politics. If you're one of the latter, I ask you to disregard what you know (or think you know) about the aesthetics of wine and look at it as a radical metaphor for... culture, art, and politics.

I'm a film director, so my first concern should be cultural. But before that I'm a citizen—technically of the United States and Brazil—in upbringing a citizen of France, Italy, Greece, and England. For any twenty-first-century citizen anywhere, beyond the cultural lies a deeper concern

that necessarily has to condition and supersede any other: the ecological-existential.

In looking at a paradox—how the doomsday state of agriculture has provoked a joyous response from a utopian fringe of wine farmers—this book proposes a reimagining of aesthetic, political, and cultural questions as essentially ecological ones.

And the reverse: how no environmental question should be considered separately from culture and aesthetics, as well as politics.

One

><

# The New Cultural Hell
# (Cast Out of Purgatory)

IN 1974, a year before he was murdered, Pier Paolo
Pasolini, taboo-busting filmmaker, poet, novel-
ist, journalist, relentless antifascist, and one of the
last genuinely public intellectuals anywhere in
the world—was invited by RAI, the Italian pub-
lic broadcasting company, to narrate a visit to the
model fascist town of Sabaudia.

Though the producers were expecting a vio-
lent denunciation of fascist-era city planning, they
should've known that Pasolini was above all a free
man, free even from his own biases: the clearest sign
of intellectual courage. In the televised report, we
follow him through the streets of this coastal town,
sixty miles south of Rome, and we hear him explain:
"In fact, there isn't anything fascist about this model
city. The buildings here are all built on a human
scale. You feel in harmony wherever you go."

The TV film crew, surprisingly attentive to his subtlest gesture, follows him onto the sand dunes. As the February wind rakes his hair dramatically, Pasolini turns to the camera and addresses the viewer. But he also speaks to the television crew, whom he clearly considered his colleagues. This is not a famous intellectual condescending to technicians and "the public." This is a profoundly compassionate poet terrified by the world, urging every sentient being around him to rethink what they see. His intensity and instinctive egalitarianism produce an intimacy between viewer and onscreen actor unlike anything we're accustomed to from the sterilizing lens of a TV camera.

"The fact is, the fascists even screwed this up. At the end of the day, they were just a bunch of criminals who came to power. They failed to leave a lasting stamp on any aspect of Italian life." His gaze then seems to bore into each one of us.

"Today, in 1974, it's the opposite. Our government is democratic. But this consumer society has managed to homogenize culture in a way the fascist government was never able to."

WHAT WOULD HE SAY TODAY, over forty years after his death, about the state of culture? Is there any national network anywhere that would put a

renegade poet in front of a prime-time audience? And are there still artists and intellectuals who can raise their voice in a forum that commands an audience as complete as television did in 1974? Or as the *agora*—the marketplace of ideas and commerce in Athens at the inception of a democracy—did 2,500 years ago?

What has happened to the status of public intellectuals? How can they address the general public today? How can they bring culture to life as an affirmation of subjective freedom? What popular venue is left for them to express culture as a joyous invention of aesthetic forms, as a way to question the mechanisms of power, as a guarantee of our collective freedoms? The infinite compartmentalization of the Internet is one of many guarantees that this has become *virtually* impossible.

The dream of every totalitarian state has been to silence artists and make them invisible. By the nature of their activity, artists are uncontrollable. This makes them the truest counterweight to any exercise of power. Pasolini was prophetic in his understanding of how an omnivorous consumer society has managed surreptitiously, even unintentionally, to accomplish what the fascists only dreamed of.

American-led Western consumer society—decisively implanted in Europe through the Marshall Plan following World War II and transformed

into a global reality by the 1980s—is the only society to accomplish the totalitarian dream of eliminating cultural actors from the public stage, reducing them to a largely ornamental role in the spectacle of entertainment, of cultural consumption, that consumed culture itself even before Trump. Or rather, the existence of Trump and the authoritarian contempt for culture is the logical result of this process.

BUT IF CULTURE in the Americas and in Europe is no longer the agent of freedom it once was and if artists no longer have the access to the public stage they enjoyed as recently as the 1970s, a question has to be faced: to what extent have artists collaborated in their own exile? How many of those who work in the cultural sector genuinely call into question, at the risk of their own status, the dominant political, economic, and cultural system?

How much are we responsible for the erosion of our own raison d'être? Filmmakers, writers, journalists, editors, distributors, teachers, visual artists, musicians, booksellers, librarians...and even you, dear (poor) reader of this book?

If we lament the gradual decline in readers of books and the abrupt disappearance of major daily newspapers (with the exception of the *New York Times*, every newspaper in America and Europe has

lost the majority of its readership in the space of a few years) and are dismayed that the audience for independent films is evaporating while blockbusters corner the market; that the CD and DVD industries have collapsed, that no one even pays to download a movie or a song from the Internet, how is it possible that the key cultural actors (who are also the victims) of this catastrophe aren't also responsible?

Pasolini's assessment of culture, in the end, is closer to Aldous Huxley's *Brave New World*, published in 1931, than it is to George Orwell's *1984*, written in 1947. We are not Big Brother's victims, we are accomplices. We voluntarily take "soma," the pill Huxley imagined, that relieves all our anxiety and wipes our memories clean, obliterating our liberty.

Thomas Piketty, Joseph Stiglitz, and other economists who disagree on both technical and moral grounds with the prevailing economic model have maintained that the skyrocketing income inequality of recent decades is disrupting the general mechanisms of upward mobility and of democracy itself. The widening gap between rich and poor has also led to the gradual impoverishment of the middle class and has directly threatened all those engaged in cultural activities. The interests of workers in the cultural sectors overlap closely with those of the middle class. Their standing in the major democracies is

tied to the well-being of that class, whose members include the majority of their practitioners: teachers, contract workers in entertainment, artists, writers, journalists. The middle class is the first to benefit from a rich and flourishing cultural life, and its fate is closely linked to the fortunes of those involved in cultural activities. The simultaneous decline of both destabilizes democracy and cripples the ability of society's most disadvantaged to improve their standard of living. Because a "standard of living" is both economic and cultural.

Today, with conditions in the cultural realm proving disastrous for most of its participants, these effects are becoming more pronounced. In all the wealthier countries, there are massive numbers of experienced and well-regarded journalists who are unable to find a job—or a job worthy of their abilities and experience, writers who are forced to make writing a hobby, independent filmmakers who create "cultural" movies for a public that ages year by year (with occasional exceptions, which the docile remnants of the press corps celebrate as symbols of health) and for whom a future as home-movie hobbyists is the only path that beckons. Those who remain in news, film, music, or publishing can pride themselves on winning the Darwinian contest, but for how long? Just as all elements of a natural

ecosystem are interdependent, no artist can survive alone (though his ego often tells him differently).

How many artists are left who manage to be at once popular and exacting, who refuse to compromise their civic role? A handful, maybe. But do we even know how to find them in the new landscape that the Internet has created, with its black holes and the digital fragmentation of the *res publica*?

How many writers, photographers, journalists, actors, painters, editors, and filmmakers have abdicated their role as counterweights to the established powers? With their voices now muted or inaudible, they've become self-exiled. The *polis* no longer needs them. The *polis* no longer wants to see or hear them. All the *polis* wants from them is escapist distraction, like the last days of the Roman Empire. But now more than ever, the *polis* needs genuinely independent and defiant artists, journalists, researchers, teachers, editors, scientists.

The artist who is at once popular and serious, a free agent and a public figure, as Pasolini managed to be in front of the Italian television cameras, has been cast out of the new world order. The artist, the object of too much veneration for too long, has broken into two antithetical figures: the Great Artist

and the obscure militant. The first finds ever more elaborate ways to say nothing so that he can trade on his style, which becomes a "signature," a brand. The second preaches fervently to four faithful acolytes (you, the four readers of this book?).

What is certain is that we are all struggling to make a living, even the most established among us. In the future, aside from stars and the makers of a few exceptional commercial successes, few people will be able to live from their craft. It's of course possible that new economic models will develop thanks to (and in spite of) the Internet. But for the moment, nothing suggests that a true cultural scene will emerge that is capable of providing even a modest living to a global community of artists, engaged in the serious business of preserving, transmitting, and reinventing our culture.

*Two*

❦

# A Personal Film (Love) Story

SINCE A DISCUSSION of the role of the artist (and artisan) forms the spine of this book, it's only fair to reveal my own biases and their origins.

I discovered cinema very late, when I was already eighteen. I grew up mostly in Europe, but also in Asia and briefly in the United States, following my father's postings as a foreign correspondent for the *Washington Post*.

My mother grew up in a Boston suburb with parents who were not particularly interested in culture, although her father, a Jewish immigrant born in London at the turn of the twentieth century, sang in the chorus of the Boston opera to put himself through medical school. My father was brought up on the Upper West Side of Manhattan by parents who were economically better off but equally unmoved by cultural matters. But somehow both my

parents spontaneously developed a passionate belief in the personal and social value of literature, music, and painting. And without any fuss, they transmitted their convictions to their four sons.

But cinema was rarely mentioned. The only movies I happened to see as an adolescent were blockbusters that I'd go to with a group of friends. After attending several dozen schools across Europe, Asia, and North America, I decided to pursue my dream of becoming a painter at the San Francisco Art Institute and then at the École des Beaux-Arts in Paris. But when it was clear (sooner rather than later) that I had no future as a painter, I enrolled at Dartmouth College to study Ancient Greek. By 1980 classics was anything but a popular subject, so many of my classes had only two or three students. I reached the apex of marginality in a second-year course on Homer, where I was, gleefully, the lone student with two professors.

It's no accident that I am still close to one of them, Edward Bradley, whose enormous passion for Homer was intertwined with his love of movies. He managed to convey the urgency, the tactile immediacy, and the audiovisual power of Ancient Greek, in part by sprinkling his lectures with references to the great humanist films of Renoir, De Sica, Bresson, Rossellini, Kurosawa. Ever since, Ancient Greek for me has been rooted in the movies. And

vice versa. Without Edward Bradley's vigorous and contemporary imagining of Greek, I doubt I would have become a film director.

But there was another factor in my cinematic conversion, a magical, improbable "Saul on the road to Damascus" moment. When I first arrived at Dartmouth, buried in the New Hampshire woods, three hours from the nearest city, I felt isolated from everything I had grown up with. I was especially homesick for Italy, which, along with France and Greece, had formed the backbone of my childhood. I needed to hear Italian spoken around me. But to my astonishment, the only course conducted in Italian during my first semester was on contemporary Italian cinema. For dilettantes, I thought. Must be a gut.

But I enrolled anyway, the nostalgic heart stronger (apparently) than the mind. In 1980, "contemporary Italian cinema" meant the most recent releases of Fellini, Pasolini, Wertmüller, Scola, Bertolucci, and Monicelli, names that meant nothing to me at the time.

The next day, I was sitting in a screening room watching a print of Federico Fellini's *8½*. I'd never seen anything like it. After the first three minutes I wanted to leave. The baroque parade of black-and-white images and the purely dream logic was incomprehensible to me. My anger grew with each passing minute. I was convinced the film was an

intellectual scam that I looked forward to demolishing the next day in class. Its sheer pretension, its unlike-anything-elseness, enraged me. But I realized I needed to see it at least once more to have a hope of articulating my feelings about this novel medium. But the only way to see a film again back then was to request a second, laborious screening of the 35 mm print. That evening, I went to see the projectionist, a latterday hippy and cinephile. To my surprise, he agreed to stay on past the end of his workday to screen *8½* for me after midnight. It was my first exposure to the larger-than-life passions of a committed film buff.

After three minutes, exactly at the point in the movie where my anger had flared that morning, I felt a sudden surge of joy. To my amazement, everything I loved about painting, literature, and music I could see present in one single form. It seemed to contain the distilled essence of all the arts together. I had no background in film, no theoretical framework for understanding what I was seeing. I experienced the dreamlike flood of images in an untutored, primitive way. I watched half the film on my feet, pacing around alone in an increasing state of excitement, between midnight and two-thirty in the morning.

I lost my virginity to this film, and I've stayed faithful to it for the last thirty-five years, not

from nostalgia (or devotion to the cult of virginity) but because I think it's the one movie that has managed—even more than *Citizen Kane*—to absorb and transmit the whole history *and* potential of cinema. Only later did I learn how it cites, transforms, and interprets all the American and European films that preceded it: never as a glib homage, but as an omnivorous act of love. Unlike many postmodernist works, which practice a form of cultural name dropping, this movie is a genuine palimpsest: built from successive layers of evocations that both supersede and reinterpret its past, but always preserving the vital traces of the earlier works.

Like Cézanne's late paintings, it embraces all that came before and anticipates all that is to follow. In its seamless passage from dream to reality within a single sequence, its mockery of the society of the spectacle and its attendant narcissism, *8½* anticipates the jump cuts of the New Wave, the caustic irony of the Italian cinema of the 1970s, the experimental films of Stan Brakhage, and the dreamy lyricism of Tarkovsky.

It also belongs within the Homeric tradition of ekphrasis, a critical technique of cultural transmission across history. Ekphrasis, the verbal description of a work of art that consciously interrupts the flow of a narrative, can be dismissed as a simple digression. But it often provides an original and lively way

of avoiding the lulling effect of conventional, linear narration. The first instance of ekphrasis appears in Homer's *Iliad,* in a long, detailed passage describing the scenes sculpted by Hephaestus, the god of artisans, on the shield of Achilles. The listener in Homer's time, or the reader in our own, is invited to reflect on the creative power of the word, transforming the words into deeds, the passive into the active.

*8½* tells the story of a film director overwhelmed by the enormous expectations that are the result of his previous success. It is a highly personal film. After already winning two Oscars, Fellini's previous film, *La Dolce Vita*, had just won the 1960 Palme d'Or at Cannes.

Since his first film in 1950, *Luci del varietà* (*Variety Lights*), Fellini had flirted with neorealism but had never embraced it fully. He'd adopted some aspects of the aesthetic, but, an iconoclast from the start, he never became a card-carrying member of the movement. He always cared more about human behavior than ideology. In *La Dolce Vita,* his first modernist movie and his definite break with neorealism, he tried to express a spiritual and intellectual emptiness that would haunt the postwar consumer society.

Pasolini's 1974 denunciation of the consumer culture had its origins in the early 1960s. For Pasolini, the most significant change that Italy had

undergone was its transition from a profoundly rural society, which the war destroyed—a rural world that had always influenced urban culture—to a society that had lost all connection with the countryside and whose original, rural fabric had been dissolved. And this world, cut off from its roots, had become the consumer society that Pasolini denounced to the RAI TV cameras.

Fellini, a prophetic artist, had already understood the angst and existential emptiness brought on by this new materialist world, and he'd already expressed it in *La Dolce Vita* fourteen years before. But of all his films, *La Dolce Vita* is his least intimate, least touching, least humorous to that point. And despite its great virtuosity, it can leave you with the same feeling of emptiness it seeks to articulate. The acclaim this calculatingly aestheticized and emotionally removed film received must have been agonizing for a jovial humanist like Fellini. In *8½*, which he made the subsequent year, he chose to tell the story of a famous director excruciatingly aware of his own bad faith. But it's the self-mocking irony and the sheer delight in the strangeness of the stories we tell ourselves that make this acid reflection the polar opposite of *La Dolce Vita*.

Having watched *8½* at least twenty times in the last thirty years (always with renewed pleasure), I was clearly shocked the first time by a cultural object

that called into question my limited understanding of what constitutes a work of art. Fellini managed to convey exactly what he was experiencing at the time: the fear of being complicit in an intellectual fraud. But watching it a second time, it seemed he was suggesting that the only protection against fraudulence and bad faith is to cultivate one's own fear of being susceptible to it. This felt enormously liberating. And terrifying. Later, I realized that a director's work—like an actor's—revolves around this perilous paradox.

Fellini's films of the 1950s, like *La Strada* (1954) and *Nights of Cabiria* (1957), may sometimes veer into sentimentality. For all their virtues, they come close to a Hollywood-style manipulation of the viewer (and it's no accident that both won Oscars). With *8½*, however, Fellini broke decisively with cinema's traditional means of orchestrating our emotions. That said, it's a long way from the detached, intellectual experimentation of the French New Wave that followed on its (Achilles') heels, a form of cinema which also sought to disrupt the sentimental mechanisms of traditional cinema narrative. *8½* is a movie brimming with emotion, but the emotion is displaced, with constant irony, from any sentimentality. While the tone of *La Dolce Vita* is generally solemn, in *8½* Fellini is unfettered, radically playful, both tender *and* cruel with himself and with all

of the viewer's expectations. Even when you can't quite follow the narrative skein, the affectionate irony and sheer childlike delight in the filmmaking create a sympathy that keeps the viewer from ever feeling excluded. Since the film's release in 1963, no filmmaker who has made an even slightly innovative work has failed to suck a few drops from the inexhaustible teats (ample and Felliniesque!) of *8½*.

## My Man, Wim

But while in college I also came in contact with a filmmaker whom I consider a symbol of my generation. Through working at the Dartmouth Film Society—a student-run film club—I discovered Wim Wenders. When I saw *Kings of the Road, Alice in the Cities*, and especially *The American Friend*, I felt I was seeing the work of a shaman of my era. What I didn't realize then, as a postadolescent, was that he was in fact a shaman. To a permanently postadolescent era.

My point isn't to disparage Wim Wenders, but to describe the trajectory of my own subjective development (which seems critical to allow the reader of this book to better gauge what's up ahead). Any craftsman or artist has to search for his place in a cultural tradition by continuously redefining, through

affirmation and rejection, what he sees as his cultural inheritance. Harold Bloom's landmark book of the early 1970s, *The Anxiety of Influence*, describes how this necessary struggle is at the heart of vigorous cultural transmission, one of the fundamental concerns of this book as we shift back and forth between the artisans of culture and agriculture.

I remember having fairly violent arguments with an older film professor, Maury Rapf, whom I was otherwise fond of. A former Hollywood screenwriter who'd been blacklisted by McCarthy, the son of one of Hollywood's founders, Rapf grew hysterical whenever the discussion turned to Wenders. He believed Wenders was a con artist, a vacuous aesthete. "Old man, modernity in cinema has passed you by," I used to think. Today, closer to the status of an old fogy myself, I think he was completely right.

Wenders embodied a kind of protohipster, predigested rebellion for postwar bourgeois kids. His rebellion carried no risk, no danger. As children of the World War II generation, we were marked by the profound moral and political issues faced by our fathers, but without ever having to face them ourselves. It was easy for us to adopt the cool posturing of Wim Wenders, with his long, seemingly poetic takes of displaced hipsters and his knowing use of contemporary music.

In 1984, after majoring in Ancient Greek, I went to live in New York. Burning with a desire to direct films, I felt I still had to spend a few years in the theater to learn about the inner work of actors. I knew that on a movie set, with the whole production crew milling around, the distance separating me from the actors would otherwise be unbridgeable for years.

I'd been in New York a few months, working as assistant director on an off-off-Broadway production of *A Winter's Tale*, after directing an (absurd) production of my own (highly suspect) translation of Aeschylus's *Prometheus Bound*, at an even more off-off-off-Broadway venue, when I learned that a preview of my hero Wim Wenders's latest film would be showing at the New York Film Festival. Through a friend who worked there, I wangled a ticket for the sacred screening of *Paris, Texas*, aware that the master himself would be on hand.

Along with the other devotees, when the lights went down, I was dazzled by the cinematography of Robby Müller, by the highly romanticized, saturated images of the American West captured largely at sunset (cinema's notorious "magic hour") on the still chromatically rich film stock of the early 1980s. Today, when I reproject these images in my memory, I see their clear relation to the unbridled kitschiness of Caspar David Friedrich and the German Romantic painters of the early nineteenth century.

At the time, sitting in the audience, I hadn't imagined this link to a specific German tradition, but I remember the growing sense that I was seeing an ersatz, aesthetically sentimentalized European version of America that began to grate.

Of course there is a long tradition of official Teutonic art, whose self-regarding search for purity has gone hand in hand with a history of great violence. With an eighties hipster's spin on Wagnerian Romanticism, Wenders's eye seemed wholly narcissistic (what the old codger Rapf had always maintained), transformative only in manipulating the reality of others for his own ends. The apparent sensibility to *the other* was being employed simply to have us admire the depth of his own. The longer the movie went on (all 147 minutes of it), the more unnerved I became. How could this great master have made such a schlocky and ingenuous film? Or was it calculated disingenuousness, I began to wonder. And when Nastassja Kinski delivered her ten-minute-long Sam Shepard–authored monologue, I was dumbfounded. Was this a Dadaist gesture? It seemed that Wenders, the European infatuated with his own gaze at America, hadn't grasped the cynical irony of the all-American hipster Sam Shepard.

During the discussion after the movie, I'm sure I was not the only American baffled to hear Wenders say how much he venerated the sincerity

of Shepard's text, vaunting his own courage for not cutting a single line of the script pages faxed to him on the set by the author of *True West*.

At any rate, four years of university had done nothing to diminish the passion that cinema inspired. On the night of the film festival screening of *Paris, Texas*, it wasn't simply a question of disappointment in the work of an artist I admired. Accepting or refusing the film seemed to me practically a matter of life and death.

Going to a screening of Wim Wenders's newest opus was like going to church. Cinephilia was a profession of faith, an expression of "belonging" that has both cultural and spiritual dimensions. Some of the spectators around me swallowed *Paris, Texas*, whole, as though it were a communion wafer. I couldn't. But I absolutely defend their right to believe in it as much as my own to refuse it.

# The White Limo and the Tractor

I WALKED OUT of the Lincoln Center screening of *Paris, Texas*, into the gentle early October night. I was confused and unhappy. Around me, I sensed others were also troubled. Though they were mostly silent. Then I saw Wenders, in jeans and cowboy boots. Most directors at that time still wore a suit and tie for gala events. But his clothes instead announced that he wasn't a "star." He was one of us. Of course in retrospect it seems he was simply playing the eighties hipster *as star*. I don't remember whether I was waiting for him to come out the stage door or whether I just happened to see him. But I remember that I looked at him intently, in awe at the sight of Wenders-the-director in the flesh. I knew he would be going to an after-party at the Tavern on the Green a few blocks away, so I was dismayed to see an enormous white

limousine waiting for him, one of those endless New York limos as stretched as the egos of those who ride in them. Everything that Wenders nominally opposed.

I told myself there was no way Wim would climb in. Wenders, the maker of the down-and-out bohemian elegy *Alice in the Cities*; the man-of-the-people filmmaker with the intellectual touch; the guy who incarnated the calculatedly cool rebellion of our generation. It boggled my (twenty-two-year-old) mind. But he ducked into the white limo, relaxed and happy, to travel less than half a mile.

Today, of course, I'd judge him less harshly. When my first movie, *Resident Alien*, came out only a few years later, its world premiere was at the Toronto Film Festival. When the car came to take me to the screening, I was gobsmacked to see that it was a white limousine. Even if it was only half the size of the one that had picked up my man Wim, one fit for a twenty-something first-time director in Toronto, not an acclaimed artist in Gotham, it was still the Mini-Me white limo.

Haunted by the illusion-shattering image of Wenders in New York six years earlier, I told the festival staff that I would absolutely not ride in a limousine to a film that defends the underdog. But the movie's main character, the octogenarian Quentin Crisp, was already inside. They looked at

me and wondered if I'd really pull a stunt like that while a frail, elderly man was waiting. I climbed in, ashamed, for the symbolic procession that lasted less than half a mile.

Twenty-five years later, after many other films shown from Tbilisi to Cannes, I've ridden in other festival limousines without feeling unduly troubled. Was I being hypocritical then? Or am I hypocritical now? Given the current state of the world, I'm more inclined to side with the indignant young man from back then.

The love-hate relation to power has been a source of daily tension for every artist, in every society, in every period. A rare few have demonstrated equal genius for politics and for their craft, perhaps none more cannily than the painter Velázquez, who spent his life courting favor from kings and popes. In *Las Meninas*, finished in 1656, he paid the most sublime and provocative tribute to the artist's relationship to power. The king and queen of Spain appear as ghostly reflections in a mirror, while their children and court dwarves occupy the foreground. But what animates the painting is the self-portrait of the artist and his own unflinching gaze directed toward both the viewer and the presumed presences of the king and queen, who must have stood (or were imagined) in our place.

His painting perfectly embodies the paradox of the artist in the emerging modern world: subversion by means of apparent submission. Or the reverse.

Similarly, many Russians (especially the expatriate intelligentsia) reproached the legendary film director Andrei Tarkovsky for playing too subtle a double game with Soviet authorities, especially in *Nostalghia* and *The Sacrifice*, the two movies he made abroad during the period of his soft "exile." His Western defenders have always claimed that it was his only means of survival and that it allowed him to make a number of masterpieces, a defense scoffed at by those who believed themselves insiders.

Today, 360 years on, no one reproaches Velázquez for sucking up to the Spanish throne, because no one claims he could have made a better painting than *Las Meninas*. And contemporary viewers of Tarkovsky's *Andrei Rublev* or *The Mirror*, unaware of his biography, will simply marvel at his bold poetry. Even if the ethical contradictions of the artist's relationship to power are present in both cases.

The fundamental questions for every artist, journalist, teacher, intellectual, and parent are: What does it mean to exercise power while calling into question the workings of power? How can one preserve one's own freedom but also promote the

freedom of others? How far can you take civil dis-obedience within a society? Within a household?

Wenders embodies, for me, the archetype of the artist who has sacrificed his most vital function. And so becomes emblematic of his era.

In the early and mid-1970s, keenly sensitive to the lingering culture of political protest but equally aware of its dwindling force each year, Wenders ap-proached political topics only indirectly and with a self-exonerating irony. At the same time, he knew that movies needed to have some political edge if they were to find an audience. Art house crowds (very substantial in those days) might have been tiring of the crusades of the 1960s, but they still believed that the ordinary acts of daily life carried political meaning. Any ambitious film of that era needed a political dimension, just as a film today needs a layer of explicit violence to have its hip-ster seal of approval. Wenders embodied the shifting spirits of the 1970s, going from the alienated cool of *Alice in the Cities* and *Kings of the Road*, with its iconic hipster line for a generation of Europeans, "The Americans have colonized our subconscious," to the sleek imagery and postmodern posturing of *The American Friend*. His ironic disenchantment with politics resonated strongly with twenty-year-old students like me at the turn of the 1980s.

But as that decade took form, Wenders quickly intuited the shift from political disengagement to the embrace of pure consumerism, defined by the radical neoliberal revolution of Reagan and Thatcher. Ever the man of the shifting zeitgeist, he turned to nicely packaged objects: pretty light, pretty actors, pretty moments of "poetry." *The State of Things*, *Paris, Texas*, and *Wings of Desire* were emblematic products of the 1980s.

As the consumer society metastasized in the 1990s into an even more homogenized form, many of those who claimed countercultural status became more explicit in their embrace of the marketplace. Wenders rebranded as a fashionista, a pop figure, a designer. It was no accident that he made films about the fashion world, that he became an international jet-setter, trailed by upscale paparazzi, going from white limousines to private jets with his rock star collaborators like U2's Bono. Rather than make movies that ostensibly tracked the zeitgeist, Wenders was living it.

But by the time he made *The End of Violence* in 1997, he was really making "The End of Wenders," since the decade had by then been swept up by the Tarantino tsunami (*Reservoir Dogs* in 1992 and *Pulp Fiction* in 1994). A society that prided itself on its superficiality and that sought excess as a norm needed

much stronger stimulants than Wim Wenders's fading namby-pamby intellectual posturing. He hadn't understood that to adapt to the times he would have to embrace violence, declare "The Start of Violence," not its end. Wenders, skillful merchant of the poetry of the unsaid and the unseen (not to mention the unfelt), couldn't compete with the high-octane pulp-porn violence of Tarantino and his many acolytes. Wenders was losing his public with what were often expensive flops, an ironic market-determined fate for an artist who marketed hipster freedom from convention as his visiting card. *Until the End of the World,* which cost 23 million euros in 1991 (roughly $40 million today), grossed $750,000. *The Million Dollar Hotel,* made at the turn of the millennium, cost $8 million and grossed $59,000.

Wenders can be considered a symbol of his times in the sense that, obsessed by the end of things, he knew himself to be the end of *something.* He somehow recognized that he and his movies represented the capitulation of art to the marketplace. He made many movies that nostalgically proclaimed the end of all things he was thought to hold dear. He became paradoxically the symbol of artists' tabloid glamour *and* of auteur cinema, the poet of German film (who cannily avoids mentioning the Nazi past but celebrates the new world master, "American culture"), a leading international poet *and* a

member of the jet set. Wenders the *filmmaker* be-
comes a *designer,* in the parlance of his friends in
the fashion world, itself the apex of creativity in
the new neoliberal world order.

What is the logical endgame of Wenders the
zeitgeist seeker? For a long time I thought I'd found
it while traveling on an Iberia Airline flight in 2009.
I opened the in-flight magazine to find a full-page
advertisement for Sony screens carrying the smil-
ing face of Wim Wenders and his signature under a
promotional text along the lines of "Nothing beats
a screen by Sony..."

But the real point of no return (*Faraway, So
Close*—the title of another one of his films—
indeed) can more likely be found in the 2014
film *The Salt of the Earth*, about his world-famous
friend, the Brazilian photographer Sebastião Sal-
gado. The contemporary *cursus honorum* of the great
jet-setting artist reaches an apotheosis here. In an
emblematic sequence, Salgado is photographing
Wenders, who in turn is filming him. Salgado says,
"Wim, I've taken a great picture of you!" Wenders
answers, "Me too!" to which Salgado replies, "I'm
not surprised..." Wenders by Salgado, Salgado
by Wenders. The portrait of millionaire artist X
by millionaire artist Y. The portrait of *Homo eco-
nomicus* turned artist by an artist turned "economic
man." Mutually autocentric hagiographies, stripped

of content or critical judgment. The portrait of selling out (or selling *in*).

Once again, a Wenders film shows us the state of things today, not by appraising critically but by serving the market and reassuring our expectations. One brand-name artist canonizes another, without any real consideration of the state of the world that the photographs are meant to depict. In a sequence that is the epitome of narcissism, Wenders presents some of Salgado's most horrendous photos, taken during a severe famine in the Sub-Sahara. More than their aestheticization of human suffering, which raises serious ethical questions (in Brazil, Salgado is frequently criticized for his for-profit eroticization of poverty), what is most troubling is their use in the film as straightforward illustrations of Salgado's humanity. At no point does Wenders reflect on what seems obvious. Are these photographs cries of distress or are they cultural commodities? A view of the world or simply self-aggrandizing reflections of the man who took them? In the end, Wenders, who collects Salgado's photos—and thus speculates on their (substantial) market value— shows us his thinking as a consumer. And as a retailer. What's worse is that it's possible none of it is done consciously.

---

BUT WENDERS is not an isolated case. The global film market expects the artist to be a brand name, a designer with a recognizable signature, a label. He needs to launch products whose visual and audio design is identifiable, exportable, salable. What used to be the celebration of artistic individuality and freedom from convention, the auteur, is now merely the artisanal re-creation of an industrial model: the repetition of a sales brand. And Wim Wenders has proven to be one of its pioneers.

*Four*

# The Artisanist

THE ARTIST no longer has the political or social credit as a public figure that he had at the time Pasolini addressed Italian television from the fascist town of Sabaudia. And artists are as much to blame for their increasing irrelevance as the power structure that has exiled them. Belief in artists has declined to the point where they are recognized only as product designers, on a par with other traffickers in luxury goods.

On the one hand, they're often too rich, too narcissistic, and too elitist, clinging to their privileges without always having deserved them. More product than producer, they sell their signatures and their names, self-forgers of recognizable goods rather than inventors of new forms, critical thinkers, or inquiring minds.

At the other extreme (another expression of our bipolar world), they are often too poor, too excluded,

or too marginal in their reach, precisely because of their rejection of the industry they're meant to serve. They address only a specialized circle of enlightened admirers, often in their own cultural field. These voluntary and involuntary outcasts have stopped speaking to society as a whole and are heard only by a nebulous sphere of self-identified subgroups. They survive only in a hothouse atmosphere, while public funding (and public faith) is drying up, and while the vast, indifferent, and undifferentiating tide of the Internet is drowning them.

So what's needed to give artists a different place in society? Not as great and unconnected jet-setters or as marginal crypto-militants on the cultural scene? Just as there is an environmental ecology, perhaps there's room for a new cultural ecology. Their objectives after all would be similar: the protection of biodiversity, the preservation of that biodiversity for new generations via cultural transmission, the promotion of a humane and fraternal ethic, an emphasis on qualitative rather than purely quantitative democratization. A cultural reawakening is certainly necessary: not just a commercial remake of past glories but a restoration of culture's vital role in a healthy society, where culture *replaces* consumerism just as consumerism had previously *displaced* culture. But this can only happen when artists, cultural actors of all fields,

seek to reinvent their own place in the society and not wait for society to do it for them.

As improbable as it might seem, the natural wine movement, a cultural phenomenon in rural and urban life across the globe, may open the way for a reunion of the two senses of the word "culture," which, until the mid-seventeenth century, meant only "working the soil" in Romance languages. The phenomenon of natural winegrowers offers hope and inspiration. Since the mid-2000s, it has carved out a remarkable degree of political, social, and aesthetic freedom, thanks to the fiercely individual as well as fiercely collective spirit of its practitioners.

This mix of traditional farmers and recently converted urbanites faced a series of threats fifteen or twenty years ago similar to those confronting filmmakers, journalists, and other urban cultural workers today. Yet they managed within ten years to create an alternate culture and economy of wine that stands in a vigorous and joyous parallel to the existing one. Their acts of civil disobedience and their affirmation of cultural freedom in the face of the vast global regulatory-industrial system have provided inspiration to farmers of all kinds. We are now seeing militant importers and distributors, playfully evangelical sommeliers, enlightened, sometimes utopian restaurant owners, and free-speaking critics and bloggers. This global network of genuinely

independent artisans and artisan-merchants offers a guarantee of freedom for the person who, at the end of a long chain of exchanges, receives the final fruit of this culture. And it turns that person into an enthusiastic citizen, an unconsumer. Could this happen in the world of urban "culture"? Would it be possible to construct a parallel organization for cinema, painting, publishing, inter alia, that could flourish in a fully independent, self-sustaining environment, beholden to no established power?

As the new world of wine gains a wider (and ever younger) audience, the aesthetic principles of wine are being vigorously reimagined and vigorously reconnected to the past. Natural winegrowers are giving a new face to the wine craftsman. In place of the enologist and wine guru, reprising the role of all-powerful artist, creator, demiurge, and genius, capable of growing vines on the moon and making wine with the same sweet, fruit-cocktail profile from China to Bordeaux, we now have the small artisan, rooted in his (ancestral or newly adopted) locality. He is concerned with the nature and expression of his land, and he is unable to make a wine that is not the transcription of a particular history, inscribed in the double cycle of the previous season's harvest and of generational renewal and innovation.

In this way, we move from the Romantic image of the artist, conceived as the century's prophet,

elevated by genius (or by God) to the artisan-artist, whose primary concern is to keep ethics and aesthetics from drifting apart. The artisan-artist is ambitious and humble (that is, close to the humus, the top layer of soil that contains most life on earth), but in no way modest in the sense of "limited" or "undistinguished." Nor modest in having a taste for what is average, working within the parameters of the industry to reach the greatest number with a product that is unexceptional. The most exacting natural winegrowers are not modest. They abhor dullness. They are as ambitious as their colleagues the urban artists.

But precisely because these artisans generally don't think of themselves as creators, but more as inventors (and because of the merciless nature of nature itself), their ambition is always tempered by humility. They don't claim to make something out of nothing, but they find ways to put their vision of human beings and the world into the substance of their wines. They take into account the radical otherness of nature.

The artist who derives inspiration from the artisan, who in today's world adopts the artisan's spirit, is an inventor. But he is not an artisan in the old sense, with its overtones of crafts and guilds, but rather an *artisanist,* an artist who has reconnected with his artisanal origins.

*Five*

✺

# Agro-artisans

TWELVE YEARS AGO, when I took a detour from my work as a fiction film director to make *Mondovino*, a documentary about the anthropology of the wine world, I saw wine above all as a cultural expression rather than as an urban commodity. Despite my parallel life making wine lists for restaurants while I began my filmmaking career, my encounters with winegrowers all over the world had convinced me that the quality of a wine, what gave it alimentary *and* cultural value, was determined by the history of the vineyards themselves and not by its final (urban-destined) product. In fact the distance between the American term "winemaker" and the French *vigneron*—very roughly "vineyardist"—or the Italian *vignaiolo* is telling.*

---

* In fact, throughout this book, I'll tend to use "winegrower," an awkward but less invasive term, instead of "winemaker."

At any rate, a dozen years later, I've come to believe that I only half understood what's at stake. The more decisive leap is to recognize that work in a vineyard is significant only because it's part of a larger agricultural practice. Vineyard work is not the beginning of a process that ends in wine; rather, it is one extension—perhaps in its most refined form—of a much larger engagement with the land.

Maybe the most significant contribution of the natural wine movement has been to encourage us to reflect on agriculture as a cultural gesture in itself. Which inevitably leads to a keener understanding of how critical agriculture is for the future of humanity. The natural wine movement has led many city dwellers like me to see it as the (most chatty) ambassador for the culture of the countryside at a moment in history when the fate of our species may depend greatly on reinventing the urban-rural relationship.

The celebrated art historian Robert Hughes defined "the shock of the new" as the tectonic shift in the perception of painting in the first decades of the twentieth century. If the film *8½* shook my sense of what cinema and art were capable of when I was eighteen, then twenty-five years later, natural wine had the same effect on my understanding of what I drink and eat. Improbably, this change has also produced a radical shift in my sense of what it means to be a citizen.

I was living in Paris in 2004 when *Mondovino* was released in cinemas. It was received by the French as a critique of the homogenizing forces of free-market globalization, so I wasn't surprised that in one of my first interviews a reporter for the conservative newspaper *Le Figaro* began our encounter in a reproachful tone. But to my astonishment his critique of my film was not that it went too far, but that it hadn't gone nearly far enough. "Why is there no discussion of natural wine in your film?" he wanted to know.

My interviewer was Sébastien Lapaque, literary critic for *Le Figaro* as well as a prolific novelist and essayist (including a brilliant reimagining of Saint Francis returning to earth the year mendicancy, one of Saint Francis's sacred subjects, was declared illegal in his hometown of Assisi). I didn't realize then that Lapaque was one of the first champions of natural wine. He was close to both pioneering natural winegrower Marcel Lapierre in the Beaujolais and his friend, the radical sociologist Guy Debord, author of the seminal 1970s book and film, *The Society of the Spectacle*.

At that point I had already been serially experimenting with natural wine (like a teenager discovering the delights and perils of pot?), but I had yet to fully determine my feelings on the subject. I was convinced long before by organic and above all biodynamic farming. But the natural wine movement,

which was even more rigorous in its pursuit of chemical-free purity, remained, like many of its wines, a little cloudy. Still, Lapaque's disappointment resonated with me. Was it because of him that I arranged to have most of my subsequent interviews at the Verre Volé, nearby my apartment? I can't really remember. But I do know that for the next few months I jousted with my interlocutors in one or the other of perhaps two places in Paris at the time which stocked exclusively natural wines. Long before it became a disenchanted home to a rising tide of trend-seekers, this wine bar off the Canal St.-Martin was a cozy spot for passionate young people who shared their joy of discovery like bibliophiles or cinephiles from another era. But instead of talking books and movies, the young people who worked there and who came in to eat and drink natural, *talked* wine.

The wines they argued about both fascinated and—sometimes—repelled me. They broke with most of my a priori assumptions of what wine was. On the one hand, in 2004 many winegrowers (confirmed and neophyte) were just beginning their engagement with "experimental" wine. Some—but certainly not most—of the wines I tasted were so *out there*, furiously acidic or bitterly oxidized, that my pleasure in tasting them was limited. But it was a crucial schooling, for those of us discovering the

wines for sure, but also for those making it. And unlike others who see wine as a product that needs to meet the demands of its consumers, I think it's entirely reasonable for a winegrower to have us pay for his or her experimentation: a reproach of natural wines that's still thrown around by the vino (climate) skeptics.

Why shouldn't the public faithfully accompany artisans who dare to experiment? It's a simple question of faith: the necessary yeast that allows culture to exist in the first place. The periods when cinema was at its most vital, like the 1970s, were doubtless those in which filmmakers could count on a public's loyalty even in their experimental missteps.

Tasting these wines that were so much less polished, less accommodating—sometimes downright crazy compared to what I knew—I began to feel the same sort of excitement that the anticonformist cinema of Fellini, Fassbinder, and Cassavetes had provoked in me more than twenty years before. I was tasting reds that were lighter-bodied, more taut and acidic than the fuller, more alcoholic, sweeter wines that had dominated the marketplace since the "go-go, Coca-Cola, and cocaine" 1980s. But the rupture with what had become conventional white wine was even more radical. Like a certain self-consciously spare indie filmmaking style of the 1980s, white wine had been neutered—either

stripped of its content and made colorless and odor-less, or it touched the other extreme, made over-stuffed and cloyingly sweet, like Hollywood's 1980s love affair with bloated bimbos, steroidal special ef-fects, and saccharine comedies.

In complete contrast, the natural white wines I was discovering were often tannic, aromatic, and deeply colored, sometimes even orangey-amber, and always in a saline, bitingly acidic, down-to-earth register. These whites astounded me for their tactility and their vitality.

It took me a while to understand that I was tast-ing the shock of the new, but also the shock of the old. As with any moment of cultural rupture, the act of innovation cannot have any enduring value unless it is also a profound regeneration of the past. In this case, I was tasting wines that I would dis-cover were renewing, in a contemporary idiom, a tradition stretching back at least eight thousand years, a tradition sundered only after World War II with the global imposition of chemical agriculture. These natural wines restore a vital link to civili-zation's founding gestures that began with the first agricultural practice ten thousand years ago.

As with the films I had encountered twenty-five years before, these wines never left me indifferent: neither those that entranced me nor those that un-nerved me. Their vital energy necessarily provoked

reactions of equal intensity. It seemed to me that their natural effervescence (many in fact *are* bubbly) was genuinely radical, in the metaphoric but also the literal sense of *radix*, Latin for "roots."

Of course there are natural wines of a spurious radicality where the desire to provoke is the end in itself, shock for shock's sake, as was sometimes the case with the French New Wave cinema for instance, where Jean-Luc Godard especially practiced the old prankster formula to *épater le bourgeois*.

But after more than a dozen years of paying attention to the natural wine scene, I'm convinced by the authenticity of the overwhelming majority of these winegrowers' gestures, the authenticity of established farmers as well as the numerous neophytes. They share a commitment to a historical exploration of their terroir—not as a reactionary affirmation of "the way it was" but as a legitimate search for collective cultural roots. And in this sense, the presence of so many urban immigrants and their pioneering adoption of new places have been critical. Natural winegrowers' experimentation is an act of liberty that provides a sense of freedom to others. And it's exactly that contagious liberty that defines the emancipatory character of any vital culture.

Today it's virtually impossible for me to drink a so-called conventional or traditional wine with any pleasure, especially since what is presented as

"conventional," from the legendary Château Haut-Brion in Bordeaux—Samuel Pepys's favorite wine—to America's favorite, Sutter Home, is in fact in the most violent rupture imaginable with the conventions of any era, so disfigured by chemicals are their lands and so technically manipulated are the finished wines. These wines suggest how far man is capable of muzzling nature and any territorial expression, just as film directors are confronted with the Scylla and Charybdis of technology in relation to the (potential!) humanity of their actors.

IN 1997, when I made my second feature, my first pure fiction film, *Sunday*, I worked with a wonderful British actor, David Suchet. Star of the Royal Shakespeare Company for thirty years, the beloved Poirot on television, and veteran character actor in countless British and Hollywood films, Suchet was an ambulatory film school for me. The first day of the shoot, on a numbingly cold February day on a Queens overpass, I went (nervously) about the business of choosing the camera angle with the cinematographer. I saw Suchet eyeing me carefully. My nervousness increased. He was clocking every gesture. After about ten minutes I felt more like a CT-scan patient than a film director. When the shot was finally set up, I'd completely forgotten about

the video assist, the portable screen that allows directors to follow what the camera captures in real time. Introduced in the 1980s, it had become every film director's security blanket.

As soon as I cried "Action," I found it impossible to take my eyes off Suchet, as if he was simultaneously looking at the actor in front of him and me behind the camera.

When the take was over, Suchet strode over (with an athlete's gait, despite having put on forty pounds for the part). He put his arm around my shoulders and smiled at me with a hint of menace. "Good thing you understood." In fact, I had no idea what he meant. But I nodded my head in a sign of feigned complicity.

It was only days later, when I'd gained more of his trust, that he told me that the take was a test of whether I could be prodded toward being more of a craftsman than a technician. From then on I hedged my bets, out of fear of his wrath and from a desire to cement a budding friendship, and kept my eyes as much on his as possible.

Only on my next film, *Signs & Wonders*, did I realize how critical Suchet's schooling had been. It was Stellan Skarsgård, the magnificent Swedish actor who regularly commutes back and forth between European arthouse films for directors like Lars von Trier and big Hollywood blockbusters like

*Pirates of the Caribbean*, who offered me a simple explanation. "The eyes of the director are the gaze of the spectator. An actor needs to feel that attention to give what's deepest inside him. But if the director spends his whole fucking time watching that little video monitor—the formal element—instead of what produces emotion—the real substance—then the spectator is likely to do the same, whether he knows it or not."

*Six*

# The Mind and the Body

It's not only (nor even primarily) taste that has maintained my passion for wine. Much more compelling for me has been to observe the gestures of the men and women who make wine. Even if the singular connection between nature and man might somehow be perceptible in the taste of wine, much as the personality and engagement of an artist might condition—but don't define—the aesthetic quality of his work, aesthetics without ethics is inert. It is disconnected from what is alive. In fact, I'm more inclined to believe today that *how* a wine is made is as important as where it's made. Just as I've become more convinced that how a film is made determines the deepest nature of what we see on the screen. Process is (deepest) substance.

The contemporary significance of this question was brought home to me recently when I met up in a café near the Luxembourg Gardens with my old friends Rachel Rosenblum and her husband, Daniel

Dayan. Rachel, a psychoanalyst and writer specializing in the memories of trauma, described to me the effect of discovering natural wines. "For the first time in my life," said Rachel, "I feel like the material world has something to teach me."

Born in 1940, Rachel belongs to the generation that came of age after World War II believing that the great material questions were being resolved. Even for those critical of the emerging consumer society, it was credible to accept the fundamental legitimacy of the economic system. With the exception of certain Marxist critics and more convincing dissenters (against all orthodoxies) like Pasolini or Guy Debord, who resisted up until (and including?) his suicide any recuperation by the system that he denounced, Rachel's generation, left and right, remained largely faithful to the notion that the Western materialist model was fundamentally a source of progress and eventually could be remolded to be beneficial to all. This generation, in the flush of palpable—and historically unparalleled—prosperity, seemed to believe that the great questions that remained were of an existential, theoretical, and immaterial nature. Those who were drawn to the arts, to culture, to the intellectual life, lived in a culture of the purely immaterial (and deconstructionism is doubtless its relativist apotheosis—or nadir).

Rachel's husband, Daniel Dayan, a social anthropologist, is from the same generation. As we sipped our typically Parisian coffee—a bitter, mean-spirited version of the Italian—Rachel explained that when Daniel was a student in 1963, he was obligated to spend a year doing practical anthropology. He dealt only with verifiable, concrete matter. Daniel smiled at the memory: "it bored me so much that I waited for each day to go by so I could get back to 'real anthropology': pure theory."

I was born in 1961, but I belong much more to their generation than to the one that immediately followed mine. However, when Rachel then tells me that their son, Emmanuel, a filmmaker born twenty-five years after me, is a committed ecologist, I was surprised she even mentioned it. It seems impossible to imagine that anyone under forty could *not* consider themselves ecologists. His generation as well as each one that succeeded his have understood much better than ours that the greatest questions today, politically, culturally, existentially, are solely material.

## The Reincarnation of the Flesh?

Natural winegrowers and their engagement in completely material, agricultural questions (without ever

losing sight of the spiritual dimension) have allowed for a return toward a more concrete vision of the world and may hold a key for a reinvigoration of urban culture.

A dozen years ago, it seemed that the future was as bleak for the partisans of wine as a cultural and artisanal expression as it is for partisans of any cultural expression today. It appeared that eight thousand years of viticulture were going to be annihilated by the double whammy of chemically destructive industrial wine and the pseudo-artisanal version of the same, simply repackaged as a luxury product. And this was true from Chianti to Bordeaux to Napa. For any genuine, ecologically engaged artisan, the war seemed lost. There was no comfort in any country from the various institutions supposed to protect authenticity: the AOC (Appélation d'origine controlée) in France, the DOC (Denominazione di origine controllata) in Italy, universities from Chile to Australia where agronomy was taught, government watchdog agencies like the FDA or the European Union's agriculture commission. It was as if they'd all suffered the invasion of the *winebodysnatchers*. Almost all agricultural research was being dictated by the multinational agrochemical industry and its lobbies, including the drafting of ridiculously porous organic regulations on all sides of the Atlantic and Pacific that allowed for numerous chemical

additives and manipulations. Journalists submitted, out of cynicism, laziness, or ignorance, to the viticultural aberration, and each year consumers and merchants become more accommodated to a bogus system.

It seemed unlikely that an unbowed, renegade winegrower could survive.

But not only did a handful survive, they succeeded in inspiring tens of thousands of colleagues and newcomers to embrace agriculture as an act of liberty and as an ethical and aesthetic endeavor. Above all, given that most individual farmers in the twenty-first century were ending up isolated, burdened with debt, and excluded from the marketplace, the greatest miracle of the natural wine movement may be that it generated a spontaneous network of farmers' solidarity across the globe, which in turn created an alternative social and commercial urban network, from São Paulo to Paris to New York, largely populated by young people. A new culture—aesthetic, social, and economic— emerged, uniting the countryside with the city in a single phenomenon. Today natural wine is a concrete economic and cultural reality, linking Chicago to London to the Catalan hills. It's made up of old farming families, those who never abandoned what the French and Italians call (uncondescendingly) "peasant common sense," resisting the siren call of

chemically enslaved agriculture. But there are just as many neofarmers, urban exiles who often have abandoned more conventional cultural activities to become voluntary refugees from a social order they found physically and morally untenable.

Natural wine is more a phenomenon than a movement because, like Occupy Wall Street, it has a natural disdain for imposed rules. But unlike Occupy, it is *only* concrete. It has brought together tens of thousands of winegrowers, each one radically different from the other, each one determined to preserve his or her subjectivity. Predominantly French and Italian for the first years, today natural winegrowers are present in every winegrowing region of the world, and some are even pioneering new areas, like Deirdre Heekin and Caleb Barber in Barnard, Vermont.

Throughout this book, various portraits of these winegrowers will emerge, but always with the caveat that they are not being invoked as representative of any ideology but simply as expressions of themselves. Their inclusion is highly subjective. I'm neither a journalist nor a sociologist, and there's no pretense in this book of "objectivity."

In the natural wine world—the natural farming world really—I believe we're at the beginning of a new form of cultural expression, a singular hybrid between a progressive, self-conscious, and highly

contemporary urban culture and an ancestral, rural one. Every week dozens, probably hundreds of new natural winegrowers are taking up arms (scythes!). A list which might have seemed definitive a year ago could seem woefully incomplete today. In France, for instance, at the beginning of the millennium, there might have been a few dozen winegrowers who would have identified themselves as natural. Today, there must be more than three thousand.

◠

# Portraits of Artisans as Young Men (and Women)

## Deirdre in Vermont

I WAS IN LONDON having dinner with a natural wine importer, Doug Wregg (whom I write about in more detail in chapter 22). Since I live in Italy, where there's an embarrassment of Italian wine riches but a very provincial view of "foreign" wine, when I'm abroad I'm always eager to drink "the other." Knowing that Doug brings in natural wines from almost every significant wine-producing country in the world, I was tingling with excitement at the thought of a crystalline Austrian white or a fiercely vibrant Loire red or even a murky, soulful, amber wine from the ancient amphorae of the Kakheti region of Georgia.

Instead Doug pulled out a bottle of sparkling wine from Vermont. And grinned mischievously. I

thought he was pulling my leg. And I tried to see what other bottles he was hiding for us to actually *drink*. But when he insisted I taste the odd-looking green bottle with the wholly unfamiliar grape varieties, I ended up being the one with the improbable smile stretching across my face.

All the qualities I'd hoped for from the Austrian, French, and Georgian seemed to combine inside this improbable liquid...from Vermont! It was certainly the most precise and stimulating American wine I can ever remember drinking.

From Vermont. Not California, Washington, or Oregon.

Or even the Finger Lakes.

La Garagista from Vermont.

Deirdre Heekin, the winegrower of this unlikely jewel from the frozen Northeast, actually grew up in Evansville, Indiana, which she describes as "more South than Midwest." Deirdre fell in love with the movies and decided to enroll at Middlebury College in Vermont to study film. After graduating in the mid-eighties, she wanted to become a screenwriter, so she moved to New York, where she worked for British TV and for oddball production companies like Vestron.

"But I started filming dance and then became a dancer. With an Italian woman we founded a company, Castiglione Fiorentino, and we did some

touring." In fact her love of Italy kept on bringing her back to food and wine.

With her companion of twenty-nine years, Caleb Barber, whom she'd met at Middlebury, they opened a restaurant in Woodstock, Vermont, in 1996. She explains that "after a year and a half in Italy, we started it as a *tavola calda* (an Italian twist on a diner) and *pasticceria* (bakery)." As they gained experience, it slowly morphed into an *osteria* (more like a bistro). "Caleb was cooking, and me,...I was *wining*. My wine knowledge was totally self-taught. We wanted to reproduce an Italian lifestyle, sourcing locally, sourcing honestly. It started as just the desire to get access for us to the best food, but there was always a romantic side, always inspired by Italy."

In 2007 they started to think about actually trying their hand at making wine. "We were already growing apple trees and vegetables organically. I was deep into natural wine. I mean natural wine as I understand it, which is that the farming must be honest."

Deirdre is careful to emphasize that "Organic has a broad spectrum. But the health of the soil and of plants is critical, as is having a personal relationship with the vines. And always trying for low intervention. But I'm not dogmatic. I understand if a producer makes a choice in a given year to use a chemical tool to save their crop. I can't criticize

them for protecting their livelihood. Of course my hope in that case would be that they would return the following year to not using chemicals. To see what led them to need the chemical intervention in the first place."

Bruno De Conciliis, a charismatic winemaker from the Cilento region in southern Italy, was a significant influence on Deirdre. She had his wines on her list, but when he came to Vermont to her restaurant, she dared him to try an experimental batch of homemade wine with unknown grapes from California. "I wanted to learn how to make wine in the bathtub in five-gallon buckets to be able to talk about it more concretely. I had no intention of ever actually becoming a winemaker. I called the wine "No Controllo" because we didn't even know where the grapes came from. But Bruno tasted it and said, "That's a start. Now you need to make wine like a real peasant." He has remained a kind of spiritual godfather ever since, from his vineyard perch above the Gulf of Salerno and the ancient Greek temples of Paestum.

Another important influence for Deirdre was Lincoln Peak, a pioneering Vermont winery. "We were impressed by how solid and well made they were. They had integrity. Even though they're not in the natural-organic-biodynamic camp. But you could see there was great potential. We took

home a hundred plants. We didn't consciously think about being winemakers." Caleb adds: "We got just enough encouragement to keep going at each step. It was another activity that helped us leverage the kind of life we wanted to live, just like creating a bakery and an *osteria*."

It seemed improbable even to them that their cuttings of hybrid and native American grape varieties could produce serious wine. After all, any American wine that's well regarded, whether it comes from California, New Mexico, New York, Oregon, or Washington, is made from European *Vitis vinifera* grapes. Chardonnay, Pinot Noir, Cabernet, and even Zinfandel all have what is considered a noble European lineage.

To imagine truly fine wine from these American country bumpkin grapes—hybrids like La Crescent, Marquette, Frontenac Gris, and Saint Croix— would be unthinkable to many wine experts the world over, especially those in the United States.

Deirdre and Caleb knew from Lincoln Peak that the grapes "could produce something reasonable in this unlikely climate. But we had no idea what would happen if they were unleashed organically, biodynamically. It turns out they're the poster children for natural farming. Because they fight against tinkering. The more they're allowed to inhabit the wild side of their nature, the more they're at home,

comfortable, relaxed, allowed to speak. That's how they find their voice. Us too."

La Crescent, for instance, was bred in the 1950s by a Minnesota horticulturalist named Elmer Swenson, intent on discovering vines that could survive harsh and snowy winters. "But take *Vitis riparia*," says Deirdre. "It's a grape specific to New England. It grows along the water banks. Or *Vitis labrusca*, it's native American, indigenous material. Or even *vinifera* derivatives like Moscato d'Amburgo. Unlike conventional *Vitis vinifera* grapes—Barbera, Sauvignon, Merlot, or what have you, these grapes are all naturally resistant to diseases that occur up here. Which means you can let them grow naturally, without chemical or technological intervention. And with a polycultural family tree, it's easier to grow organically."

She knows most people are skeptical of what these rough-and-ready American varietals can produce. But she explains that it's precisely their rugged pioneer spirit that allows them to thrive where others might wither. "We farm biodynamically and do as little as possible in the winery. Virtually nothing. Because we want transparency of place. It's definitely different from the Napa model."

Caleb chimes in, "You go into a crazy venture like this with high hopes. But we never expected it to work. The existing Vermont wine movement—"

Deirdre interrupts him with a laugh: "That sounds like a Monty Python skit. 'The Existing Vermont Wine movement!'"

Caleb says that those who were making wine before followed the Californian combo of hype, tourism, and tasting rooms.

Their next obstacle was their conviction to grow organically. "So everybody said you can't grow organically in Vermont...but they never finish the thought. Because what they mean is you can't grow grapes organically and meet your financial goals." These theories were all based on Cornell, UC Davis, and Minnesota enology schools. "Our advantage is we weren't business people or trying to start a company to make money. We needed to survive, but it was the excitement of an experiment and as wine lovers..."

Today they have about eight acres planted to vines, but allowing for a natural biodiversity, they're not planted in a dense or systematic way. While that amount of land could easily produce twenty-five thousand bottles a year, their current level is six thousand. Their three different parcels are in the Champlain Valley outside of Vergennes, which Deirdre describes as having more limestone than clay; another vineyard outside of West Addison, which is more clay than limestone; and, nearer their home in Barnard, one with volcanic soil.

After twenty-nine years together, they casually complete each other's sentences. Or their own sentences with each other in mind. "I think so much of what Caleb does with his food, what I'm trying to do with the wine, is connecting with something larger, communal," says Deirdre. "We're not religious, but we're aware of spirit, connecting with our natural world, with people around us and with ourselves, the attempt at making art as a way of sharing a narrative. I'm a storyteller and the same goes for Caleb. Every meal he cooks at the *osteria* is a story. All of these endeavors have been about telling a story about our place in a larger context. The ambitions that I had in college and after—for film, for dance—all come together in wine. I'm still attracted to writing. I'd like to study to be a poet. But they all feed the emotion to make wine."

## Mathias Un-Bordeaux

Mathias Marquet, a thirty-four-year-old with an open face and a mischievous smile, lives near Bergerac, not far from Bordeaux, with his dynamic partner Camille and their two small children. Mathias studied political science at the University of Bordeaux and then switched to Lyon, where he met Camille. They were students, he says laughing, of "marketing

and humanitarian communication." He soon realized, though, "that it was ridiculously hypocritical. We learned about North-South relations, but always from the point of view of what favors the North!" Concerned that there was no future in France for the young, Mathias and Camille dropped out and went to New Zealand to work in agriculture. But when he found out his parents were about to sell their twelve-hectare (roughly thirty-acre) vineyard back in France, they decided to return. Together, they leased the land with the help of bank loans to see if they could make a go of it. "It was a terrifying roll of the dice," said Mathias, because neither he nor his parents could afford for him to run it into the ground. His father had kept it afloat by selling his grapes to the local wine cooperative.

When Mathias and Camille started in 2007, when they were in their early twenties, they followed the recommendations of an enological consultant suggested by the local wine authorities, the CIVRB. The enologist worked for their neighbor and half the properties in the modest Bergerac appellation. They were plunged into the world of pesticides, herbicides, and fungicides, reinforced by technological intervention at every step in the winery.

After a year or two of bottling his own wine, there was a village feast where each local winemaker

would bring his own production. With the bottles flowing freely from table to table, Mathias suddenly realized that he could no longer recognize which wine was his. It wasn't just identical to his immediate neighbor's wine, but to most of everyone else's in the appellation. He was in shock.

"At that time," he said, "I had a friend with a wineshop nearby in the town of Brantôme. He was into natural wine, and he would have me taste them," including the whites of Claude Courtois, a natural wine pioneer from the Sologne in the Loire. "The first few times I tried them, I thought they were disgusting. But after a few months, thanks to my friend's persistence, I fell for them, body and soul. They felt like they had *body* and *soul*! I understood the link between the taste of those wines and a certain way of working. I began to take the first steps toward producing natural wine."

Marquet acknowledges that the ecological aspect of natural wine appealed to him, but he insists that it was above all a question of taste that got him moving. "The other aspects, the political ones, came afterward. Honestly, sometimes people make too big a fuss about the political side. In some ways I have more respect for my immediate neighbor, who's a real farmer, and even though he doesn't even work organically, he leaves ten times less of a carbon footprint than some loudmouth natural winemakers,

flying to New York and Tokyo to preach the eco-
logical virtues of their natural wine." Marquet
laughs. "Being radical for me means what you do in
your daily life. It's not about what you say. It's real.
Concrete."

But this view comes from a winemaker who's
in fact very active politically, like many from his
generation, where being militant is a spontaneous
gesture, maybe more ethical than ideological. His
friend and contemporary Olivier Techer of nearby
Château Gombaude-Guillot in Pomerol—one of
the very few Bordeaux estates to produce natural
wine—explains: "I think our work *is* above all a
question of ethics, in the sense that a natural wine
of course has to be organic as a starting point. But
everything else around it counts too. Like how eq-
uitably you treat the people who work with you,
using lighter-weight bottles to reduce your carbon
footprint, and selling locally and to genuinely inde-
pendent retailers. But I'm reluctant to even tell you
this because it's our business really, and I don't want
to make a public show of it. I mean, reducing your
environmental impact isn't just a winegrower's con-
cern. It's everybody's. So what we do isn't anything
extraordinary."

Although the name of Mathias Marquet's estate is
the haughty-sounding Château Lestignac, his labels
are anarchic, punkish, and puckish in their imagery.

The names of his wines range from a Kubrick homage, Eyes Wine Chut (roughly, "Eyes Wine Shut Up"), to Copains Comme Cochons ("Friends like Pigs"), with the subtitle "Because every part of the pig is good." Marquet's wines, joyful, kinetic, complex, made me reconsider the Bergerac appellation, even though he's regularly denied the AOC, that is, the right to put the name Bergerac on his label.

His wines are difficult to find in the region, including in the city of Bordeaux. But from L.A. to Sydney, his bottles are in demand. It's a situation that reminds me of the rebel filmmakers of the 1970s, people like John Cassavetes or Rainer Fassbinder, spurned at home but sought after by an ever-growing coterie of international admirers.

Marquet is an artisan, keenly aware that anything "authentic" is extremely fragile in a global context, where your work can easily be appropriated by the "marketplace." At the same time that he benefits from the growing international success of natural wine, he's disturbed by its hipster tendencies, from Paris to New York. Whereas he's deeply respectful of his Japanese importer, who regularly visits his vineyard and meticulously follows his practices, he cites the wave of Parisian restaurant owner-chefs who have flipped "the trendy natural wine switch." He says, "I can't stand the sight of another Parisian hipster chef, jumped up on cocaine, with tattooed

forearms, who sells my wine at four times its cost with a big spiel about my terroir. And not only has he never bothered to even see the vineyard in person, he tells me how I should make my wine whenever I go up to Paris to drop off some cases!'"

## Thierry of the Valley

If Marcel Lapierre in the Beaujolais, who died in 2010, and Pierre Overnoy in the Jura, now eighty, can be considered the grandfathers of the natural wine movement, fifty-two-year-old Thierry Puzelat is its rakish uncle. The son and grandson of modest farmers at Cheverny, just outside the city of Blois, Puzelat, who has made natural wine with his brother since 1995, "has been an inspiration for me," according to Marquet. Although a third-generation grape grower, Puzelat says: "I never wanted to practice this craft exactly, because it was my dad's. I'd been forced to work on the farm every vacation, every weekend. It wasn't fun. But since I was a shitty student, the only chance I had to get through high school was at an agrarian technical school. I went reluctantly, partly pushed by my parents. That's where I so-called 'learned' how to make wine."

He managed to get his high school diploma and a junior-college-level technical degree in Bordeaux:

"There, I learned that *making* wine was a question of how to *sell* wine made from maximum yields of rotten grapes." Eventually Puzelat found himself in the distinguished wine region of Bandol, in Provence, "where I could apply what they'd taught me in school: wines made from laboratory yeasts, bucketfuls of tartaric acid, and a laundry list of other chemical additives. I'm lucky to still be alive!"

But in 1991, his life changed. "I was invited, sort of by accident, by a seasonal grape picker to the Fourteenth of July Bastille Day party of Marcel Lapierre in the Beaujolais. I stayed there for two or three days. It was a revelation. I was literally swept off my feet by this thing called natural wine. At that time, there were only a dozen or so winemakers in France working like that. I was also swept off my feet by Marcel, the man, because he radiated a kind of freedom and fearlessness that no one else in the wine world seemed to have."

After ten years of his errant apprenticeship, Puzelat came back to the Loire to take over the nine hectares of family vines with his brother. "Before, because my brother was alone, he let our father take care of the vines. But because we were now a team, it meant we could kick our father out and look after the vineyard as we thought best. Chemical-free."

Puzelat pauses as he thinks about what to say, because it's clear that it's something important. "As

far as the vinification process in the winery, my father was pretty close to our convictions. He was one of the rare winemakers who had refused to use the little packets of artificial yeast that had arrived like a miracle cure in the 1970s. However, in the vineyard, he was one of the first to use herbicides."

Puzelat continues: "But you have to understand my parents' context. When they finished their working life in 1989, they were making the minimum wage for two. For them, weedkiller meant being free from a back-breaking task. And at that time, in the early 1970s, they had no idea of how devastating it was to the soil. The pesticide and herbicide salesmen never said a word about that. And my parents just followed what the chamber of commerce for agriculture told them to do. Since they sold their wine for little money, using weedkiller meant more leisure time. They went directly from tilling with a horse to Monsanto's Roundup. At least they sold the horse in 1969 before they started poisoning the soil he worked."

When Thierry came back to the family farm in 1995, he was determined to make the change. "At first, we tussled. But the terms of my return were clear; my father had to retire. It was a little painful between us. He was depressed for two or three years, and then finally everything settled down when he saw that our approach was recognized. I

still think back about the effect of all those choices. It's a classic story of passing the torch. But in the end he understood and he was proud of us. And he loved our wines. He drank them until he died."

However, when the subject turns to the wine-maker as creative rebel, Puzelat is as skeptical as Marquet. "I think nature is completely beyond our comprehension and what I try to do more and more is simply to make my hand in the process as transparent as possible. I think when you're young, you're desperate for recognition. You want to be more of a show-off. But when you begin to understand a little what a terroir and a harvest is, you try to disappear from the process."

When I ask him if he considers himself an artist, he gets annoyed. "There are winemakers who consider themselves 'artists,' but I think that's pretentious. We're just not that important a factor in the end result in the bottle. I think we all need to move in that direction, if we really want to defend the idea that our wines are unique and unreproducible."

Is it a coincidence that according to French intellectual property law, what constitutes the definition of a work of art is that it be "unique and unreproducible"?

*Eight*

# Artist, Artisan . . . Artisanist?

*Sed quis custodiet ipsos custodes?*[*]

ARTISTS, from the heroic times of the ancient Greeks to their contemporary ontological crisis, have always had to navigate between their own desires and the civic reality around them, between the Scylla of submission to the dominant powers and the Charybdis of exclusion.

But the status of the artist in society was tied from the beginning to the first democracy. The three great tragic playwrights of the fifth century BC whose work survives, Aeschylus, Sophocles, and Euripides, as well as the one comic master, Aristophanes, are among the earliest individual artists identified as critical to their society's well-being. Not coincidentally, they are all Athenians, from the home of the first democratic experiment.

---

[*] But who will watch over the watchmen?

## The Archaic Artist as Archetype

Aeschylus epitomized the notion of the civically engaged, heroic artist, whose art and life are at the service of the community. The son of a patrician family, and a decorated soldier in the two victorious wars against the Persians (in 490 and 480 BC), he was crowned thirteen times the winner of the Athenian playwrights' festival. Aeschylus was not only a celebrated folk hero but also a moral conscience for his fellow citizens.

His last play, *Prometheus Bound*, offered one of the earliest portraits of the politically engaged artist: the artist as martyr for the cause of liberty. Prometheus, a demigod saddened by man's barbarism and ignorance, decides to steal fire from the gods. Fire is energy, power, technical innovation, learning. The agent of civilization. It gives man autonomy from the gods. For this emancipatory act, Prometheus is punished by the gods. He's tied to a rock in the Caucasus Mountains (likely the region where wine was first revealed eight thousand years ago), where a vulture comes each day to eat out his liver, which then grows back again at night.

An artist's self-sacrifice for the public good was never so painful.

What we call an artist today was considered vital to the Athenians, the first civil society to conceive

a social democracy. The artist, as personified by Aeschylus's Prometheus, liberated his fellow citizens from ignorance and oppression. Still, warning signs of the artist as megalomaniac were already present in the play, suggesting that he might subvert his devotion to the public good for the sake of his own vanity.

Sophocles and Euripides, born a generation after Aeschylus, came from more modest backgrounds, but they were exact contemporaries of the great democratic champion, Pericles. Recognition of their artistic contribution went hand in hand with the flourishing of Athenian democracy. In the second half of the fifth century, the ideal of the artist as civil watchdog began to emerge. Aristophanes, the great comic poet, a ferocious political and cultural satirist in the vein of the Marx Brothers or Monty Python or (I kid you not) Adam Sandler, was protected by his fellow citizens despite constant threat of lawsuits by the city's elite.

But the vertiginous slide of Athenian power during the Peloponnesian War, in the last decades of the fifth century, and a progressive marginalization of the artist's standing, were prefigured, if not encouraged, by a later contemporary of Aristophanes, Plato.

In the *Republic*, a savagely antirepublican text, Plato sought to banish the artist from participation in city life altogether. He made a distinction between

the artist and the craftsman, between *poesis* and *tekné*. Plato distinguished the *teknetes,* the craftsmen, those who create an object according to a precise design (the contemporary definition of the artisan), and the *poietes*, those who create according to their imagination (the artist). Plato concludes that since the artist works from his imagination, he creates a world of illusion, of dangerously misleading imitations of life. The artist endangers truth and reason, which are indispensable for the governance of a city-state. The artist by his nature is uncontrollable and therefore a menace that should be banished.

There is a double irony here. Plato's fear of the artist as toxic illusionist to some extent has been realized in the last century (e.g., the conceptual artist as huckster). But to the extent that Plato harbored a repressive, totalitarian fear of the artist as a menace to the state, he himself is a gleaming example of the liberating poetic imagination that he denounces.

During the Roman era, when the state and its powers subjugated everyone, artists and especially poets (Horace, Juvenal, Virgil, inter alia) seemed much more anxious about the fragility of their position in society, both under the republic and imperial rule. The relation between artistic creation and power was decidedly cozier in Rome than in Athens, just as the freedom of citizens was much more circumscribed. Artistic production, as a consequence,

was significantly more imitative, more timid than its Greek predecessors.

## Monks and Troubadours

Is there a link between the decline of the ancient civilizations and the absence of artists to contest those in power? However much contemporary historians call into question the term "Dark Ages" to describe the period between the fall of Rome in the early fifth century AD and the rise of Charlemagne almost four hundred years later, there is no question that artists and writers during that period completely disappeared from the Western landscape. Art became anonymous, collective, wholly effaced behind the importance of its sole subject matter, the worship of God.

An artist, faceless (or sublimated by the face of God) because of his largely anonymous status for nearly a thousand years, reappears in the twelfth century in the guise of the troubadour. The name is derived from the French *trouver* (find), and this etymology is worth considering today.

In contrast to the minstrels, who were servants— they "ministered" to others with texts that were not their own—troubadours were inventers of texts, and

this conferred a superior social status. They became known individually, and their lives were celebrated ("*Vidas*"). But the beauty that they were said to evoke came from what was preexistent. They "discovered" stories and settings and allowed them to bloom. They transformed what they found into objects of delight, pleasure, and reflection (much like winegrowers).

But neither the freedom nor the humility of their status as "finders" protected them from power. Troubadours were attached to courts, protected by lords or princes, or they would wander from court to court where they would place their "trobars," their poems. Sometimes they were rich noblemen, even lords, like Guillaume IX of Aquitaine. Or they might be poor, wholly dependent for survival on their wits and their talent, like Bernart de Ventadour, the son of a baker and a smith. Treated like sages, they would often engage in political debates and were known even to challenge a prince or two. Their intellectual status depended on their inventiveness with ideas and words. Although under the patronage of a lord, they were able to negotiate their independence, as this verse of the troubadour Cerverí de Girona (1259–1285) attests:

> *I would find the king tiresome*
> *If he called for me when I pleasure in my work,*

> *Or if he asked for me when I have no pleasure to*
>  *see him,*
> *Because I would die if I had no time for reflection.*
> *So I say to those who ask, "What do you think,*
>  *Cerverí,*
> *What pleasure will we have?"*
> *I say, "Leave me in peace, so I can compose my*
>  *couplets."** 

## The Re-creation of the Artist

A few centuries later, the word "artist" in France and Italy surfaced in the realm of the visual arts. Its birth—or rebirth—was directly inspired by the model of the troubadour. In Renaissance Italy, when the *artisan*-painter became a thinker, an intellectual, a poet, he became an *artist*-painter. The plastic arts were originally classified as mechanical arts, more manual than intellectual. To ensure its practitioners a more noble and independent status, to exalt the individual qualities of creativity and virtuosity in the age of humanism, the passage from mere artisan to intellectual-artist was necessary. In the Middle Ages

---

* Author's translation of verses in an article by Gérard Zuchetto, "Petite introduction au monde des troubadours XIIe–XIIIe siècles. À l'aube de la littérature moderne…" (http://www.musicologie.org/publirem/gerard_zuchetto_01.html).

a land surveyor was considered to practice a noble art, while a painter's was distinctly inferior. And in some ways, they were likely not mistaken.

In fifteenth-century Florence, painting had become what Leonardo da Vinci called "a mental thing." In his *Lives of the Artists*, published in 1550, Giorgio Vasari evoked the ancient Roman, Pliny the Elder, and the "*Vidas*" of the troubadour in order to plead for the importance of the Italian (and especially Tuscan) painters. Vasari insisted on the singularity of their technical power, suggesting that their renown expressed a new form of saintliness.

Over two centuries earlier, Dante Alighieri had been the first person to use the word *artista*, in Canto XIII of the *Paradiso*. For Dante an artist strives (not always successfully!) to inscribe the divine in a material form.

> *Se fosse a punto la cera dedutta*
> *e fosse il cielo in sua virtù supprema,*
> *la luce del suggel parrebbe tutta*
> *ma la natura la dà sempre scema,*
> *similemente operando a l'artista*
> *ch'a l'abito de l'arte ha man che trema.*

> *(If the wax was molded at its best,*
> *with Heaven at its most virtuous,*
> *the light of the seal would be wholly apparent.*

*But nature always makes it imperfectly.*
*Similarly an artist,*
*who has the technique of his art, also has a*
*    trembling hand.)**

His association of the imperfection of nature with the imperfection of the artist, of the purely material form with the anxieties of a divine aspiration, places his artist in a thoroughly novel and modern paradox. Even if today this paradox would resonate more deeply with a natural winegrower than a conceptual artist.

Above all it was Michelangelo who consecrated the word "artist" in the modern sense with his sonnet "l'Ottima Artista":

*Non ha l'ottimo artista alcun concetto*
*c'un marmo solo in sé non circonscriva*
*col suo superchio, e solo a quello arriva*
*la man che ubbidisce all'intelletto.*

*(No great artist can conceive*
*that even a perfect block of marble*
*can shape itself, but that it must be touched*
*by a hand that obeys the intellect.)***

---

\* Author's translation.
\*\* Author's translation.

It's ironic—and telling—that his contemporaries thought so little of his skills as a poet and so little of his learning that this sonnet that exalts the artist as intellectual wasn't published until 1623, nearly a hundred years after it was written!

The very same year marked the consecration of the modern literary artist with the publication of the complete works of Shakespeare, only seven years after his death. While Shakespeare was immensely popular during his lifetime, a figure universally admired for his virtuosity at the service of an independent intellectual and moral authority, the publication of the First Folio marked a turning point for the writer as public figure.

In France, the foundation of the Royal Academy of Painting and Sculpture in 1648 ushered in another defining modern conception of the artist. The academy permitted a dozen or so painters and sculptors to become autonomous from the guilds that had previously condemned them to the status of artisan. They could now be free to pursue their intellectual, aesthetic, and financial independence.

But in this apparent upgrade, a critical rupture was established between the artisan and the artist. Indeed the modern artist would now consciously, progressively distinguish himself from the artisan, culminating quite logically in the utterly dematerialized role of the conceptual artist today. In the

seventeenth century, many artists took pains to distinguish their capacity for invention and creation from the simple task of fulfilling instructions or executing a specific request.

Of course this distinction echoes the Platonic one between craftsman and creator, but here with a greater emphasis—and a strictly positive interpretation—of the artist's imaginative powers. In fact, what distinguishes the two conceptions, positive and negative, had perhaps less to do with anything essential and was more simply a question of power.

So in the seventeenth century, on the one hand there were moderately remunerated *artisan*-painters who belonged to guilds, worked out of shops, painted portraits, and accepted commissions. Then there was a new breed of independent *artist*-painter who frequented the Royal Academy, approached painting as a search for beauty, and cultivated prestigious clients. This nexus of political and aesthetic aspiration was exemplified by Charles Le Brun. Currying favor with Cardinal Mazarin and the all-powerful finance minister Jean-Baptiste Colbert before ending up as Louis XIV's favorite, Le Brun carved out a career as illustrious for the money he made and the power he gained as for his florid Baroque canvases and frescoes. The newfound artist's independence clearly had a price. Or prices.

*Nine*

⤢

# The Time of the Prophets

EUROPE IN THE EIGHTEENTH CENTURY was characterized by the radical subversion of Christianity and its terrestrial agent, the monarchy, as the arbiter of truth. The Enlightenment redirected the people's gaze away from king and clergy toward writers, painters, journalists: secular thinkers. The French Revolution was built around the (sometimes involuntary) patron saints Voltaire, Rousseau, Diderot, and Montesquieu. The world that emerged after the Revolution was proclaimed as the fruit of man's intellectual prowess. It was his creation, not God's.

The literary historian Paul Bénichou has called the proto-Romantic, post-Revolutionary moment "the time of the prophets." The artist progressively replaced the priest in the role of explaining the world, the hereafter, and one's place in both. How well equipped was he for the task?

Doubtless in order to convince others—if not also to convince himself—the early nineteenth-century artist devoted his *being* with (religious) fervor to his *art*. The notion of heroic personal sacrifice for one's artistic engagement became the principal trajectory of the Romantic artist, exemplified by the death of three poets: Lord Byron's in Missolonghi fighting (sort of) for Greek independence, at the age of thirty-six; John Keats's of tuberculosis at the age of twenty-five in Rome, anticipated by his request that no name or date be inscribed on his tombstone but only the phrase "Here lies one whose name was writ in water"; and Percy Bysshe Shelley's drowning off the Ligurian coast at the age of twenty-nine. Shelley's body was only identified when it washed ashore days later, a volume of Keats's poetry in his pocket.

The artist conceived of himself for the first time as taking the place not only of a priest but of the divine spirit itself, a substitute for God. Given God's estrangement from an increasingly industrialized, urbanized, alphabetized, and secular world, it's no wonder. The new artist of the industrial world was no longer a "finder," a troubadour, but a creator, a demiurge (an etymological irony, since "demiurge" comes from the Greek δημιουργός, or artisan).

Now perched on a pedestal of his own making, the artist was cut off from the soil, his roots, his

fellow citizens. To represent the world was no longer a question of geometry and appearance but of personal will and re-creative imagination. The painter who most decisively embodies this displacement of nature by the self is the Pomeranian, Caspar David Friedrich, master of the spiritual selfie (already evoked in the chapter on Wim Wenders, himself a direct descendant of the selfie-with-landscape tradition). Friedrich's predominantly landscape paintings reflect a world utterly re-created in the image of his own interior suffering and longing. He proposes a world in ruins, nature abandoned, men left to their own solitude, and here and there a few markers of divine (or at least painterly) transcendence. "A painter," he said, "must not only paint what's in front of him but what is inside him."

Did the bifurcation between man and nature, which the natural winegrower has now called into question, find its modern turning point here? Certainly the nineteenth-century cleavage between the words "culture" and "agriculture" (as explored in chapter 23) provides a clue. In the world of wine, the winegrower had been replaced by the enologist, a man who dominates and remakes nature in the laboratory, in the omnipotent alchemist's image. In reaction, the natural winegrowers maintain that they are not the source of their own wine. They are intermediaries between nature

and culture. They accept, find, translate. Nature's troubadours.

Most critically in the nineteenth century, the artist became a crucial figure in the urban cultural landscape of the emerging bourgeoisie and their de-sacralized alliance of the market and social democracy. Certain artists, aware of being subsumed into a new sphere of power, were determined to distinguish themselves from the bourgeois world. Poets like Baudelaire and Rimbaud and the painter Van Gogh took great pains to celebrate their bohemian life, free, amoral, and contemptuous of money and status. In their view, the true modern artist contests power at every turn, by the liberating nature of art itself. The artist's duty is to himself, his art, and a transcendent, transgressive notion of authenticity in the face of emerging industrial reproduction and homogenization. Until the second half of the twentieth century, it was the artist's life much more than his worldly success that could attest to his intimate spiritual and artistic success.

## Ergo Sum

Today, as we face the eradication of culture and art from the central role that it has enjoyed for centuries, even millennia, one question alone is worth

asking: how did the nineteenth-century artist, dedicated to his art in opposition to the bourgeois life, become in the twentieth century the artist-star, the great conformist, speculating consciously on the value of his own image?

Of course this question is bitterly ironic, since there have probably never been so many artists and cultural agents, both newcomers and veterans, without adequate means to earn their livelihood and with little hope for their future. Is this simply the artist's reflection of the 1 percent–99 percent split of contemporary fame?

Did the problem begin with the discovery that artistic posterity could be commodified and speculated on in the more immediate exchange for celebrity? And that celebrity itself could be parlayed into considerable profit, creating a kind of instantaneous posterity? So, pace Orson Welles, it *is* possible to work both for money and for posterity. Indeed the emergence of the film industry between 1915 and 1920 and the subsequent creation of a mediatized culture based on photographic illustration and publicity created the basis for the star system. Orson Welles, "boy genius" director of *Citizen Kane* at the age of twenty-five, was one of its prime examples.

At the start of the twentieth century, Pablo Picasso pioneered a new role for the artist: the artist as merchant. Not a small-time merchant but a

big-time trader, a self-speculator in the international marketplace. Picasso's protean genius, like Le Brun and others before him, expressed itself as much off canvas as on. He learned how to increase the value of his work by playing off his own signature. He produced at a frenetic pace, carefully adjusting the value of his work in the marketplace, certain of his own historical *and* monetary worth. Inheritor of the nineteenth-century mantle of the glorious artist, he cannily adapted to the new century, in which the more fluid bourgeoisie conflated the fetishization of art with commercial value.

Picasso's (naughty) spiritual stepson, Salvador Dalí, took it a (cynical) step further, concocting work expressly to create market value. He provided a model for the late-century artist, who has come to resemble a banker much more than a Byronian avatar of freedom or the Van Goghian model of heroic self-sacrifice.

Ezra Pound, inventor of Anglo-Saxon modernity, had intuited at the beginning of the twentieth century that God and the sublime would be replaced by money and that artists and priests would yield their (spiritual) place to bankers. Of course Pound's grotesque descent into anti-Semitism, with his mad diatribes against the international Jewish banking conspiracy, betrayed the logic of his inspired intuition. It would have been better served had he

developed it in the direction, say, of the chummy relation between the auto-speculator Dalí and the Spanish dictator Franco.

After Dalí, Andy Warhol provided the definitive rupture. His winking pursuit (all the way to the bank) of art for money's sake provided a flimsy (acrylic) fig leaf for the abandonment of content, of the object itself. A work of art became, a priori, an instrument of financial speculation. He opened the door for every postmodern con game from the 1970s and 1980s on, with Jeff Koons as its apotheosis. The artist as money trader becomes simply the artist as ATM. With conceptual art only two things count: the discourse surrounding a token object and its perceived market value (of course an impious view might hold that this simply brought religion full circle).

The object is completely disincarnated and infinitely reproducible, yet it retains, against all logic, the price of a "unique object." This constitutes a *reductio ad absurdum* of Walter Benjamin's critical 1936 meditation on the loss of an artwork's singular aura, in *The Work of Art in the Age of Mechanical Reproduction*.

Among writers in the postwar era, the situation was more ambiguous. Still, some managed to find fame and fortune equivalent to their plastic-art brethren. Authors like Arthur Miller not only made millions but became celebrities by marrying

film stars like Marilyn Monroe. The press, ever more colorful, ever more picture-packed, made celebrities of writers like Miller, Norman Mailer, and Ernest Hemingway, documenting every move of their fabulous lifestyle. They are no longer heroes but living myths. In France, Edgar Morin and Roland Barthes consciously invoked the ancient Greeks to describe these new stars of the 1950s: Picasso on vacation, Dalí at home, Samuel Beckett on the ski slopes!

When I made a short documentary in 1997 about Arthur Penn (director of *Bonnie and Clyde, Little Big Man,* and a little-seen masterpiece, *Night Moves,* among other powerful films from the 1960s and 1970s), the phenomenon of the artist as celebrity was brought home to me.

I had a day to spend with Penn for an Italian TV series that paired a young director with a master. It started off shakily. Famous for his work with actors, from the Actor's Studio and live TV in the 1950s, through coaxing unusually revealing performances in Hollywood from Paul Newman, Robert Redford, Marlon Brando, Jack Nicholson, and Gene Hackman, among many others, Penn seemed to have no wish to reveal a sliver of himself to my camera. At the end of a long shoot day that consisted mostly of me firing blanks, we headed back to his Upper West Side apartment in a checker cab

big enough to shoot in. Penn was clearly exhausted, but I also sensed a certain collegial pity for my day of misfires.

I decided to ask him whom he would have chosen as his master had he been in my situation thirty years before. "[Elia] Kazan," he said, suddenly perking up. "No doubt, Kazan."

"What would you have asked him to get him to reveal himself?" I asked Penn.

Out of compassion (or simply fatigue) he answered laconically; "Oh, I'd have asked him what makes him uncomfortable. Personally. But I don't know if he would have answered me."

We looked at each other. Had the old fox anticipated my angle of last attack? Had he planted the thing from the start to save me? He looked out the window and waited.

"And if I asked you that, would you answer my question, the way you'd want Kazan to have done?"

With the light fading outside, the last slivers of winter orange turning electric blue, Penn seemed lost for a moment in some recollection. Then he turned and faced me very simply: "I'd say, I wish had more talent. When I see Fellini, when I see the films of De Sica, Rossellini, I think I wouldn't have had the courage to do that. I know I wouldn't have. Yet the appetite was there. I guess my ambition outstretched my abilities."

Deeply moved by this unexpected confession from one of the great (and most soft-spoken) iconoclastic masters of the new Hollywood, I thought about what he'd said earlier when we'd broken for lunch. I'd asked him if the international success of *Bonnie and Clyde* (released in 1967) had changed him, changed his life. "Of course. But it was new that directors had become quasi-stars. There was now a new generation of people who knew everything about directors. We were a handful: Altman, Scorsese—not Cassavetes because he was always outside all of that, independent—Francis [Ford Coppola], and me. We got to an amazing level of notoriety."

For those convinced that Coppola and Scorsese merit their place in the filmic firmament while Penn has been justly relegated to the status of skilled craftsman, they would doubtless feel that Penn's withering self-assessment in the cab was simple truth. And that his fall from grace (the "grace" of notoriety, that is) was justified. For others less convinced of the former directors' deity and more admiring of the latter's subtle, determinedly unflashy brilliance, Penn's twilight-hour confession is an example of the humility and authenticity that define a true artist *and* craftsman.

At any rate, it *was* in the 1970s that film directors, like other artists, began to follow the model of the rock star, whether they wanted the acclaim or not.

The Elvis Presley–Beatles phenomenon had already demonstrated its transformation into economic power far beyond the old Hollywood star system. Rock stars had become the new model of artistic celebrity, spawning an entertainment industry built around the "starification" of select individuals, including even those who would otherwise be invisible, like film directors. They had become media icons that went beyond mere mortal fame, cut off from the hurly-burly of ordinary lives. A new class was born. With *MASH*, *The Godfather*, and *Taxi Driver*, the new Hollywood directors transformed the "authorial" status of the French and Italian New Wave into an industrial commodity: the auteur-star. This was yet another example of the immediate appropriation by the society of the spectacle of any innovative or rebellious gestures. As Penn noted, John Cassavetes was the rare maverick able to hang on to his marginal status and hence his liberty.

Stars after all have the right to a grander life: flying in private airplanes, earning huge amounts of money, hanging out with other stars. It's a milieu above the law and above conventional ethics, as the Polanski affair suggested, or even Coppola's Medici-like purchase of a trophy vineyard in Napa Valley. As an artist class becomes celebrity millionaires, many young people became pricked by the desire to emulate them as much for the lifestyle as for

the work itself. We now judge an artist for his fortune as much as for his output. And then we wonder why artists have lost their civic credit? As celebrated as Pasolini became, he was never fascinated by his status and remained a committed citizen-artist. And like Cassavetes, he clung to that with such tenacity that he never lost the respect even of his adversaries, even up to his violent death in 1975, possibly at their hands.

# Zero-Sum Game

WHAT HAPPENED TO ARTISTS at the end of the twentieth century? The same thing that happened to all other urban dwellers: they sanctioned the disappearance of the tangible world. The increasing distance between an art form and its physical object was reflected in the increasing gap between urban life and the material elements of the countryside: a phenomenon most clearly gauged by the decreasing ability of citizens throughout the Western world to identify what they eat, what they recognize in a market or supermarket as having rural, biological origins. Having subsumed the role of the priest during the progressive decline of religious influence throughout the nineteenth century and having slipped into the role of celebrity in the mid-twentieth, the artist naturally found a sympathetic bedfellow in the financial speculator who has (perhaps briefly) girdled

the twenty-first. Since the late 1990s and the era of spiraling financial deregulation and the consequent speculation on fictitious derivatives, the artist has found his place both symbolically and literally by the side of these banker-fabulists.

But the general cultural tendency toward disembodiment from the material world can also be traced to another paradoxical, improbable fellow traveler. In the 1970s and 1980s a de facto alliance occurred—unacknowledged and in most cases unsought after—between political radicals of the right and certain self-proclaimed radical intellectuals of the left. The former abandoned their historical role as conservatives and became the most radical subversives of any notion of preservation and transmission of a common heritage. Reagan and Thatcher, who might well be viewed by future historians (assuming that in the future there will be historians) as the most *systemically* destructive leaders of the twentieth century, unleashed the neoliberal revolution, destroying in the space of a single decade many of the most vital safeguards that social democracies had painstakingly evolved over two centuries. Specifically, their deregulation of the banking industry (aided and abetted by Blair, Clinton, and other successors) produced the financial Society of the Spectacle of our times. To lament Trump's destructiveness today as sui generis is to seriously underestimate how wide

the door was thrown open for him by his spiritual forebears, Reagan and Thatcher.

But the wholly immaterial, self-invented character of derivative trading found an improbable echo in the deconstructionist movement and many aspects of postmodernism. The real-world deconstructionists dreamt up by leftist theory were in fact actors on the right: the dark princes of fairy-tale finance and their enablers in the financial and political world. In both cases, the fundamental proposition is an absolute, unlimited, and fatally narcissistic relativism and consequent contempt for all things material and actual, from the notion of scientific fact to manual labor to a house you might actually live in and thought you owned.

In New York in the 1980s, heyday for the lefty-righty relativist two-step, I constantly came up against intellectual fashionistas, especially from academia and the art world, self-proclaimed postmodernists and deconstructionists, all of them dripping with contempt at the mention of "emotion," "authenticity," or the value of the work of the hand. Above all they disbelieved in the *intention* (ethical, moral, emotional) of the individual. As with the new banking masters of the universe, there was simply no room for namby-pamby empathy or humanism.

Defenders of all these antiquated notions, they would say, had understood nothing about the

evolution of conceptual art, the virtual economy, the coming virtual revolution, the gloriously egalitarian era of the immaterial. Many Anglo-Saxon interpreters of the work of pioneering French theoreticians Michel Foucault, Jacques Derrida, and Gilles Deleuze, among others, insisted—ironically—on a literal interpretation of what these French thinkers imagined as playful and metaphoric. French theory and its subsequent identikit subgroupings dominated the art world. While the roots of conceptual art can be traced back in one sense to the Renaissance insistence that the manual is guided by the mental, the definitive break with the value of the artisanal, of the handicraft element, is a pure late twentieth-century fantasy.

Having spent my first year after high school at the San Francisco Art Institute (in 1979–1980) and having then spent another half year at the Beaux-Arts in Paris shortly after, I followed the birth of conceptual art, from the trenches, as I wrestled with my own craft demons (they won hands down). By the time I moved to New York in the mid-1980s, I noticed that artists spoke almost exclusively about one thing: power. Everything was about power. Even the intimacy of their relationships. In fact at that time power in the art world was clearly shifting away from the artist, toward the critic, with his more arcane (and therefore more "powerful") discourse. I

watched artists scramble to curry favor with critics not in order to ensure a good review—as had been the case for centuries—but in order to understand what concept to propose as their art "piece" to a gallery. Inevitably in this climate, the critic replaced the artist. Art became only art criticism, purely theoretical, wholly immaterial. Mostly jargon-filled and (thankfully) mostly unintelligible. In this ever more solipsistic and disincarnated world, it's no surprise that the *res publica*—any public not in on the game—became utterly excluded. The "plastic arts" became wholly plastic.

IN THE EARLY 1990S, a painter friend (always accompanied by a gaggle of soothsaying critics) brought me a few times to the studio of one of the kings of the New York art scene, Joseph Kosuth, multimillionaire conceptual artist. He lived in a gargantuan loft on Broadway in Soho, draped with dozens of decorative young females dressed in black. Half of them looked like models, but in an even more rigidly "plastic" iteration. The proximity of the loft to Wall Street seemed more than geographical. Indeed, since the 1980s, when Quentin Tarantino's precursor and sometime collaborator Oliver Stone had made films that glorified—by ostensibly criticizing—the material (and therefore in their

terms, spiritual) ascension of bankers, *Wall Street* included, Soho lofts were liberally traded back and forth between bankers and artists, often with no discernible shift in the decor. The mannequins stayed.

For those not familiar with Kosuth's work, this is the rare occasion it might be appropriate to quote Wikipedia, whose relation to encyclopedias is akin (in a giddily, comically relative way) to conceptual art's relation to painting. The irony-free pages intone:

> *Kosuth belongs to a broadly international generation of conceptual artists that began to emerge in the mid-1960s, stripping art of personal emotion, reducing it to nearly pure information or idea and greatly playing down the art object . . . One of his most famous works is* One and Three Chairs, *a visual expression of Plato's concept of the Forms. The piece features a physical chair, a photograph of that chair, and the text of a dictionary definition of the word "chair." The photograph is a representation of the actual chair situated on the floor, in the foreground of the work. The definition, posted on the same wall as the photograph, delineates in words the concept of what a chair is, in its various incarnations.*

Who could've made this stuff up?

Is it any surprise then that Kosuth explained in a 2013 televised discussion with noted art dealer Josh

Baer that "I do different kinds of work, so I have different price schemes"? To which Baer naturally responded: "In the 1980s, artists said that quality corresponds to price and since I'm just as good as such and such an artist, my prices should reflect that. But I want to talk about Leon Golub and Nancy Spero, since they're not here anymore to defend themselves [they were dead at the time of the interview] and because they're famous left-wing artists. And I can tell you, they were as concerned about the sales price of their work as any artist I'd ever worked with."

The explosion of the financial bubble in 2008 was a kind of sublime fusion of the postmodernist left and neoliberal right. The burst bubble could be seen as the result, on the left, of thirty years of abandonment of the defense of the notion of authenticity as a progressive force, and on the right, the result of thirty years of abandonment of the authentic as a value to be preserved and transmitted.

IN ADDITION TO the millions of direct victims of the subprime fraud, there were other victims, including most of those involved in the creation and transmission of culture. But there was one notable exception. In a landscape in which ever richer investors accustomed to cashing in on invented derivatives find ever fewer fields for their speculatory investments, it's

logical that they would look to the world of contemporary art, utterly disconnected from any concrete reality, from any pretense to authenticity. It represented a true fiscal paradise for the new huckster plutocracy. The ad hoc invention of market value is not only legal, but it can be celebrated in this context as a civic virtue (as much as civitas and virtue are still linked). It's the art of speculation *ex nihilo, pro nihilo*. Ashes to ashes, junk to junk.

To this unholy alliance of left-right and their crusade against authenticity (the Trumpian world of alternative facts is its logical by-product), there is a third element that has formed a new and even more unholy trinity; the digitalization of the world, the infinite virtualization of all relations. Affectless relativism without (relative) limits. Trump *ad infinitum*!

Christopher Glazek, founder of Genius.com, a "post-Internet" (and doubtless postironic) cultural site, revealed the less than artfully crafted mechanisms of this world. In an article written for the *New York Times Magazine* in 2015, he undulated blithely between fawning and mockery ("reeling and writhing and fainting in coils"). Describing the daily life of Stefan Simchowitz, one of the new breed of post-Internet art dealers, Glazek writes:

> *Although laypeople may look at a $30 million Richter and compare it to splatters from a second grader,*

*Richter's prices are determined not by chance but by the elaborate academic, journalistic and institutional infrastructure the art world has built to mete out prizes and anoint the next generation of cultural torchbearers. The collector class has traditionally come from the very top of the wealth spectrum and has included people looking to trade money for social prestige by participating in the art world's stately rituals. Over the last few years, though, a new class of speculators has emerged with crasser objectives: They are less interested in flying to Basel to attend a dinner than in riding the economic wave that has caused the market for emerging contemporary art to surge in the past decade.*

Glazek pursues his journey through the L.A. underartworld with Simchowitz, who batch-collects young artists with only one idea in mind: play their futures like the commodity futures market. He continues, with a deadpan breathlessness in lieu of irony:

*We went to see Petra Cortright, one of Simchowitz's most promising investments and a leading figure in what's called post-Internet art. Simchowitz uses the term as a generational marker to describe how art history has been "flattened" for artists of a certain age. "When they typed in 'tree' in a search engine,"*

*Simchowitz explained, "they got a thousand pictures of a tree: a picture of a tree made in the 18th century, a tree made last year, a cartoon of a tree. You have this flattening of time." To the extent that "post-Internet" sometimes defines a sensibility, you could say that it's characterized by positivity, the melding of satire and admiration, an emphasis on popularity over exclusivity and an uncomplicated reverence for fame and success.*

The author of this article, an undisguised expression himself of the culture he's meant to critique (or of which he wishes to appear at once as critic and avatar), goes on:

*In November [2014], a pair of Cortright's digital paintings on aluminum sold at auctions put on by Phillips and Sotheby's for $40,000 and $43,750, up from less than $13,000 at an auction in July. Simchowitz says he has no doubt that her paintings will eventually breach the $1 million mark (an achievement that would put her in the company of perhaps 2,000 other artists in the history of the world). An alternate trajectory for Cortright would be that of her studiomate and longtime friend Parker Ito, another Simchowitz investment, who had a painting sold at auction for more than $80,000 in July but who in his subsequent 13 auction results averaged*

*just $30,000 per piece. In three other auctions during that period, his work failed to sell at all.*

Who is better placed to arrive at the following definitive (last) judgment than the author of the piece?

*Art pricing is a pure confidence game—there are no fundamentals to anchor the price of a painting, because a painting doesn't produce a stream of revenue. Emerging artists can be likened to start-ups, in that most eventually go to zero but one could become the next Jeff Koons. When an artist's prices overheat, though, it can instigate a panic and cause his or her market to implode. Young artists momentarily heralded as the next big thing can just as quickly be tossed in the trash. As Riedl (ex-model, ex-wife, but still Simchowitz's business partner) explained it, the trouble with speculators is that they "flip, flip, flip," and the piece "becomes like a musical chair. When it tops out and they can't get any more, they throw it away, and then it's done, and the artist is over. You don't go back to a reasonable price—you're cooked, you're finished."*

*Eleven*

❧

# Chemical Chimera

In response to the self-inflicted wounds of the chimerically disembodied artist, the phenomenon of natural winegrowers may offer us a healing artisan's materiality. And the (rooted) radicality of their work is already a clear reaction to another, more lethal form of disincarnation: the era of modern chemical agriculture. The ubiquitous use of synthetic chemicals in the last fifty years has transformed wine and most foodstuffs into chimeras: chimera in the sense of the mythological evocation of a fire-breathing she-monster (made of lion's head, goat's body, and serpent's tail) and chimera in the sense of a perilous fabrication of the mind. Supermarkets and specialty markets, from Iowa to Marseille, from Brasília to Melbourne, propose a conceptual notion of a tomato or a cucumber, the simulacra of fruits and vegetables, contentless meat instead of savory carnality.

If wine's history stretches back eight thousand years, it's possible to say that for 7,950 years, *only* natural wine could be found on people's tables. It's only since World War II that wine—like grains, meat, fruits, and vegetables—has become something else. So it's absurd to contrast natural wine to so-called conventional or traditional wine, as most people in the wine industry persist in doing. Natural wine was the norm for all but a recent fraction of its existence.

The massive chemical industrialization of agricultural practices (viticulture included) between the 1950s and the present day has had a dramatic triple effect. The biological life of soils has been devastated by the use of pesticides, herbicides, and fungicides. And this in turn has provoked the disappearance of any expression of terroir, an elusive French word that describes both the cultural and gustative specificity of a place. The technochemical assault has also poisoned wine and all other foodstuffs. Ninety-nine percent of the world's wines are made today with a significant quantity of synthetic chemicals both in the fields and in the winery. Vines everywhere are drenched with toxic formulas. Then, in the winery, the second assault against nature is made by hundreds of legal chemical additives and technological contortions that ensure that these so-called conventional wines have less and less of a link to the grapes,

the soil, the terroir, to nature itself. Even the majority of wines labeled "organic" (as per US and European Union regulations) are legally entitled to hundreds of chemical additives and numerous technological manipulations that completely denature the wine. These practices include the use of laboratory yeasts, which produce a Frankensteinian transformation of the grape juice during fermentation. Though the amount of sulfites allowed afterward would probably kill the poor monster anyway. And it is this chimerical monster wine that we've been drinking for the past fifty years, whether it's $5 Yellow Tail or a $1,000 bottle of First Growth Bordeaux or Napa luxury flimflam.

It should be said of course that edulcorated wine has a long history. The Romans cut, mixed, and remixed their wines with everything from honey to lead. They were so enamored of the sweet and dreamy effect of lead in their wine that it's often cited as one of the causes of their destruction. According to the venerable Edward Gibbon, author of the eighteenth-century classic *The Decline and Fall of the Roman Empire* (the reading of which would make a useful substitute—perhaps even antidote—to the morning newspaper today), numerous emperors' fondness for adulterated wines induced widespread lead poisoning and madness. Even the greatest Bordeaux estates in the nineteenth century were known to "hermitage" their wines, that is, to add the richer

wines of the Rhône Valley to make them more substantial. But still, the history of wine for nearly eight thousand years is defined by a liquid that has faithfully reflected the nature of the grapes that produced it.

It wasn't until after World War II that chemicals invaded agriculture. The celebrated Green Revolution—the transformation of global agricultural to industrial monoculture—should be renamed the Black Revolution. Or the New Black Death. In fact, the two activities—war and agriculture—were intimately linked throughout the twentieth century. The origins of modern warfare and the agrochemical industry have been intertwined since World War I. At the turn of the twentieth century the chemical industry was neither military nor agricultural nor pharmaceutical. It was all three together. The great industrial chemical companies like BASF, Bayer, Dow, and Monsanto operated—and continue to operate today—on all fronts, all markets at the same time, creating maladies and their remedies together. Indeed, the self-renewing cycle of creating both the illness and then the cure neatly characterizes the history of the twentieth century.

When the German megalith Bayer bought its American counterpart Monsanto, a move that defied

all humanitarian sense as well as the last vestiges of antitrust laws, it meant not only that one company now controls two-thirds of the world's seeds and pesticides, but that one company's net worth now exceeds the GNP of the majority of the world's countries.

If you consider the history of Bayer, however, this doomsday scenario is not a surprise. Their history is our history of the last 120 years. Bayer produced pure aspirin in 1897, then yperite (commonly known as mustard gas) during World War I. Since World War II, they have produced and commercialized pesticides that have caused record levels of cancer in farmers (not to mention their clients), as well as numerous medicines to combat those cancers and other life-threatening maladies. The one common thread, of course, is the constant creation of new markets for these synthetic products that have long been bathed in a modernist aura because their very synthesis proves the intelligence of humans and the preeminence of scientific progress.

## *Deutschland* Haber *Alles*

The story of the German Fritz Haber's synthesis of ammonia is emblematic and profoundly troubling. Hollywoodian in its form, avant-gardist in

its content (or maybe the reverse), it crystallizes how the twentieth century redesigned humanity's destiny. Throughout the course of the nineteenth century, Thomas Malthus's theories of irreconcilable population explosion macerated in the consciousness of progressive thinkers. Malthus predicted that population growth would lead humanity to a choice between famine and war. The rising anxiety, keeping pace with the population increase, reached a crisis point by century's end. In 1898, William Crookes, president of the British Association for the Advancement of Science, foresaw a food crisis in the coming decades: "population growth will greatly outdistance the harvests of The United States and Russia, principal producers of wheat, who will be obliged to curtail their exports in order to satisfy their own needs," he said. Pleading for an intensification of wheat production in England, he asked, "Where will we find the necessary nitrogen fertilizer?" It was pointless to count on the South American reserves of guano (bird droppings) and saltpeter from Chile, both of which were nearly exhausted. The only plausible recourse to avoid catastrophe was to fabricate nitrogen fertilizer from ammonia by extracting the necessary nitrogen from the atmosphere, exploiting a limitless reserve.

At the time that Crookes issued his warning in

England, the Prussian Fritz Haber, then thirty years old, a patriot of the new German federation, was on the verge of synthesizing nitrogen fertilizer. His hope, like Crookes's, was to create a cheap means of producing food in vast quantities. In 1909, he sold his patent for producing synthetic ammonia to the German agrochemical giant BASF. The future transnational—the biggest in the world until the Bayer takeover of Monsanto, bigger than Dow or Exxon—committed their chemists to the industrial production of ammonia. They quickly improved Haber's methods, building a large factory at Oppau. The production of nitrogen fertilizer liberated the emerging German empire from dependence on Chilean saltpeter and safeguarded them against the fear of famine.

But the philanthropic destiny of the factory would be redirected. With an ammonia base, it's also possible to obtain nitric acid, an indispensable component of explosives and munitions. When the Great War erupted in 1914, massive amounts of nitric acid needed to be produced for the German army. By 1915, the BASF plant in Oppau was producing 150 tons a day. Fritz Haber now worked exclusively for BASF, seconded to the German war effort. He was the first chemist to perfect the use of poison gas in combat. Indeed, it was Haber who decided on the chlorine that BASF then was able

to render in the liquid form required to massively exterminate Germany's enemies.

On April 22, 1915, Fritz Haber, now fully integrated into the military, personally led the world's first attack of poison gas near Ypres in Belgium. Some 150 tons of chlorine killed five thousand Frenchmen in the space of a few hours.

His wife, Clara Immerwahr, was a chemist of Jewish origin, like Haber himself. And when he converted to Lutheranism, so did she. But Clara, the mother of their two children, was also a pacifist. When Haber returned home to his family eight days later, she committed suicide.

Incredibly, Haber received the Nobel Prize in Chemistry for the year 1918. The ceremony, which didn't take place until 1920, was boycotted by the French, the British, and the Americans.

But Haber, a committed patriot, wasn't finished. In the 1920s he oriented his team's research toward the creation of a powerful insecticide against lice and other biological pests. This work utilized hydrogen cyanide, a compound that would become emblematic of the industrial recycling of synthetic molecules, from their agricultural application to their criminal use. And vice versa. But Haber was prevented from patenting his work. He was chased into exile by the Nazis, who of course didn't recognize his conversion from Judaism, when they came to

power in 1933. Soon after his death in Switzerland, his former assistant, Walter Heerdt, perfected and trademarked Haber's work under the name Zyklon B. His "odorless" version was quickly adapted for criminal use by the SS. This homicidal version of the insecticide was produced by numerous companies, including IG Farben, BASF, and Bayer. Zyklon B was marginalized after the war because of its genocidal fame in the hands of the Nazi death industry, but the chemistry itself remained useful to the capitalist industries that flourished after the armed conflict was ended. And even variations of Zyklon B remained, approved under the commercial name "Green Eden" in France in 1958 for the protection of the Green Revolution's new cereals. Zyklon B exists to this day in many forms, including in the Czech Republic, where it is sold as a pesticide under the name Urgan D2. Man comes and goes, but molecules are forever.

*Twelve*

❧

# The Green Revolution . . . Was Dressed in Black

THE BIOCIDE AVANT-GARDE is always aligned with the powerful. The chemical industry's systematic assault against all things living was pursued by every country throughout the twentieth century, its most lethal effects always coming from the dominant powers at any given time. Following the end of World War II, for instance, during the period of denazification, the Allied powers were only too happy to allow the Nazis' principal chemical industrialists to continue with business, as it were, as usual. IG Farben, the principal manufacturer, was simply subdivided into four companies: AGFA, BASF, Bayer, and Hoechst (which later became Sanofi-Aventis), with most executives and workers kept on.

After the war, most countries were faced with the urgent need to rebuild. So the chemical industry that had supplied the war effort reacted like a single

(transnational) organism, putting its molecules at the service of a new combat: the Green Revolution. Agriculture opened its arms wide for the chemical embrace. Nations on all continents, devastated after five years of total warfare, were desperate for miracle solutions. The new mantra of maximum yield provoked by the demographic explosion and industrial hegemony did the rest.

The Marshall Plan, which helped put postwar Europe back on its feet, also carried with it an agenda, not so much hidden as naturally embedded, much like the Gates Foundation's presence in African agriculture today. Bill Gates signed an agreement in 2015 with Monsanto, the world's leading manufacturer of GMOs, to make African agriculture as dependent as possible on the agrochemical giant. The philanthropy of the powerful is always conditioned by ideology and commercial self-interest.

In the 1950s and 1960s, the agricultural surface of the world was utterly transformed by the use of chemical fertilizers and biocides (pesticides, insecticides, herbicides, and fungicides).

Though partly a humanitarian gesture, the Marshall Plan nonetheless served as a Trojan horse for American business. The US armaments industry—principal agent for overcoming the Great Depression—needed new markets for its products in order to continue its exploding wartime growth.

The reconversion of nitrate-based munitions was heralded as the "necessary" tool to relaunch European (and world) agriculture. A new global war was declared. Who was the enemy? Insects, fungi, weeds, and, by extension, ecologists. In the United States at that time, Monsanto, Dow Chemical, DuPont, and others propagated a new generation of agromilitary molecules, including DDT (only banned in 1972), all of which derived from the wartime munitions industry. For scientific research the distinction between military and agricultural use was always fluid. Agent Orange, widely used by the US military in Vietnam, is a defoliant, a dioxin-based herbicide. It was banned in the United States in 1970 when the cancer risks became undeniable. But this didn't stop its use in Vietnam, where Monsanto and Dow Chemical had adapted the dosage for military use. Unlike the use of ammonia, a synthetic compound conceived as fertilizer but converted for war, or Zyklon B, a killer of pests adapted to kill human beings, Agent Orange was used by the US Army to destroy Vietnamese crops and forest cover. The agricultural product was employed as conceived, but in an unimagined—if utterly coherent—context. That the fields devastated by Agent Orange in Vietnam visually resembled the ones where the same substance was employed for so-called productive purposes in the United States was a cruel irony. This agrochemical invention

also revealed itself to be a killer of humans, causing cancer and malformations among millions of Vietnamese, not to mention numerous US Army veterans. Agent Orange is so toxic that it's transmitted through DNA and has wreaked even more damage on subsequent generations in Vietnam than on the hundreds of thousands originally affected. UNICEF has estimated that 1.2 million children in Vietnam suffer from disabilities today due to the use of Agent Orange. But the Vietnamese victims of the US Army's Agent Orange bombing campaign are still waiting for justice from the agrochemical industry, even though the air force bombers themselves have had their pathologies recognized by Monsanto and six other American companies, receiving damages in an out-of-court settlement.

But elsewhere the war was not so clearly declared. Little by little, beginning after World War II, farmers on all continents buckled under the political pressure of governments enthusiastic to expand the reach of the agrochemical industry and its promise of abundance. But the Green Revolution that promised to nourish the planet was never anything more than a phantom. At first there were significant increases in yields for many staple crops, thanks to the steroidlike stimulation of the various biocidal potions. But the ubiquitous and indefatigable agrochemical salesmen and their executives failed to mention three factors to

credulous farmers all over the world. First, their soils would suffer long-term erosion and eventual death. Second, the nutritional quality of their crops would suffer catastrophically. And finally, the risk of cancer from exposure to the various agrochemical killers would be more than double that of the population at large (whose own cancer risks were increasing thanks to their consumption of these tainted products).

But nowhere is the great agrochemical fraud more evident than in the nutritional analysis of fruits and vegetables. Philippe Desbrosses, agricultural consultant for the European Union and the French Ministry of Agriculture, has backed up numerous other studies concluding that you need a hundred standard apples today to arrive at the same level of vitamin C contained in a standard apple in 1950. "When our grandparents, as children, bit into a Granny Smith, they swallowed 400 mg of vitamin C, indispensable for the growth and maintenance of bones and skin. Today, supermarket aisles are filled with standardized clones that average 4 mg of vitamin C each," Desbrosses writes.

So even if chemical-driven intensive agriculture was able, for a time, to produce four times more apples than previously—the principal argument for the success of the Green Revolution—we're still losing twenty-five times the nutritional value of an apple from 1950!

"After decades of cloning and hybridisation, 'big agro' has selected the most disease resistant and visually enticing clones, but almost never those that are the richest nutritionally or the tastiest," says Desbrosses. A century ago, one single orange delivered almost our entire daily requirement of vitamin A. Today, you'll need to eat twenty-one oranges to ingest enough of a vitamin critical for our vision and our immune system. Similarly, a peach from 1950 has the equivalent nutritional value of twenty-six today.

The argument that increased yields have intrinsic merit is a fatal sham.

What folly has led us to accept such an aberrant situation? We've outdone Aldous Huxley, whose dystopian vision imagined a world of "soma" eaters, in our capacity to ingest the synthetic substances of oblivion.

HENRI DE PAZZIS, direct descendant of the Pazzi family, who staged a coup against the Medici in the fifteenth century (famous for their failure to galvanize public support despite the cries of "liberty, liberty"), is the former director and founder of Pronatura, the largest distributor of organic fruit and vegetables in Europe. Today he's a small farmer, cultivating ancient wheat varieties in the South of

France. As he states in *La part de la terre: L'agriculture comme art* (Portions of the Land: Agriculture as Art), the lyrical book on farming that he cowrote with Louise Browaeys, "the agricultural industry, blinded by the three major elements of soil—nitrogen, phosphorus and potassium, forgot the minor keys: calcium, magnesium, sulfur, zinc, copper and many others. This has drastically weakened all plants, especially in the reduction of the soil's biological life. The mineral impoverishment of the vegetal is transmitted, through the alimentary chain, to animals and to man. Between 1940 and 2002, cows lost half their iron, chickens a third of their calcium."

De Pazzis continues: "Selection was concentrated on plants with rapid growth whose size could become bloated with water and whose appearance was sleek and uniform. Our plates are filled with an illusion: they combine excess volume with a nutritional void."

## Agro-omertà

Gilles-Éric Séralini, professor of biology and genetics at the University of Caen in Normandy, was a French government expert on GMOs for ten years until he quit in disgust, convinced that his panel was hopelessly compromised by agrobusiness

support of all research, both in the government and in the universities. With the help of ecological activists, he set up a crowdfunding site and collected over two million euros for an independent study of the carcinogenic effect of Monsanto's Roundup-Ready GMOs and of Roundup itself, the most widely used herbicide on earth. His two-year study produced devastating results. It found significant increases in tumors, liver and kidney toxicity, and hormonal disturbances in rats fed both Monsanto's GMO maize NK603 and very small doses of Roundup.

For several days in September 2012, after the publication of his findings, he was hailed in France and across Europe as a whistleblowing hero. Then the worm suddenly turned (poison). The same newspapers—including *Le Monde*, *Libération*, and other so-called liberal media outlets—that had celebrated his landmark work a few days before, denounced him as compromised, incompetent, perhaps even fraudulent. Scores of respected scientists had been mobilized by Monsanto to debunk Séralini. Lazy—or complicit—journalists relayed their opinions as fact. Séralini was so thoroughly discredited that within a year the distinguished journal *Food and Chemical Toxicology* (*FCT*), which had published his initial paper, retracted it, a highly unusual step when neither fraud, plagiarism, nor verifiable error

are involved. Séralini's paper was the first ever to be retracted on the grounds of "inconclusiveness." His career seemed finished.

But the belief that agrochemical behemoths like Monsanto (über-behemoth Bayer-Monsanto since the end of 2018) ruthlessly silence critics in Stalinist fashion prodded a food transparency organization, the USRTK (US Right To Know) to invoke the Freedom of Information Act.

They obtained a copy of damning emails between one of the editors of *Food and Chemical Toxicology* and Monsanto regarding Séralini's case. It turns out that Richard E. Goodman, a professor at the University of Nebraska and a specialist in food allergens, had been brought on the board of the journal soon after the publication of Séralini's study. Goodman also happened to have been a longtime employee of Monsanto. In a messages in 2012 to the magazine's editor in chief, A. Wallace Hayes, Goodman wrote that 50 percent of his salary came from a project funded by Monsanto, Bayer, BASF, Dow, DuPont, and Syngenta. This revelation was damning enough by itself, given that these six companies, which account for almost all of the world's agro-pharma business, are technically competitors. It's the latterday equivalent of the infamous incestuous Seven Sisters, the leading petroleum companies that have historically colluded to rig the world's oil market.

But the fact that Séralini's study was retracted after Goodman's appointment to the editorial board is devastating. Among the emails obtained by USRTK is a September 2012 message sent by Goodman to Monsanto, right after publication of Séralini's study. He wrote that "he would appreciate it" if the firm could provide him with rebuttals. "We're reviewing the paper," his Monsanto correspondent replied, "I will send you the arguments that we have developed." Goodman was named associate editor of *FCT* a few days later. The journal's editor in chief went even further. In November 2012, while the Séralini controversy was still making headlines in Europe, Hayes wrote directly to Monsanto, reassuring them that Goodman would now be in charge of all biotechnology questions at the journal and adding: "My request, as editor, and from Professor Goodman, is that those of you who are highly critical of the recent paper by Séralini and his coauthors volunteer as potential reviewers." And it was this undisclosed "peer" reviewing panel, led by Monsanto's own Goodman, that pushed the journal to retract and therefore indelibly discredit Séralini the following year.

Séralini's story is a cautionary tale about how the legacy of Fritz Haber is embedded, like a cancer, in our lives.

But Séralini also offers us hope. Since being blackballed, he has successfully sued several scientists and several publications for libel and defamation. He has published two books, *Tous cobayes! OGM, pesticides et produits chimiques* (We're All Guinea Pigs! GMOs, Pesticides and Chemical Products) and *Plaisirs cuisinés ou poisons cachés* (Culinary Pleasures or Hidden Poisons), and authored numerous academic articles, including the republication in 2014 of his 2012 paper, in the journal *Environmental Sciences Europe*. In his most recent book, he writes:

> *intensive agriculture, sustained by chemical products derived from petrol, is killing the earth, given that 90% of pesticides and fertilizers are derived from lethal petrochemicals. When we talk about nitrates, they remain war munitions, and when we speak of insecticides, we're talking about products that were used in concentration camps. So we shouldn't be surprised that there are devastating secondary effects accumulating in our ecosystems. The principal role of all of these products is to block the synthesis of aromas so that a plant can grow more quickly. And in speeding up the growth rate, the plant is unable to become enriched by essential elements, instead concentrating sugars and proteins that result directly from chemical products.*

JONATHAN NO

## Whistleblowing in the Wind

As deadly as the drastic decrease in nutritional and aromatic qualities of foodstuffs produced by chemical treatments has been the molecular devastation of the biological life of soils. In France, Claude Bourguignon is one of the chief whistleblowers of this phenomenon, and his book *Les sols, la terre et les champs* (The Soil, the Earth, and the Fields) has had a critical influence on natural winemakers and farmers throughout the world. Both a microbiologist and an agronomist by training, he, along with his wife and partner Lydia Bourguignon, quit France's National Institute of Agricultural Research (INRA) over forty years ago to found their own independent laboratory, one of the very few throughout Europe. At the time they quit, as it is today, most agricultural research is directed toward intensive industrial monoculture and almost wholly dependent on grant money from large agrobusinesses, whether done in universities or government agencies. Bourguignon explained in an interview long after he quit that "the INRA has rejected wholesale organic and biodynamic agriculture without ever having studied it. It is a major professional and ethical lapse from a scientific standpoint. And indeed from that moment on, the INRA lost its liberty. It no longer remained

124

a governmental institute because it was not devoted to the common good. It is an institution at the service of the agrochemical and fertilizer industry." More than half of the studies conducted by the INRA are funded by such companies.

Already during Fritz Haber's period, Bourguignon says,

> *German universities were intimately entwined with the chemical manufacturers, especially those involved with drugs and dyes. Every new molecule created in factories was immediately sent to the university library for analysis. And vice-versa. University chemists would turn over their patents to the chemical industry for use in synthesizing new products. Scientists set a precedent for a revolving door between academia and industry. The fundamental conflicts of interest that have governed the use of chemicals in agriculture (and elsewhere) in the 20th and 21st century began here.*

In discussing the attacks on Séralini's study of Roundup and the shield raised by the chemical industry's Praetorian Guard of so-called neutral experts, a journalist in the highly respected whistleblowing French newspaper *Mediapart* explains, "Gérard Pascal, former toxicologist at the INRA and former president of the French government's Scientific Council for Food Safety, mocked Séralini

from the first day of publication with the ironic comment 'that if any of it were true, it would be the scoop of the century, requiring the banning of GMOs throughout the world.'" *Mediapart* continues: "Now retired, Mr. Pascal remains a consultant for multinationals Nestlé and Dannone, who are dependent on GMO crops." Or consider the highly mediatized, highly cultivated geneticist and essayist Axel Kahn. Godfather of the AFBV (French Association of Vegetal Biotechnologies), a pro-GMO lobbying group, for over twenty years Kahn has been on the payroll of one of France's leading agrochemical and drug manufacturers, Aventis Pharma (formerly Rhône-Poulenc), and is responsible for numerous patents registered on behalf of Aventis. But between 1988 and 1997, Kahn was also the president of the government's Commission for Biomolecular Engineering, charged with evaluating the risks of GMOs. The year he stepped down from the commission, he was promoted at Aventis-Rhône-Poulenc to scientific director of all agrochemical research.

In the United States, many ecologists were horrified by Donald Trump's appointment of Scott Pruitt, an attacker of the Environmental Protection Agency and a climate change denier, to head the EPA. But the tradition of EPA and FDA (Food and Drug Administration) directors and their immediate subordinates who are far too compromised

to be watchdogs is long and snakes through every administration of at least the last thirty years. Numerous high-ranking FDA officials in the Clinton, Bush, and Obama administrations had ties to Monsanto. For example, Michael Taylor served as deputy commissioner for policy under Clinton and deputy commissioner of the Office of Foods under Obama; he sandwiched a vice-presidency for public policy at Monsanto between the two gigs. Obama's last FDA chief, Dr. Robert Califf, was denounced by activists but unanimously approved by Congress. *Time* magazine noted at the time that Califf admitted "his salary [at Duke University] is contractually underwritten in part by several large pharmaceutical companies, including Merck, Bristol-Myers Squibb, Eli Lilly and Novartis. He also receives as much as $100,000 a year in consulting fees from some of those companies, and from others, according to his 2014 conflict of interest disclosure."

So much for the value of such disclosures.

*Thirteen*

❦

# The Conflict of
# Conflicting Interests

In February 2017, the scientific journal of the Public Library of Science, *PLOS One*, published a devastating report on the heels of a major conflict between two highly prized scientific bodies.

The previous year, the World Health Organization (WHO) had decisively concluded that certain GMOs and GMO-ready pesticides (including Monsanto's Roundup) represented a serious health risk for humans (the trickle-down effect of Séralini's work?). Especially in Europe, but all over the world, media and public consensus began to move more powerfully against GMOs and their attendant pesticides.

But as with the Séralini affair, the lobbies for Bayer-Monsanto, Novartis, Syngenta, Dow, and others mobilized a massive pushback. In the wake of their efforts, the American Academy of Sciences published an extensive study that concluded the

opposite of the WHO report: GMOs were innocuous. Suddenly the force of the WHO report had been blunted. Doubt had been sown everywhere. The doubt had been intentionally engineered. You could even say "genetically modified."

How was it possible that two of the world's leading scientific bodies could come to such diametrically opposed conclusions?

Thanks to the extensive study of conflict of interest in *PLOS One*, we have a better idea. The journal wrote:

> *Our inquiry found that six out of twenty committee members had financial COIs (conflicts of interest). Five individuals received research funding from for-profit companies related to the subject matter of the report and five had patents or patent applications on the subject matter of GE (genetically engineered) crops. Four panel members had two financial COIs. In all cases, the financial COIs concerned private interests that have a financial interest in the promotion of genetic engineering, not in opposition to it.*

They go on to fault the National Academy of Sciences for not declaring the conflicts of interest: "Just as the NASEM did not disclose any *financial* COIs among its committee members, it also did not disclose *institutional* COIs."

Even more disturbing is their finding that the National Academy of Sciences seemed to have expressly ignored warnings. "Even if committee members did not disclose all of the financial COIs we documented, the Academies were apprised of conflicts from other sources." NASEM was supposed to make the public comments it receives available for public review, but they refused, "including those that allege financial COIs."

The authors go on:

*Nevertheless, we were able to secure and review several letters submitted to the NASEM that discuss problems with the committee. One letter, co-signed by 23 individuals, mostly from academia, criticized the committee composition, noting that "the panel includes staff and representatives from institutions and agencies that have an established history and institutional orientation toward seeking technological approaches to intensifying agricultural production and prioritizing yield increases over addressing the complex amalgam of factors that contribute to achieving authentic food security."*

Even more conclusive for any remaining skeptics is a subsequent paragraph:

*It is noteworthy that several members of the committee that did not meet the financial COI criteria adopted in*

*this analysis, had ties to companies that a broader analysis may have cited as potentially introducing bias or imbalance. For example, one committee member directs a research project that accepts money from the Syngenta Foundation (associated with the agricultural biotechnology company Syngenta) and has recently published research that received in-kind contributions from agricultural biotechnology companies. Another committee member serves as the director of a university-industry research center that receives money from an agricultural biotechnology company. While these financial relationships may present potential financial COIs, they did not meet our strict criteria.*

So the six COIs become eight, nearly half of the committee. And who knows what further digging might have revealed.

Robert Proctor, historian of science at Stanford University, has developed an intriguing theory, which he calls agnotology (from the Greek word *agnosis*, "not knowing"), that seems to govern much of the scientific community directly linked to the agrochemical and biochemical industries. The theory first occurred to him as he read about a secret memo from the tobacco industry that was revealed to the public, called the Smoking and Health Proposal.

The Brown & Williamson tobacco company, which wrote the memo in the late 1960s, revealed many of the strategies big tobacco used to fight "anti-cigarette forces."

The memo read, "Doubt is our product since it is the best means of competing with the 'body of fact' that exists in the mind of the general public. It is also the means of establishing a controversy." Proctor explained that this led him to explore "how powerful industries could promote ignorance to sell their wares. Ignorance is power. And agnotology is about the deliberate creation of ignorance."

In the post-postmodern age of the viral relativization of truth (consciously nurtured by artists and academia, as suggested in previous chapters), the application of spurious balance, the strategy of alternate facts or conclusions, is epitomized of course by the frontal Trumpian assault on all things authentic. But Chris Hedges, formerly of the *New York Times*, in an article for Truthdig entitled "Donald Trump's Greatest Allies Are the Liberal Elites," argues:

> *The liberal elites, who bear significant responsibility for the death of our democracy, now hold themselves up as the saviors of the republic. They have embarked on a self-righteous moral crusade to topple Donald Trump.*
>
> *Where was this moral outrage when our privacy was taken from us by the security and surveillance*

*state, the criminals on Wall Street were bailed out, we were stripped of our civil liberties and 2.3 million men and women were packed into our prisons, most of them poor people of color? Why did they not thunder with indignation as money replaced the vote and elected officials and corporate lobbyists instituted our system of legalized bribery? Where were the impassioned critiques of the absurd idea of allowing a nation to be governed by the dictates of corporations, banks and hedge fund managers? Why did they cater to the foibles and utterings of fellow elites, all the while blacklisting critics of the corporate state and ignoring the misery of the poor and the working class? What the liberal elites do now is not moral. It is self-exaltation disguised as piety. It is part of the carnival act.*

A new American routine in the ongoing Society of the Spectacle.

A 2017 UN REPORT presented to the UN Human Rights Council accused multinational corporations that manufacture pesticides of "systematic denial of harms," "aggressive, unethical marketing tactics," and heavy lobbying of governments, which has "obstructed reforms and paralyzed global pesticide restrictions." In the *Guardian* newspaper, Damian

Carrington wrote: "The report says pesticides have 'catastrophic impacts on the environment, human health and society as a whole,' including an estimated 200,000 deaths a year from acute poisoning. Its authors said: 'It is time to create a global process to transition toward safer and healthier food and agricultural production.'"

Noting that the world's population is set to go from 7 billion to 9 billion by 2050, Carrington goes on: "The pesticide industry argues that its products—a market worth about $50bn a year and growing—are vital in protecting crops and ensuring sufficient food supplies. 'It is a myth,' said Hilal Elver, the UN's special rapporteur on the right to food. 'Using more pesticides has nothing to do with getting rid of hunger. According to the UN Food and Agriculture Organisation (FAO), we are able to feed 9 billion people today. Production is definitely increasing, but the problem is poverty, inequality and distribution.'"

Physicist Stephen Hawking, in a television interview with Larry King in 2016, famously asserted that greediness and stupidity were the biggest threats to humanity. He predicted that they will likely provoke the extinction of the species much earlier than previously expected.

It seems the brief but lethal history of the agrochemical industry served as his model.

➤⟨

# The Waltz of the Bacteria (or, as Joni Mitchell sang, "The perils of benefactors, the blessings of parasites")

SINCE HE LEFT the French National Institute of Agronomic Research in the 1980s, Claude Bourguignon has concentrated his work at his independent laboratory, LAMS, on the analysis and reparation of soils destroyed by intensive chemical-driven agriculture. For Bourguignon, soil is a magical repository of life. He describes it as

> *a highly complex, living material, even more complex than water or the atmosphere. Soil, as an ambiance, takes up only a fraction of our planet. It averages 30 centimeters in depth. But it's the only environment that exists as the fusion of the mineral world and its bedrock with the organic world of the earth's surface, the humus. And, above all, in that layer of 30 centimeters (less than 12 inches), the soil is home to 80%*

*of the living biomass of the globe. In that thin strip*
*of soil there are many more living creatures than on*
*the rest of the earth's surface. But it's unseen. It's a*
*world of micro-organisms that we've utterly neglected,*
*because they're seen as valueless. Or worse. There's*
*an enormous taboo that weighs on them.*

Indeed, soil is frowned on as "germs" in our society. In the worldview established since Louis Pasteur first made the notion of fanatical hygiene paramount, the microbial world is viewed as the central agent of death. Whereas it is in fact the source of everything that gives life. Without the mediation of the microbial world, plants cannot be nourished. Human industrial pursuits, the agrochemical industry in particular, essentially can do nothing more than mimic microbial activity. And the biggest problem is the phenomenal energy expenditure that it demands. Bacteria, for instance, can fix atmospheric nitrogen to produce nitrates. For free. Man needs ten tons of petrol to fix one ton of nitrates. That he then sells. At a steep price. Bourguignon reminds us that the agrochemical industry conveniently "forgets to mention that chemical molecules cannot create a soil. It's the farmer who creates it with the work of his hands. Inevitably the agrochemical industry needed to change all traditional agricultural models. By the time I'd honed my techniques for measuring the biological life of soils,

I realized the extent of what had happened. Devastated soils everywhere. Organic or biodynamic farmers have soils that are significantly more active, more alive than those who work so-called *conventionally*."

In the case of grapevines, the presence of synthetic molecules radically inhibits the capacity of the roots to penetrate the soil with any depth. And the plants' ability to ingest the mineral salts that are transformed into aroma and flavor entirely depend on the depth and breadth of penetration. All of a wine's character and flavor depend on the metamorphosis of the mineral salts. And this process is dependent on the biological vitality of the soil that is host to the roots. It's not the minerals themselves that are absorbed by the root. The oligo-elements (trace amounts of minerals) must first be cooked in a kind of bacterial stew that the roots can suck up. The underground fauna, like a brigade of microscopic chefs, have to break down the minerals for ingestion. The greater the contact of the roots with more layers of soil and subsoil, the more complex the taste of the wine will be. When a soil is alive to stimulate this penetration, its microbial population is highly diverse and aerated so that water, air, flora, and fauna can all circulate freely (the role of the artist in any society?). A grapevine is capable of sending roots down as far as sixty meters, depending on the soil and the subsoil. In an identical situation,

if the soil is treated chemically, the same roots won't go beyond two meters. The soil will have been poisoned and the microbial activity—life—with it. What's lost then, in 99.9 percent of the world's wines, is any relation between the wine and its origins. What makes wine—like people—interesting in the first place.

Since the 1960s, most wines of terroir, that much-ballyhooed notion of place, have been rendered dumb. Speechless. All of the mineral rootedness—radicality in the sense of the Latin *radix, radicis,* or root—that has determined the taste of wine for eight thousand years has disappeared. Wines became tasteless, colorless, bodiless. *Ex nihilo,* wines became wholly disincarnated: another striking parallel to the movement of the culture at large.

As is so often the case in situations of revolutionary change, man reacted to an unintended perversion in a manner just as thoroughly perverse. Instead of examining the root of the problem—literally—by eliminating the chemical cause of the devastation of the soils, man applied himself with great invention—and at a great expense, therefore justifying future demands for great returns on that investment—to rectifying the first chemical incursion with a compensatory chemical assault elsewhere! Combating chemical disfiguration with more chemicals. The disease and its remedy

conjoined by their very nature. And by denaturing nature itself, the remedy is of course the disease.

To reincarnate these newly nonsubstantive wines—dead wines from dead soils—the 1970s saw a boom in enological laboratories and corresponding enologists. With that astonishing inventiveness that characterizes the loftiest of human ambitions, enologists and their partners (in crime?) invented a thousand stratagems for reinvesting the simulacra of life into the wine. Paramount was the creation of lab-selected yeasts to begin the fermentation of the grape juice that no longer was capable of generating activity spontaneously. When the soil is sterilized and the wineries are scrubbed down to resemble a hospital, the complex population of indigenous yeasts is sterilized with them. Naturally the ecosystem of a subsoil is linked to that of topsoil, but it's also linked to all the surrounding ecosystems: an expression of the unending cycle of interdependence among all forms of life. According to many scientists, the majority of components in a wine that determine its flavors come from bacteria. Even at the University of California at Davis, known for its resolute defense of a techno-industrial approach to winemaking, several of its researchers published an article in the National Academy of Sciences journal in 2013 in which they affirmed that "grapes are transformed into wine primarily through microbial activity." In

the *New Scientist*, the equally terroir-skeptical professors Jack Gilbert at Argonne National Laboratory in Illinois and Barry Smith of the University of London assert that "of all the bacteria, it is probably yeasts which most directly determine the taste of wine, by a process which creates 400 elements that define taste, aroma and texture."

Beginning in the 1960s, because of decimated soils, it became increasingly difficult for grapes to ferment. The very process of how wines come into being was under threat. It became necessary to stimulate the fermentation process with artificial yeasts, codified, isolated, chemically reconstituted, and commercialized by laboratories. Like a world in which women could only be impregnated artificially. Faced with grape juice that had been stripped of most of its taste components, these new franken-yeasts offered a chance to completely reconstruct the taste and structure of wine based on criteria that were mercantilistic and eugenic. The most adaptable yeasts were fabricated and commercialized, based on those tastes that were easiest to sell. And in order to sell these new tastes, stories had to be invented about them. The reality of terroir was exchanged for the marketing of terroir. The genuine terroir that had been lost became the bucolic spectacle of an imaginary terroir. "Authenticity" was no longer a relationship between tangible things (humans, soil history, microclimate),

but a concept that can sell and be sold. Much like the movement in the art world at that time. A "terroir" becomes associated with the taste of banana here, apricot there, and an exotic (canned) fruit cocktail elsewhere (the latter, especially in California), depending on the desires and the needs of the new merchants. And so the new merchant became the wine producer himself. In the iconic twentieth-century cultural reinvention.

In the case of wine, formerly characterized by the minerality and salinity of its rooted origins, it became transformed into a sugary concoction, consistent with the gustatory shift toward a permanent infantilization taking place elsewhere. Everywhere else, in fact. And so in the 1970s and especially the 1980s (marked by Reagan's jellybeans in the White House), new wines were born, the wines of child's play, sticky-sweet, industrial concoctions designed carefully for each market niche: the sweet infantile wine for the masses (Yellow Tail), the still-saccharine but cannily "terroir"-marketed wine for the middle class (Mondavi), and then, for the socially aspiring, the luxury boutique wine, just as sweet but bursting with engineered flavors and textures and the appearance of complexity (the mid- to late 1980s films of Coppola and his Napa Valley "prestige" winery). And the French, Italians, and Spanish were only too happy to follow the new leaders. Their wines,

stripped of savory salinity, were also reconstructed as liquid candy, with each market niche carefully catered to, but the same industrial design behind it.

Except for those with cellars filled with the liquid memories of a previous reality, it took maybe a decade for wine lovers to become amnesiacs and to mistake this new aberration for the norm. In the 1980s, the era of Reagan and Thatcher, Wall Street unfettered, Wenders and Jeff Koons, there began to appear a new breed of wine expert: journalists, critics, new age hawkers and hucksters, for whom the taste of the new regime was what formed their palates. They began to proclaim the chimerical, chemical concoctions, often with great sincerity, as "authentic" expressions of wine.

*Fifteen*

# An Ethical Rebellion

BETWEEN 1930 AND 2010, the industrial output of the world's chemical industries went from one million tons to 500 million tons. Revenue for the chemical industry soared from $171 billion in 1930 to $41 trillion in 2010, more than twice the GNP of the United States. It's no surprise then that government agencies, research facilities, and universities across the world are completely dominated by a pro-chemical, pro-agroindustry bias. One could even say the global agrochemical lobby is not so much a dematerialized state *within* the state, but a state *beyond* all states.

In the face of the economic hegemony of what is called "conventional" agriculture (would we say of a serial murderer that his behavior is *conventional?*), some farmers, including numerous winegrowers, have decided on a response in the spirit

of the antifascist Italian political philosopher Antonio Gramsci. They have displaced the economic battle to cultural grounds. Instead of tackling the monster head-on, they've simply turned their backs on it, concentrating their efforts on the full cultural ramifications of *cultivating* the land. The natural farmers are constructing a parallel terrain: healthy, open, and deeply conscious of their neighbors, above and below ground (the latter in the sense both of microbial and ancestral life!). They're upending the quasi-religious belief in chemical agriculture not by a return to some prelapsarian fantasy, but in the most progressive sense possible. It's no surprise that more and more young people, rightly skeptical of all institutional thinking, are gravitating toward them.

The cultural insurrection of natural winegrowers in particular is generating an aesthetic and social movement that isn't oriented in a battle *against* the industrial standard but outside of it. And more importantly, they're inventing a model that can't even be described as alternative because it exists outside of any fixed dogma, categories, or conventions of any kind. The natural wine movement, whose contours are cheerfully undefined in everything but an ethical commitment, is often unrecognized even by its practitioners. Some are a part of the movement without trumpeting it, neither insisting on organic

certification nor even wishing for the "natural" moniker to be applied to their work.

Natural wine isn't an aesthetic movement or a school of thought organized around a defined manifesto, like the Impressionists, the Pre-Raphaelites, or the Surrealists. And while there are echoes of a kind of Romantic humanism, it's closer to a concrete form of poetic realism. And like Flaubert, who was considered a poetic realist without ever belonging to any movement simply because he embodied a cultural revolution taking place in the second half of the nineteenth century, many winegrowers are natural without any desire or sometimes even consciousness of their "naturalness."

But if there are no rules, what is natural wine?

## The Natures of Wine

As a committed Marxist (school of Harpo, Groucho, and Chico), I'm convinced that what distinguishes natural wine is precisely the absence of fixed rules. That is, in fact, the only rule. Each winegrower exercises his craft in his own way. Each one narrates what he does in his own way. That said, there are some commonly held beliefs: the interdiction of any synthetic molecules in the vineyard as well as their introduction at any stage in the

winery. We could also add that the soil should be plowed as delicately as possible so that the maximum biodiversity can flourish in the soil and subsoil as well as above the surface of the land. Most natural winemakers would probably agree that some form of polyculture—precisely to create as complex and vital an ecosystem as possible—is equally critical. A particular ecosystem's vigor and distinctiveness— the bedrock of the French notion of terroir—is dependent on this. (And therefore the miles and miles of monocultivation of vines in Champagne, Burgundy, and Bordeaux are certainly responsible for diminished expression in their wines.) Simply following the rules for organic certification, however—either in the United States, Europe, or elsewhere—is wholly inadequate, given that those regulations have been determined with the open complicity of the agrochemical lobby. Neither by the FDA nor by the European Union in Brussels are any notions of biodiversity or the biological life of the soils taken into account. There are simply lists of chemical substances that are inadmissible. But even more damning for the organic regulations as they relate to wine is what happens in the winery once the grapes are harvested. While the grapes that are brought in for fermentation may well be technically healthy (if not fully vital and expressive), once they're crushed, the rules for "organic"

allow the juice to then be manipulated in hundreds of ways, including the addition of multiple synthetic chemical compounds and dozens of extreme technological processes that can completely denature the wine. These include vinifying up to 158 degrees Farenheit, intense filtration that is akin to the nineteenth-century practice of "restoring" Old Master paintings by ironing the impasto to a smooth surface, and reverse osmosis machines that can make a thin wine into a pot of jam. But the most profound denaturing of wine, organic and conventional alike, is determined by the addition of laboratory-created yeasts to provoke and guide the fermentation process, the critical transformation that makes wine wine in the first place. Winemakers buy little sachets of yeast powders artificially constructed to promote certain predetermined tastes, like the infamous lab yeast 71B that makes any wine taste like banana and tropical fruits. It's as if 99 percent of the world's pregnant women were to receive injections that would assure that their children would be born with blond hair, blue eyes, and all the answers to the last thirty years of *Jeopardy*. It's the most profound disfigurement of a wine's intrinsic character, and 99 percent of the world's wines, from Manischewitz to the rarest Burgundy Grand Cru, organic and chemical-happy alike, have been manufactured this way for the last decades. It's a kind of Darwinian

eugenics with the selection not even of the fittest but of the most easily marketable. This process also implies the suppression of all deviation, of all difference, of all the accidents that contribute to what is most noble in the civilizing gesture of humanity: the acceptance of imperfection.

Why is the character of the yeast so critical? All of a wine's alchemy depends on it. The magical transformation of grape juice into wine, of natural grape sugars into alcohol, depends on the actions of these unicellular fungi. If the music of a wine emerges from the biological and mineral life of the soil, the score is committed to paper by the grape. But the musicians, the interpreters, are the yeasts. In which case, the winegrower is the conductor, channeling and harmonizing the choral work of nature, especially attentive to the quirks of the artisan yeasts.

Yeasts are present everywhere in nature, but those most useful for wine fermentation can be found on the skin of the grapes and in the winery. The more biologically vigorous the surrounding land and the plants, the more the winery itself will be fecund.

But the opposite tendency is equally true. For the last fifty years, because of the progressive death of soils coupled with an increasingly fanatic belief in the sterilization of the winery (sterilization of the entire food chain allows for its complete domination

by the largest, most homogenizing industries), natural yeasts have had nowhere to go (or stay!).

The more diverse the population of yeasts, the greater complexity and diversity of flavors will be produced in the finished wine. Each individual, microscopic yeast will play a singular role in the fermentation process, just like the different musicians with different instruments in an orchestra.

With natural wine, the fermentation isn't only a question of allowing the native yeasts to do their work, because even they can be identified and pre-selected to guide the transformation, just like engineered lab yeasts. A second guarantee is required. The time must be allowed—a sometimes risky undertaking—for the fermentation to ignite spontaneously, so that the entire population of yeasts can participate. Like a genuine, grass-roots democracy. All voices have to be heard. And at their own pace, in their own way, to construct a truly choral plurality. Where discrimination takes place, eugenics and a corresponding repression of individual liberties are soon to follow.

In a natural wine not only are spontaneous fermentations of naturally occurring populations of yeasts necessary, but the fruit of that labor must be preserved intact though bottling. This means avoiding all invasive technical manipulations, like aggressive filtering to produce a clear (vacant) juice.

Instead, unfiltered wines contain all of the textural and tonal complexities—impurities—of the original fermented juice. If we think of a village with a heterogeneous population, it means believing that the collective whole is bettered by the presence of the weak, the elderly, the infirm, children…the list of potential undesirables could be extended in multiple directions. In this way a natural wine becomes the richest reflection of a local community, of a terroir.

The final factor that distinguishes natural wine is the sticky (or smelly) question of sulfur. Sulfur is an antimicrobial agent and an antioxidant used in tiny doses since the ancient Romans and heavily used by the English and the Dutch since the sixteenth century. But the sulfur used historically was in an organic, unsynthesized form, unlike most sulfur used in wine today, which is a synthetic derivative of petroleum. Moreover, natural sulfur was generally used in small doses, whereas standard winemaking practices today allow for massive infusions.

Wines that are concocted from chemical agriculture, without any natural antibodies to protect them, are like children stuffed with antibiotics and overvaccinated from infancy. They have no natural defense system against disease or infection. These chemically compromised wines, unable to survive or develop on their own, require massive doses of sulfur to stabilize them. By EU law, up to 210 milligrams

per liter (210 parts per million) are permitted, while in the United States the figure is a staggering 350 mg/l. Even organic wines are allowed 100 or more mg/l. The net effect is wine on quaaludes. Sedated. In fact, it's like a drug addict whose chemical dependency is a self-perpetuating cycle.

While more and more natural winegrowers are making wine entirely free of added sulfites, all of them share a commitment to keeping the dose at least below 30 parts per million. And more and more natural winemakers are succeeding in reducing doses to under 15 and even eliminating them altogether, as they grow more skillful in their homeopathic knowledge of how to protect their natural "children." At any rate with each successive reduction of sulfites, the wine itself becomes more expressive.

But the importance of the sulfite question was brought home to me a few years ago when I visited my friends Giovanna Tiezzi and Stefano Borsa, farmers and winegrowers at the Pacina estate in the hills near Siena in Tuscany. They had me taste their rosé made from Sangiovese grapes—the Chianti workhorse—in which they put the minimal dose of 18 mg/l of sulfur. The wine was bone dry, evanescent but taut and expressive. Then they opened one of their experimental bottles of the same wine made with absolutely no sulfites added. I explained that it

was probably a pointless exercise as my palate would certainly not be capable of distinguishing between the two. But they insisted I try. And they were right. The difference even for a moderately sensitive palate was astonishing. The second wine felt like a child during summertime: joyful, free of any restraint. The first wine was the same child, equally appealing but as if met on a brisk winter's day.

And as if this test wasn't sufficient reason to walk on the wild, sulfite-free side, it's also become clear to me over the years, from painfully empirical experience, that headaches and hangovers—even after lengthy drinking bouts—are almost entirely eliminated when sulfite-free or highly limited-sulfite wines are drunk.

That said, there is an important caveat. Some wine drinkers and merchants have become "no-sulfite" fanatics in a rigid, ideological way. It's critical to remember that no two vineyards and no two winemakers can or should have a similar need or ability to reduce their wines to zero sulfites. Each terroir, each vintage, and each winemaker's knowledge, experience, and personality will require a different response. The ethical question at the core of natural winegrowing would demand no less.

At Clos des Cimes in the Drôme region of France, Elodie Aubert and her husband, Raphaël

Gonzales, both make the domain's wines, but not always together and not always in agreement about technique. They believe that respect for each other lies in the mutual tolerance of their differences. In their mid-thirties, they have two children, six hectares of vines, an olive grove, different fruit orchards, and an extensive vegetable garden.

Though they live on 600 euros a month of income for the whole family, Elodie considers their family "lucky because we have few debts, so the bank isn't going to kick us off the land and my children have a rich and varied life." Elodie does most of the work in the fields while Raphaël is in the winery. A few years ago she decided to acquire a flock of twenty-eight sheep, who graze among the vines and the olive trees because she doesn't "want to use the vegetal only to take from the earth. You have to give back, thanks to the animals." Raphaël makes the whites and the rosé while Elodie makes the reds. The reds are 100 percent sulfite-free, while Raphaël puts in no more than 20 mg/l (as opposed to the 200 that are authorized). They each have different preoccupations, different approaches for the health and expressiveness of their wines, and the two approaches coexist "in a largely peaceful, but always stimulating way" within the same farm.

The spirit of natural wine may be embodied in this fecund disagreement, because fecundity concerns the earth itself, the upbringing of their children amid the births of the flock's lambs, and the vitality and the complexity of the civilizing gesture of their wines.

><

# Biodynamical

ONE OF THE UNQUESTIONABLE GRANDFATHERS
of the natural wine movement is Rudolf Steiner—
even for winegrowers like Elodie and Raphaël,
who remain skeptical of his guru status and don't
follow his agricultural practices, known as bio-
dynamics, in a literal way. An Austrian philoso-
pher active between the two world wars, Steiner
viewed agriculture as a potential salvation for peo-
ple ravaged by unbridled urbanization and what he
considered a general loss of the sacred. The link
between the cultivation of the land and one's per-
sonal cultivation was self-evident for him. He had
witnessed how the First World War ignited two
dangerous tendencies. The first was the emphasis
on specialization, which limited people's ability
to view any situation as an interconnected whole.
The second was the introduction of murderous

chemicals, destined to cut people off from their ancestral roots in the earth, from their active role in nature, from themselves. In what he called Anthroposophy ("the wisdom of man"), Steiner proposed a vision radically opposed to the compartmentalization and fragmentation of industrial modernity. He wrote widely across numerous fields. His views on education, for example, have spawned the Waldorf schools, present across the globe and known for their emphasis on the interdependence of all human gestures, physical, spiritual, and intellectual. At a Waldorf school, a child, like an adult among the vines, can't simply work on one aspect of a given thing, but is encouraged to take into account an entire ecosystem. Any given gesture is only a part of a larger whole. Children of course study geometry. But they will also become conscious of the geometry of their own bodies and of their physical activities. And of the natural geometry inherent in a plant cultivated in the classroom.

As for agriculture, it's not difficult to imagine why Steiner insisted on polyculture and biodiversity—practices that had defined agriculture during its ten-thousand-year existence. That is, until the arrival of the Industrial Revolution with its unbridled materialism and obsession with productivity. Steiner wrote as early as the 1920s that it was suicidal for both man and the planet to cultivate a single plant to

the exclusion of all others. Not to take into account the vast interconnection of animal, vegetal, geological, and bacterial life would prove devastating.

He anticipated by more than a half century the ecological catastrophe that the agrochemical industry was to provoke: the death of soils, the nutritional death of the resulting fruit, and the premature death of those who consume it. Meanwhile, a Frankensteinian society, compensating hysterically, created chemical cocktails to retard the death of men but hasten the death of man.

Farmers and winegrowers who practice Steinerian biodynamics are as different from each other in both their theory and practice as the thousands of philosophers who have drawn on Plato (say Descartes and Schopenhauer) or all the filmmakers (Kubrick and Visconti) who have been influenced by Eisenstein.

I couldn't imagine winegrowers more unlike each other in temperament, desire, and understanding than Aubert de Villaine, proprietor of the world's most venerated (and expensive) wine, Romanée-Conti in Burgundy; Jean-Pierre Amoreau in Bordeaux; Nicolas Joly in the Loire; or Jean-Pierre Frick in Alsace. Not to mention Vasco Croft in Portugal; Stefano Bellotti or Camillo Donati in Italy; Martin Nigl or Andreas Tscheppe in Austria; Marion Granges in Switzerland; or Kelley Fox in Oregon, among the

tens of thousands of biodynamic winegrowers across the globe.

Aubert de Villaine considers himself a rationalist and empiricist. He first converted only a few parcels of the storied Romanée-Conti vineyards to biodynamic practice in 1993. Very slowly, through what he describes as a mix of Cartesian reasoning and ancient peasant observation in which he clearly saw that greater biological activity in the soil produced more complex grapes, he spent the next twenty years converting parcel after parcel until the entire estate was farmed biodynamically.

Jean-Pierre Amoreau, in the less fashionable Bordeaux appellation of Côtes de Francs, says simply: "My family have made natural wine since they first worked this land. That is, for the last four hundred years. There has never been a drop of chemical in our soil or in the winery. Converting to biodynamic farming in 1988 didn't go against the nature of how we'd always worked."

Nicolas Joly, on the other hand, a French banker on Wall Street who repudiated his speculatory life, converted to winegrowing in 1977, taking over his family's vines in the Anjou region of the Loire Valley, at Savennières. With the ardor of the convert, he quickly became the leading spokesperson for biodynamics in France and eventually abroad. In his book *Wine from Sky to Earth*, Joly insists on the materially

religious aspect of nature. All elements are related through a governing principle of creation, says Joly. "No elements in nature should be separated but instead they should all be linked together. That synergy allows for each element to express itself clearly. In this way, we rediscover the etymology of the word 'religion,' which comes from the Latin *religare*, to bind." As Goethe wrote: "the material is nothing. What counts is the gesture that produces it." In studying the soil, not only its biological life should be considered, but the entire ecosystem that created it and allowed for it to flourish. Joly's organization, La Renaissance des Appellations, includes 156 biodynamic winegrowers in France, Italy, and elsewhere.

Vasco Croft, in the northern Minho region of Portugal, abandoned his career as an architect at the age of forty to devote himself to six hectares of family vines, from which he extracts a notably penetrating and complex sparkling red wine marked by his granitic soils. For Croft, the choice of biodynamics was easy. While still a practicing architect, he founded the first Steinerian school in Lisbon.

Jean-Pierre Frick, a lifelong farmer in Alsace, is a model of civic engagement. An activist for the last forty years against the nuclear power plant in nearby Fessenheim, his expressions of civil disobedience include standing trial for destroying an experimental

GMO vineyard. That he conceives each vine in his twelve hectares of vineyards as an individual belonging to a larger community is entirely consistent with his beliefs.

The late Stefano Bellotti, a close friend of Frick's for the last thirty years, read Steiner (and the anarchist Bakunin) deeply as a high school dropout. Turning his back on the urban movements for social reform in Genoa in the early 1970s—because of his perception that they were too conformist and ideologically rigid—Bellotti went to his grandfather's small farm in southern Piedmont to practice a different form of political engagement. By the late 1970s Bellotti was already practicing biodynamic farming, one of the first winegrowers in Italy to do so. Today, he conducts hundreds of scientific experiments based on the principles of biodynamics among his vines, fields of wheat, spelt, and lentils, orchards, and vegetable garden. In the absence of any governmental or academic support for the resolution of agronomic problems by any means other than those supported by the agrochemical industry, Bellotti has become a one-man alternate research facility, a kind of agro-Socratic figure in the world of wine, drawing a constant stream of young farmers from across the globe to do revolving internships at his Cascina degli Ulivi farm.

Camillo Donati, a little farther south in the hills around Parma, produces a variety of sparkling reds

and whites known for their paradoxical combination of earthy complexity and murky tonalities that produce a crystalline purity and freshness. For Donati, the son of an impoverished farmer and resistance fighter against the Nazis, there is no incoherence between his pursuit of biodynamics for the peasant common sense he sees in the practice, his devout political convictions regarding social and political equality (he sells his wines for five or six euros despite their international fame), and his equally fervent Catholicism.

Marion Granges made wine with her late husband, Jacques, in the Valais region of Switzerland beginning in the 1970s. The vineyards are on such steep mountainsides that a funicular is the only way to get access to them. In 1971 Jacques stopped work on his Ph.D. on the biological warfare waged against insects to begin his adventure with Marion at Domaine Beudon. Marion, who cultivates medicinal and aromatic plants among the vines and orchards, did her horticultural apprenticeship in a school in Thounes, Switzerland, where biodynamics have been taught since 1934. It's no surprise really, because her grandparents were close friends of Rudolf Steiner.

Andreas Tscheppe, the son of a very small farmer in the Styria region of southern Austria, insists that he never follows "Steiner the esoteric philosopher,"

but simply the "good, old-fashioned, peasant common sense of my grandfather" inscribed in biodynamic practice. A few kilometers from the Slovenian border, Tscheppe's vines were mostly planted in 2006 on the slopes that undulate for 360 degrees. They produce wines that are the mirror image of the geological, climatic, cultural, and topographic complexity of their origins.

Kelley Fox, like Jacques Granges, abandoned a Ph.D. (in her case in biochemistry) to make wine. After ten years of apprenticeships throughout Oregon, while bringing up her two daughters by herself, she rented three hectares of pinot noir in the Dundee Hills region. Deeply literate in both science and literature, Fox is a passionate reader of nineteenth-century English novels. Her amorous relationship to her vines reflects a committed Romantic temperament. Recently she described her conversion like this:

> *I knew I loved the vineyard work, digging into the roots of the plant and the surrounding soil, but I had an epiphany in 2002. A friend brought over three bottles of wine and put them on a table in front of me. I thought it was a blind tasting. But it was the opposite. It made me see clearly. One of the bottles astonished me, illuminated me in a way no wine had*

*before. The wine was living! Not only living because of its yeasts unsterilized by chemicals, but alive. Like life itself. I felt illuminated from within by a sacred fire. I'll never forget that instant. Well, guess what. That bottle was the one biodynamic wine among the three. Game over for me. After that day, I've pursued only biodynamic farming, moved each day by the miracle of love that it offers.*

What seems to unite these winegrowers who otherwise are so radically different in background, temperament, and aspiration is an expression of the universality of biodynamic practice itself. Their vineyards are all taken care of with a profound sensitivity to the flora, fauna, and the entire biological life above and below ground. This commitment leads them all to a minute observation of their environment, a profound sensitivity to each living thing. An ecosystem, a place, a terroir is never isolated. It's always related to its neighbor. Logically, therefore, any aspect of any ecosystem concerns the entire cosmos.

It's understandable why even the most skeptical and Cartesian atheists among the biodynamicists recognize that there is a sacred dimension, in the most eclectic and tolerant meaning of the term. For some, it can even be described as Franciscan. It's no

accident that in Pope Francis's 2015 encyclical *Laudato Si*, in which he preaches for a global renewal, there is a clear echo of biodynamic concerns. The French sociologist Edgar Morin wrote that "the Pope's encyclical is possibly ground zero for a new civilization." Morin sees the pope's viewpoint crystallized by the concept of

> *wholly integrated ecology, in which it's not a question of a deep ecology which consists in converting people to the cult of the earth with every other issue subordinate to it. The Pope demonstrated that the ecological question touches all our lives, our entire civilization, our way of acting and our thoughts. The title of this historically significant encyclical—because the Pope has dared to describe all of man's abuses that pose a threat to the survival of the species—comes from a hymn of Saint Francis. The Pope constantly evokes the Franciscan sentiment regarding the holiness of the ecosystem's interdependence, evoking "the brother sun, sister moon, brother river and mother earth."*

Morin is struck that the pope asserts, "As believers, we see the world not from the outside but from within, conscious of all the bonds with which our Father has tied us to each living thing."

In the spirit of the saint who preached to the birds, the pope adroitly invokes science to his cause,

writing that "a large part of our genetic code is shared with numerous living creatures." Without any doubt, in his denunciation of the hysterical consumerism that has brought about a mortal rupture with nature, the encyclical affirms the spiritual and material principles that underpin biodynamics.

# The Simply Dynamic

NOT ALL NATURAL WINEGROWERS follow biody-
namic protocols. Probably far fewer than half. And
Steiner never mentioned wine in all his treatises on
agriculture. Then there's the cloudier fact that the
majority of those who practice biodynamic viticul-
ture don't make natural wine.

More and more industrialists, from 5-million-
bottle wine producer (and ex–rugby star) Gérard Be-
trand in the southwest of France to 50-million-bottle
producer Zonin in Northern Italy, are producing
"biodynamic" lines within their product range
while many others ostensibly affix "biodynamic" to
their labels in an effort to capitalize on the growing
movement of legitimate biodynamicists. Just as with
"organic" wine, "biodynamic" wine, alas, is no
guarantee of quality or naturalness. A winegrower
can follow biodynamic practices in the vineyard and

then use laboratory yeasts and every technical and chemical manipulation known to man and not lose his certification.

So if "natural" is linked to, but not dependent on, biodynamic farming, what is it? Given the diversity of interpretations of what constitutes natural wine, the debate is ongoing, vital, resistant to rigid definitions or ideologies. A fair comparison could be made to the Italian neorealist movement in the cinema of the 1950s. Fellini, for example, with his baroque gestures and fantastical imagination, was viewed by certain ideologues of the time as a heretic who betrayed the movement. For others, especially those with a sense of humor *and* humanity, he personified the radical liberty of neorealism through his originality and his wish to share that liberty. The debate among ideologues and ethicists is carried on in a sometimes petty, sometimes vital fashion within the natural wine world itself.

The term "natural" first came to prominence in the early 2000s, when a more anarchic, more aesthetic, and more youthfully political slant to the notions of organic and biodynamic seemed necessary. It first gained traction in France, where a quiet and dispersed revolt was under way against the standardization of wines and the defense of that standardization by the AOC system that supposedly guaranteed authenticity of origin and taste. Above

all it seemed that there was a new ecological con-
science emerging, less stridently militant than the
Greenpeace generation, *un-* or even *anti-*ideological,
more communitarian and spontaneously rooted in
daily gestures. It was also a taste bud revolution de-
termined by the quality of the soil, since more than
ever it was the transparency and health of the soil
that was understood as of paramount importance in
determining flavor and character, in reaction to the
perverse standardization of the marketplace and its
self-interested guardians.

In terms of the aesthetics of natural wine, Jules
Chauvet was as pioneering an influence for vinifi-
cation as Steiner was for viticulture. Chemist, fanat-
ical "taster," and merchant in the Beaujolais region
of France in the 1930s, Chauvet considered wine a
work of art. He explored the biochemistry of wine
and the physiology of taste. He revolutionized the
approach to vinification by emphasizing natural,
noninterventionist methods that relied on a com-
plete knowledge of the technical aspects of what
was being renounced. He advocated minimal use of
sulfur and minimal chaptalization (the addition of
sugar to increase alcohol content), two of the prin-
cipal technical evils of pre-global-warming, pre-
chemical winemaking. Building on traditions for
vinifying in the Beaujolais, he experimented with
forms of fermentation that allowed for sulfur-free

wines. This work deepened his knowledge of how flavors and aromas are formed, so he could better pursue his goal of making the most graceful, precise, and digestible wines. Among the many books he wrote that became critical for subsequent generations of winemakers was *L'esthétique du vin* (The Esthetics of Wine). For Chauvet, the pursuit of natural wine was partly an ecological question, but above all it was cultural: how to extract the maximum gustatory expression of a terroir.

By the 1980s, Chauvet's legacy was being actively pursued by a handful of winegrowers in the Beaujolais, led by Marcel Lapierre. Along with Jean Foillard, Guy Breton, and Jean-Paul Thévenet, all working in the Morgon appellation, buttressed by Georges Descombes in Brouilly and Yvon Métras in Fleurie nearby, they formed the nucleus of the new natural pioneers. At the same time Pierre Overnoy in the Jura, Hervé Souhaut and Dard and Ribo in the Rhône, Claude Courtois in the Loire, and Jean-Pierre Frick in Alsace (among others) were also pushing the new frontier. To the cultural-aesthetic innovation of Chauvet, these winegrowers added a cultural-political dimension, consciously opposing the chemical, standardizing farming and vinification techniques of the industry.

At any rate, the natural wine movement as it began to take shape, under the radar in the 1980s,

was a self-consciously cultural phenomenon. But in order for this culture to take root, it was necessary to build a new marketplace to sustain it. But unlike, say, an independent filmmaker determined to make a go of it within Hollywood—which could include the independent, New York–based reproduction of the Hollywood culture—the natural winemakers understood from the start that the prevailing economic culture in wine wouldn't tolerate their dissent. Either they'd be co-opted or expelled from the network of critics, distributors, importers, merchants. So they simply worked away at their craft in their dissenting, insurrectionary mode and waited—often at the risk of near bankruptcy—for a new, parallel market to develop. They knew full well that the wine journalistic establishment— the *Wine Spectator* or Robert Parker in the United States, *Decanter, La Revue des Vins de France*, or *Gambero Rosso* in Europe—was too deeply embedded within an industry that had long since thrown its lot in with the agro-chemical homogenization of branded wines. What the Marcel Lapierres, Pierre Overnoys, and Jean-Pierre Fricks were instigating was a far too radical reassessment of what even constitutes wine for a thriving billion-dollar industry to accept. A global wine culture that was so deeply invested in a form of involuntary consumer fraud (as previously discussed) couldn't possibly tolerate the

most insurrectional of gestures today: sincerity. It took until the turn of the twenty-first century for a sufficient alternative to emerge, but emerge it did. And with astonishing speed and breadth the movement went from a fringe Paris phenomenon in 2002 to an extensive presence across the globe, from São Paulo to Hong Kong, from London to Los Angeles, within the space of a few years. In Japan in 2004, there was a single importer of conventional organic wines that included a handful of natural wines. Ten years later, there were twenty importers of exclusively, rigorously natural wine. In Paris in 2004, you could count on one hand the outlets for natural wine. Ten years later, there were over three hundred listed on an incomplete Internet site.

How did this happen? There is something in the engagement of the wine farmers themselves, in their ecological, aesthetic, social, and political tendencies that provoked a rapid urban response across the globe. It could be argued that for the first time in two centuries, since the beginning of the Industrial Revolution, a rural phenomenon of a self-consciously cultural character began to influence urban life. Unlike the British arts and crafts movement, the Pre-Raphaelites, or the Romantic artists of the nineteenth century, all of whom reacted against industrialization, mechanization, and the loss of art's spiritual (and manual) dimension, here

there is no woozy idealism about nature. The natural wine farmers—especially the first generation—are, by nature (that is, their daily contact with nature), obliged to be wholly pragmatic, concrete, and material. They maintain a utopian vision of how their relationship to nature can be transformed into a cultural object, but as working farmers engaged in a daily tussle with natural forces that humble them, there can be no room for woolly-headedness. I'm convinced that it's this singularly *spiritual* combination of tough-minded, intimate contact with natural, material phenomena, combined with an unstintingly idealistic social and political vision, that has allowed for a rural contamination of urban life, reversing an opposing trend that has only been accelerating since the seventeenth century.

So who are the urban beneficiaries?

Let's take Lee Campbell for example. "I grew up in Wappingers Falls as the eternal minority," Lee confided recently in a Crown Heights, Brooklyn, food court where she's been able to convince the bar owner to favor natural wines. "I would've been the homecoming queen, everybody used to tell me. If only I wasn't the only black kid in class." She laughs with a malicious twinkle.

"My parents were born in the West Indies and emigrated to the States: my dad's Jamaican and my mom's from Trinidad. So even for the tiny commu-

nity of American blacks, we were outsiders. From an early age I wanted to be in politics. But I was less interested in power than in the notion of helping people get along." She went to Washington, DC, after college, sniffing around for political work. To pay her rent, she worked in restaurants.

"I had relatives in Jamaica who were farmers and I grew up near the countryside, but the whole wine scene as I saw it in DC turned me off. Because of the snobbery of the sommeliers. But by 2000 I began to learn more about the farming aspect of wine and that drew me in." She went up to New York and worked in some of Manhattan's flashiest restaurants of the time: Gotham Bar and Grill, Verbena, Union Pacific, Felidia. But the huge prices and the "flashy labels made me sick. It didn't completely turn me off wine but it certainly didn't turn me on. Until I went to Chambers Street Wines. Suddenly I was drinking things that felt completely alive. And with people who were equally alive and democratic, welcoming. Unsnobby."

Chambers Street Wines was founded by David Lillie, a hardworking jazzman surviving on the fringes of the New York music scene in the 1980s. To help support his family he had a day job as a wine buyer for a traditional Upper East Side shop, Garnet Liquors. He took it seriously, enjoyed it, but didn't commit to wine until he began to notice the work

of Jean-Pierre Frick, Marcel Lapierre, Pierre Over-
noy, and others in the 1990s. By 2001, he decided
to open his own wineshop with Jamie Wolff, ded-
icated to the nascent phenomenon of natural wine.
He was certainly one of the first merchants not only
in the United States but anywhere in the world to
stake out a claim as a "natural pusher," as he called it.
When Campbell gravitated there in 2002, the shop
had already rebounded from the effects of 9/11 (it's a
stone's throw from the World Trade Center), and its
anomalous status began to draw the curious young
(above all) from uptown, crosstown, and downtown.
Lillie was scoffed at by conventional importers, crit-
ics, colleagues, and legions of self-proclaimed wine
experts. But thanks to the excitement of younger
customers like Lee Campbell on the receiving end
and the delight of following a René Moss or Thierry
Puzelat in the Loire on the producing end, Lillie
found fulfillment outside of conventional economic
or professional parameters. It was a satisfaction that
he likened to playing jazz: "the pleasure of the thing
in itself. A sense of joy, sharing joy and discovery."
To be sure, he had a business to run and he had to
find enough customers to pay a steep Manhattan rent
and not delay payments to the natural winegrowers
already on shaky financial ground. But he naturally
shifted his priorities from trying to maximize his
profits to simply creating an equilibrium between

his basic needs, the client's, and the supplier's, look-
ing to make the economic factor the least important
part of the equation. It fostered a sense of commu-
nity in which his role was less merchant-middleman
than ambidextrous ambassador, advocating simulta-
neously for the desires of New York City wine lover
and Loire Valley farmer.

Meanwhile, inspired by David Lillie's retail and
importing efforts, Campbell went to work for var-
ious importers and distributors, ending up in 2008
with the natural wine importing pioneer in New
York, Joe Dressner. "With Dressner his growers
were different from the growers I worked with at
other importers. There was a giddy sense of commu-
nity with the natural guys. A generosity. A sense of
freedom. The inherent elitism and sexism attached
to wine in the United States disappeared with those
guys. It was unlike anything I'd experienced in the
food or wine world. They were militant politically
but, like, militancy was a party where you could
always have fun too." Dressner, who was the prin-
cipal supplier in the first years for Lillie's Chambers
Street Wines, "lived every moment fully, intensely,
up until his death from brain cancer. Joe was all
about the search for authenticity. Not the facade I
saw in the rest of the wine world."

In 2012, with natural wine already a must-have
item for New York hipsters, she went to work doing

the wine lists for Andrew Tarlow, one of the leaders of Brooklyn Dining, owner of the Wythe Hotel, Roman's, and Diner, among other ultrafashionable spots. "Andrew and I bonded because we were both mentored by Joe Dressner." Campbell enjoyed the freedom and the influence she began to wield in the wine scene, but she also grew leery of her role in the evolution of natural wine in New York. "The novelty of being an outspoken black woman championing a cool cause made me the 'it girl' in the natural wine world. I got saturated. I mean I love people. And wine was just an excuse to be with people. When it started to become something else, I wanted to back out. There's an aspect to the wine world that is only about consumption, even the natural wine world in New York began to feel that way. It doesn't make me feel good. Consumption is at the heart of what's wrong. I'm doubling down on redistribution." Campbell sees "an inherent elitism attached to wine in the United States that runs counter to the intention of most natural winegrowers." By her definition hipsterism has been both a blessing and a curse for the spread of natural wine in America. "I mean, I exist thanks to hipsters. I was able to make a living doing what I love because they're open to new wines, are on the lookout for soulfulness, realness. Their heart is in the right place and they're into turning 'luxury' on its head." All

of that has been positive for combating the snobbery and the elitism that make her suspicious. But "it's just that quickly it becomes about ego and money even for them. Natural wine in New York became recuperated, commodified, and fetishized like anything else." After four years with Tarlow, she decided to leave the wine world in search of another outlet for her political aspirations. "When I think about black folks and drinking wine, it unnerves me. They have a right to enjoy wine too, but it doesn't work that way for most people. Above all I want to be involved in redistribution. And food comes first. I need to know that lower- and middle-class people can eat better. That feels urgent to me." That "it girl" Lee Campbell felt compelled to leave the natural wine world at the moment she found its transformation in New York politically and socially untenable for her, could be seen as a paradoxical expression of both the phenomenon's coherence and of the limits of American urban culture.

*Eighteen*

# Urban Phenomes

A DIFFERENT EXAMPLE of the urban transformation of natural wine can be found in Italy, a country where city dwellers are much more connected to rural life than in the States. The cross-pollination of town and country can be seen in the experience of a Genoese businessman and a Roman restaurateur.

Luca Gargano, a dashing Jules Verne–like character in his late fifties, owns one of Italy's leading importers of foreign spirits and high-end foreign wine. But Gargano has also maintained close relationships with farmers in the surrounding Ligurian and southern Piedmont countryside since he was a kid. When the natural wine insurrection began to take shape fifteen years ago, Gargano was among the first to embrace it. He began to channel his profits from the liquor and foreign wine business into a network of distribution to help natural winegrowers

throughout Italy. He also began to drop many of his distinguished foreign wine estates from his importer's catalogue and replace them with natural winegrowers from abroad. A bon vivant with a ferocious sense of liberty, he understood early on that the defense of natural wine couldn't remain solely an economic endeavor. "Wine is not a product," he likes to repeat, "but a cultural artifact." He contacted his old friend Stefano Bellotti, a pioneering farmer and winegrower who'd practiced biodynamic farming since the 1970s. Gargano asked Bellotti to create a larger vegetable garden alongside his farm of twelve hectares of vines, six hectares of grains, dairy, chickens, and fruit orchards near the town of Novi Ligure, in the southern Piedmont, less than two hours' drive from Genoa. Twice a week Bellotti loads up a truck with enough vegetables, grains, milk, eggs, and cheese to feed all fifty of Gargano's employees and their families. A permanent bonus in addition to their normal salaries. In 2005 when Gargano approached Bellotti with the idea of paying him to expand his garden sufficiently to offer this service, the farmer said, "Watch out. If you do this for your employees, there's a serious risk they'll become both liberated and intelligent!" Gargano laughs, remembering the story. "And it was true," he adds with a chuckle. "And almost every single one has stayed with the company for the last twelve years."

As natural wine began to shake up the Italian wine establishment, Gargano was invited by Italian television to a live debate with a leading enologist from the industry. Having published the first protocol suggesting basic parameters for natural wine in 2002, and having built up an extensive distribution network for the natural winegrowers who struggled at first to find outlets for their work, Gargano was known as the naturalist's enfant terrible. His adversary was equally well known for his defense of all manner of chemical viticulture. Attacked from the start by his adversary as a voodoo man who knew nothing about the reality of farming and the soil, Gargano smiled calmly. After the opening salvo, he reached into his pocket and pulled out a clump of earth. He explained that it came from the vineyards of his friend Stefano Bellotti. Then he plunged the earth into his mouth and ate it. Before an astounded live audience, Gargano then drew out a small bottle from his other pocket. "This," he said, "is a bottle of Monsanto's Roundup, the world's most widely used herbicide." He looked at the enologist. "Now, to prove your good faith, I'm asking you to drink this down." The enologist looked stunned for a few seconds and then the producers of the program pulled the live broadcast from the air.

Gargano stories like this are legendary in his

office in Genoa, staffed by a mixture of veterans and a multitude of what Gargano calls "post-Chernobyl kids" (those born after 1986, indelibly marked by the explosion of the Soviet nuclear reactor). The relaxed atmosphere certainly conjures a feeling of a youth-driven Silicon Valley startup. But the variation of generations and the fact that the kids don't all look alike (they don't strive for unconformity either, they just are different one from another) suggests a different social-work experiment. Gargano draws energy and inspiration from the generation of his own children (several of whom also work at the company), keen to bring their "ethical-ecological convictions and their sense of fun, of play, of joy" to the forefront of AAA, his natural wine distribution company, and his wine and spirits importing business, Velier. "It's critical to invert the rules of the marketplace," says Gargano, "flee the conventional business parameters, and build communal activities. I don't see why an economic organism can't be raised like cows on a healthy farm or cultivated like an organic field of wheat. If we don't treat a plant like an automobile, why should we treat humans like one?"

New plans are under way for joint Velier-AAA offices on the outskirts of Genoa, in the middle of cultivated farmland, a structure built partly with glass, where plants as well as humans can thrive with

sunlight and wind: "As much room for the fruits of the soil as for chairs, tables, and electrical outlets."

One of the restaurateurs that Gargano works with assiduously is Trattoria da Cesare in Rome. The restaurant's owner, Leonardo Vignoli, embodies the notion of an urban ethical insurrection rooted in the countryside.

He was born in Monte Redondo, a working-class Roman exurb in 1967, the son of a barber and a politically active mother who, with his grandmother and aunt, formed his palate. After a few juvenile scrapes with the police, Vignoli fled to France when he was seventeen. He found his way into the kitchen of a Michelin-starred restaurant in Lyon and then spent the next ten years in Lyon, Marseille, and other cities working in the kitchen and in the front of the house in several Michelin-starred restaurants. His last stop was the legendary Petit Nice in Marseille, where he became the first non-Frenchman to become chief wine steward.

Vignoli eventually returned to his Roman roots, convinced that a world that transformed eating and drinking into a luxury pursuit was a betrayal of its social purpose.

With his wife and partner, Maria Pia Cicconi, he bought Da Cesare in 2009, a distinctly low-key place, tucked away in a nondescript area of Rome, Monteverde Nuovo. The dishes are from

the distinctly working-class Roman tradition, but the grace and precision of his execution provides a *romanità* (Roman spirit or character) served with a uniquely gossamer hand. Within a year Da Cesare became the mecca for local and visiting foodies and natural wine aficionados alike, but he keeps his restaurant a third empty most of the time to "prevent the staff from getting too stressed." Turning away double the volume of potential customers, he also balances the reservations or walk-ins of neighborhood diners with everyone else. Equally unusually, the original owner, Cesare, comes every Tuesday night to eat and play cards with his friends.

Conscious that "we live in a society where all values in the end are economic, where money has replaced politics," Vignoli understands that no one can flee from a responsibility to address price and cost in any cultural activity. It has become as critical a factor for any artist or artisan as any aesthetic or moral consideration. And at Da Cesare, the politics of price are taken to a remarkable level of reflection.

For example, a wine list in a restaurant is generally a heavy instrument used to bludgeon the diner into fearful submission, either because of the overwhelming density of wines offered or because the prices would provoke shame in even the most rapacious financier. In what other activity, after all, is it an industry standard to buy a finished product, in

this case a bottle of wine, for ten euros and resell it for thirty to forty euros with almost no added benefit? In the restaurant business, from Rome to New York, a 300–500 percent markup on a bottle of wine is considered "normal." If you then realize that most conventional wines are already sold at inflated prices, the pain of drinking a bottle at a standard restaurant becomes unbearable for those who know the truth.

At Da Cesare, Vignoli has sought out the most natural and artisanal wines that move him, not only because of the singular joy of their taste but because he's sure of the ethical engagement of the wine-grower behind it. He knows that if he buys a bottle for 10 euros, he won't charge 30, 40, 50 euros, as others might. But maybe 15 or 16 euros. And his reasoning is simple. "If a farmer is going to break his back to produce a real wine and not seek to get rich from his own labor, who am I to speculate like a banker on the back of someone else's self-sacrifice?"

His house white wine, for example, comes from the Marche region. "Corrado Dottori's made his Verdicchio *sfuso* (unbottled, from the tank) so the people of limited means in Cupramontana could afford to drink something other than toxic industrial wine. By selling a five-liter demijohn at twelve euros, he allows everyone along the economic chain to participate in a kind of social experiment; of quality, health, and joy."

This conviction extends to every aspect of the trattoria's activity, from the gnocchi *fritti al cacio e pepe* that my children eat in religious silence (the only religious silence they observe) to the most elegant fried cuttlefish I've ever tasted, to the soul-warming rigatoni in tomato-oxtail sauce, to his famous six-hour-boiled meatballs with pesto. All of which cost less than nine euros. In fact, when pressed about pricing, the always wry and soft-spoken Vignoli became emphatic: "Certain winemakers justify high prices by claiming that their know-how is in the bottle. But knowledge can't have a price. You can't ask people to pay for knowledge. My meatballs in pesto, because they sell the most, should I charge more for them? No! I've never charged anybody for what I know."

In the informal natural wine movement (though "phenomenon" may be a better term), economics plays an important role. But it's a role that has been returned to its rightful place. Given the crisis state of urban culture, this may offer food for thought (quite literally). The natural wine world has assembled winegrowers, distributors, importers, restaurateurs, wineshop owners, sommeliers, and, of course, wine drinkers, all of whom react to the liminal farmer's ethical and practical gestures. There's a fluidity between the producers and the so-called consumers that in fact blurs the distinction between

the two. And it's astonishing the number of natural wine drinkers who follow their hearts to its logical conclusion, abandoning their careers to become apprentice natural wine makers themselves. At any rate, there is a radical sense of cooperation between all the actors in the chain, from production to consumption, that suggests a conscious reaction to what sociologist Guy Debord described as the society of the spectacle, in which maniacal, acontextual, ahistorical, simulacra-celebrating consumerism came to dominate a culture whose logical extension is today's *virtual society*. Here instead is a counterexample where the hollow, virtual "spectacular wine" or "wine of the spectacle," promoted by the industry, has been replaced by concrete gestures informed by a conscious pursuit of a new authenticity, based on substance, not image. It's a wine that is drunk or preserved, never collected. And in fact, like the legendary Burgundies and Bordeaux of the nineteenth and early twentieth centuries, which were themselves natural by default, contemporary natural wines improve with age.

Debord was himself an early champion of natural wine, especially those of his friend Marcel Lapierre. In 1989, five years before his suicide—a final act of desperate protest—Debord wrote (in *Panégyrique*): "the majority of wines, almost all alcoholic products and all beers have today completely lost all taste, first

in the international marketplace and then locally, thanks to industrial progress. In order to continue to sell the bottles, they've diligently preserved the labels. And this precision has furnished a guarantee that the bottles can be photographed. Not drunk." Then he added, on a more melancholy note: "with the memories of an old drunk, I never could have imagined that certain drinks would disappear before the drinker."

The movement of natural wines (and legitimate craft beers) has responded vigorously to this warning.

# Chemistry, Capitalism, and Friendship

OUR ENTIRE CAPITALIST-DEPENDENT SOCIETY is itself dependent on the alchemy of chemicals and speculation. Without chemistry, without financial speculation, there is no modern Western society. The greatest nineteenth-century empires were all founded on the hijacking of scientific research by their nascent industries. Western progress, Western domination of the last two hundred years, is purely chemical. Petroleum, the pharmaceutical industry, plastics, armaments, and of course the agrochemical industry are the commercial by-products of all-purpose, synthesized molecules. A loop has been created; a new substance is synthesized. A commercial use is invented for it. Then a justification for why it's needed, its contribution to *progress*. Until it becomes a poison that even the public recognizes. In which case, an antidote is synthesized

(often from similar molecules) to remedy or replace it.

In *À nos amis* (*To Our Friends*), the most recent book by the Comité invisible (Invisible Committee), a French collective of anonymous young thinkers and activists who have followed in the Debordian tradition, they write:

> *In order for economics to assume the status of "behavioral science," it was necessary to proliferate the notion of "economic man," the "creature of needs." The man of needs isn't found in nature. For millennia, there were only ways of living, not needs. One inhabited a certain portion of the planet and one understood how to feed, clothe, house, and amuse oneself. Needs instead were historically produced as by-products of man's separation from his world. Whether that took the form of raiding, expropriation, or colonization, it wasn't important. Needs are that with which the economy has gratified man in compensation for the relation to nature that he's deprived himself of.\**

Capitalism has developed in parallel with the chemical industry and is founded on thousands of synthetic molecules that have redefined the world

---

\* Author's translation.

and man's relationship to nature based on the needs of a small group of transnational corporations.

Today, given that the revenues of the chemical industry outstrip the GNP of even the United States, it's easy to understand why any state is impotent before the supranational primacy of the manufacturers of synthetic molecules.

Chris Hedges, author of *Wages of Rebellion: The Moral Imperative of Revolt*, told a journalist at *Salon* magazine, well before Trump came to power, that "we've undergone a corporate coup d'état in slow motion and it's over. The normal mechanisms by which we carry out incremental and piecemeal reform through liberal institutions no longer function. They have been seized by corporate power—including the press. That sets the stage for inevitable blowback, because these corporations have no internal constraints, and now they have no external constraints."

The sweet revolt of natural farmers and winegrowers, prolonged by their urban coconspirators, against a synthetic world built by the chemical and financial speculation industries, offers a rare example of efficient rebellion. This anticipates the Invisible Committee's injunction:

> *In the general unconsciousness of social relations, revolutionaries should distinguish themselves by the density of their reflection, their capacity for affection, their*

*finesse, their ability to organize and to accomplish concrete, constructive acts. They should avoid schisms and intransigence that spring from a disastrous sense of competitiveness and extremist fantasies. It's by their acute attention to phenomena, by their infinite sensitivity, that they'll achieve a genuine power. Not by ideological coherence. Misunderstanding, impatience, and negligence are the enemies. The real, the concrete, is what will remain.*

><

# Vinoccupy

TOO MANY ACTORS on the cultural scene today are afraid to make a genuinely radical gesture. And by radical, I don't mean according to the ideological parameters of the 1930s, nor by the social consciousness of the 1960s, but a radical gesture that springs from the contemporary world, where unbridled chemical and economic speculation may result in the extinction of the species, of biological life on the planet. The word "radical" for many artists is invoked as a commercial ploy because they confuse transgression with provocation. The "radical" becomes caricature to the point where too often it's the most pronounced avatars of economic power who invoke it.

But the truly radical gesture, which emanates etymologically and philosophically from the roots and not from the leaves scattered on the earth's surface,

can no longer correspond to what is promoted by the neoliberal ideology that dominates the cultural industries. The principal tenet of this ideology is that what is not produced for immediate consumption is contemptible. According to the global monotheism, success through consumption and accumulation is the ultimate human objective. This incites a preference to be *liked* rather than to *be*, to search for maximum efficiency, maximum returns on any investment. Compromise and self-censure weigh heavily on all choices in every craft, every activity, every cultural domain. Self-censorship becomes the most efficient and deadly weapon of this new monotheism.

In direct response to this tendency, the actors on the natural wine scene tend to nourish rather than consume, to strip down to essentials rather than accumulate. By not being afraid even when they were isolated and mocked, they have achieved a remarkable liberty, a sense of shared joy and contagious vitality. When they were warned that it was negligent not to treat vines with chemical substances, that they risked the return of diseases that modern science had eradicated, they weren't intimidated. Despite their economic fragility, they weren't afraid of risking their year's crop during the vinification process by not injecting it with the wine world equivalent of steroids, growth hormones, and antibiotics.

They weren't afraid to flout all the official recommendations and regulations. They weren't afraid of the tacit commercial boycott until the mid-2000s of their unacceptably unstandardized wines. They didn't flinch before the mockery of their neighbors, dependent on agrochemicals. They weren't bowed either by the constant administrative and governmental harassment that has only intensified since they've achieved a degree of economic success.

Above all, natural winegrowers presuppose a rupture with any form of fear and an embrace of genuinely progressive scientific experimentation and other acts of faith. From the first gestures of spontaneous, personal, and nonideologically determined rebellion in the countryside, an insurrection that embraces urban life has followed. Restaurateurs, wineshop owners, sommeliers, importers, and distributors in the four corners of the world have adapted the farmers' positions for city life.

IT'S INTERESTING to think about this pacific insurrection that spread from the farm to the city to other purely urban movements, like Occupy Wall Street and Los Indignados in Spain, to the extent that all concern a citizens' revolt against a polyform power that produced an immediate solidarity across class and ideological spectrums.

The influence of Occupy and Los Indignados quickly disintegrated because of their inability to act concretely, even if we accept that Bernie Sanders's campaign in the United States and the Podemos party in Spain were direct heirs of these movements. In contrast, natural winegrowers and natural farmers have transformed their spontaneous revolt, built on powerful ethical and ecological considerations, into viable, reproducible, concrete action. They have invented a new economic model that allows for the movement to take root and that permits each individual to at least subsist with dignity. It's an interesting challenge for numerous artists who, after decades of pursuing glamour and riches in the afterglow of the planet's most privileged citizens, today confront an entirely inverted situation: elimination from the economic landscape.

In principle this movement presupposes that the farmer will not become rich through ever larger land holdings, that the wineshop owner won't seek to franchise his success, that the restaurant owner will not speculate on the market's attribution of a wine label's worth. This redimensioning of ambition to more human proportions, to the parameters of a democratic citizen, is one of the keys to the movement's success. The natural wine phenomenon has displaced purely mercantile concerns for the sake of existential, cultural, social, and political

ones. The economic aspect is present, but it's always subordinate to other aspects, and it expresses itself differently for each individual in each society. Each winegrower is free from conformist ideology to replace the economic factor where he wishes. This has provoked in turn a creative reinvention, a return to an artisanal and cooperative production: in short, everything that gives importance to the word "culture."

IT'S ALSO A MOVEMENT that, thanks to farmers' acts of conscience, of civil disobedience, has placed itself in the avant-garde of the ecological movement, especially in its relation to the local. It takes root outside of urban culture but constantly seeks to exchange with it, not to separate from or oppose it. And it's not a question of city versus country but rather of reforging links between the two, of abolishing the frontiers and finding a new sense of place. It's a double (and doubly contradictory) movement, but it remains profoundly coherent in the sense imagined by the Portuguese poet Miguel Torga, who said that "the universal is the local without walls."

The naturalist winegrowers are generally cosmopolitan, often polyglot (regardless of whether they come from privileged or humble backgrounds).

They also travel, as farmers or peasants never have before. They might have studied agronomy or viticulture but they just as easily might have studied literature, philosophy, economics, or even marketing, like Mathias Marquet, who claimed, "That way I knew the devil!"

Often they're ex-urbanites who have converted to rural life, as is the case with Emile Hérédia, ex–camera assistant on film sets and war photographer for *Paris Match*, who has run a farm in the Coteaux du Vendômois in the Loire since 1999. In a little-heralded region, Hérédia was entranced by the discovery of very old, rare vines of a grape variety that had fallen completely out of fashion, the Pineau d'Aunis. "They were from 1870 . . . 120 years old when I found them," he says excitedly. "Before the arrival of phylloxera," he adds, referring to the rootstock disease of American origins that destroyed 99 percent of European vines from the late nineteenth century onward and required that all vines thereafter be grafted onto disease-resistant American rootstocks. This phenomenon is akin to the interventionist school of fresco restoration that has forever changed our perception of, say, the Sistine Chapel. We will never know how it was before the work done in the 1970s. At any rate, Hérédia is representative of the neowinegrowers who probably make up half of the natural movement. A concerned

citizen, culturally curious, he decided at forty years old at the turn of the twenty-first century that neither the (already dying) craft of photojournalist nor of cinematographer could satisfy his ambitions, either creatively or combatively (combative in the sense of civic activism, fighting *for* rather than *against*).

THERE ARE THOSE who believe that the French concept of terroir, of cultural and gustatory identity tied to place, is a fundamentally reactionary notion, involving a congealed idea of tradition and the defense of the old ways at all cost. But this very French conception of territorial specificity, which includes historical practices in their relation to soil and microclimate, the history of man in relation to the history of the land, is in fact infinitely fluid and can be invoked in the name of progress, stasis, or a reactionary return to the past. Just as artists have always demonstrated in any given place that it's above all talent and imagination, openness of spirit, and a passion for craft that are the most profound engines for a fecund transmission of the past. No intrinsic privilege is accorded to an indigenous resident, who might easily be an incompetent agent for conveying the past. If enduring talent was hereditary, the history of art and cinema would have viewed the

painter Auguste Renoir and his film director son Jean or the father-son filmmakers Max and Marcel Ophüls not as astonishing exceptions but as the rule.

Natural winegrowers, whether it's a Thierry Puzelat, son and grandson of small farmers in Cheverny, or his friend and neighbor, the neo-Vendômois Emile Hérédia, demonstrate that the defense of terroir, that is, making the land dynamic, is open to all. In the local newspaper *La Nouvelle République*, a locally born journalist recently described Hérédia as "a living encyclopedia for our local grape variety, an impassioned defender of the Pineau d'Aunis."

In fact, Puzelat could best be described as a *new peasant*. Because beyond his farmer's roots, Puzelat has invented a cultural sense for himself that surpasses the local. In addition to fueling the imagination early on of US importer Joe Dressner or New York wineshop owner David Lillie, Puzelat has an intimate knowledge of wines from all over France, Italy, Spain, Georgia, and elsewhere. What distinguishes him is that he has consciously not limited himself only to the fanatical pursuit of excellence for his own terroir, for his own wines. His desire to travel, to forge friendships, to share as widely as possible, has pushed Puzelat to become the champion in France of Georgian wine, eventually even its principal importer when he grew frustrated with the timid efforts of others. Puzelat tirelessly

organizes dinners, tastings, encounters with Georgian winemakers, to promote their existence and their rich heritage. It's likely that wine was first made eight thousand years ago in the Caucasus Mountains, often in fat amphora–like clay jars, *qvevri*, buried underground. There was continuity, in great part thanks to the orthodox Georgian monasteries, some of which still make wine today. But with the gradual imposition of industrial agricultural practices by the Soviet authorities and then the subsequent pseudo-free-market chaos unleashed after the fall of the Soviet Union, winemaking in Georgia became chemical, artificial, bureaucratic, and indistinguishable from the industrial flow from Australia, Argentina, or California. However, thanks in part to Puzelat and Italian importer Luca Gargano's championing of natural artisans seeking to rediscover the art of *qvevri* wines, a lost tradition has been revived.

Meanwhile, Puzelat also encourages a spirit of cooperation in his own region, organizing a yearly wine fair in the town of Orléans (where he co-owns a wine bar). Whom does he invite to the fair for wines made between the Loir and Cher rivers? Only natural winegrowers like Hérédia? No. Puzelat insists on dialogue with all farmers as critical. Although one of the fiercest pioneers of the natural wine movement, he invites local winegrowers who might practice biodynamic farming but don't follow

through with the same conviction in their wineries, or simply organic winegrowers, and even those who make chemical wine but who seem receptive to a dialogue about other ways of working.

If Puzelat seems like a model global citizen with purely utopian motives, he has been canny enough to function equally as an entrepreneur, successful in market terms as well. In addition to making wine on his own farm under the Clos du Tue Boeuf label, he has partnered with other winegrowers like Hervé Villemade to make *négociant* bottled wine (i.e., larger quantities of wine, from other farmers' grapes), and he imports Spanish and Italian wines as well as Georgian into France. So Puzelat is an interesting example of a polyvalent winegrower–artisan–merchant, gravitating around cultural, political, social, civic, and economic concerns. He expresses a certain form of cosmopolitanism that is not only a deeply liberating response to soul-crushing globalization; he is also forging the utopian ideal of an alternate economic system, where the dominant groups and interests are simply sidestepped. This utopia, which I fantasize might be applied to the world of cinema and other cultural domains, consists of an international network of cultural exchange in alternate spaces. This would provide for the survival of multiple groups through economic exchanges that respect the dignity—and the limits—of individuals.

# The Italians Call It "Horseshit"

OF COURSE, to be fair, not everything smells like roses in the natural vinutopia. The stench of manure that critics of natural wine claim to detect in what they consider technically faulty bottles could be interpreted as their own discomfort with the complexity and earthiness of nature's odors. Or sometimes horseshit might be, well, just horseshit.

Certainly one of the dangers of this new egalitarianism and the suspension of conventional judgments about what constitutes taste, truth, and authenticity can easily lead to abuses. Especially delicate is the ease with which the collective, rural "we" of terroir can be subjugated to the narcissistic, individualist, urban "I." The cult of personality and the culture of celebrity can easily seep into any movement. These judgments of course are always personal, and one man's huckster is another man's saint.

But I confess to being deeply unnerved in 2011 when I encountered a folk hero from the beginning of the natural wine movement's public rise. I was invited to a conference in Zurich organized by Angiolino Maule of VinNatur, one of Italy's three (warring) leaders of their three natural wine organizations. Arriving at a dismal concrete bunker in the Zurich suburbs for an encounter between winegrowers and observers, I sensed that the utopian glow was beginning to fade on Maule, an increasingly autocratic and ideologically rigid leader, entranced by his rising power. The encounter was less about investigating the culture of natural wine than affirming the branding of his organization. Despite the brilliant intervention of agronomists Claude and Lydia Bourguignon on the biological life of soils, the majority of the participants seemed to have been gathered to affirm VinNatur's international brand value. Midway through, Maule introduced Frank Cornelissen as a Sicilian wine (rock) star. Cornelissen bounded onto the stage like an aging Mick Jagger. Diminutive but taut and handsome, clad in super-tight black leather pants and an open white shirt (despite the wintry Swiss temperatures outside the concrete bunker), he grabbed the microphone with a theatrical gesture and launched instantly into the narrative of his *Sicilianity*. There was excitement in the room as the master discussed his island

wizardry. A young man raised his hand to ask a question. "I've been importing wine in the United States for over three years," he said, visibly proud of the extent of his commitment. "I just wanted to say to you, Frank, that you express the most profound part of Sicily. You rock, man!"

## Rock Man

Frank Cornelissen spent many decades in his native Belgium working the gray market of rare, old Bordeaux and other products of the wine-speculation industry. The exact circumstances of his hasty departure from Belgium remain shrouded in mystery. Some in the wine world whisper about a million euros of unpaid debts. According to Cornelissen himself, he simply underwent a Nicolas Joly–like conversion from the world of banking and speculation to the truth of natural wine. At any rate, in 2000 he transferred his life to the slopes of Mount Etna in Sicily, a fashionable destination at the turn of the century for numerous businessmen, trust funders, and ambitious outsiders of all stripes.

Etna, quickly hailed by the wine press as a new mecca, suggests how the recuperation of any gesture can be made by the convergence of economic power and media complicity. Forgotten for centuries—if

not millennia—as a significant wine-producing re-
gion, Etna has undergone a renaissance in the eyes
of the conventional and natural wine press since the
Belgian Frank Cornelissen, the American merchant
Marco de Grazia, and the international multimil-
lionaire jet-setter Andrea Franchetti decided to set
up shop on the slopes above Catania. De Grazia,
a charming, erudite exporter of Italian wines to
the United States since the early 1980s, has been a
controversial figure in the wine scene. Viewed as
an early champion of artisanal Italian wines of ter-
roir, he's also notorious for having pushed numer-
ous Piedmont winemakers in the go-go 1980s to
abandon any semblance of terroir in adopting the
new oak-barreled, dense, sweet, almost Coca-Cola-
inflected style that appealed to his old friend, the
all-powerful critic of the time, Robert Parker. Since
then, de Grazia created his Tenuta delle Terre Nere
estate near the town of Randazzo on Mount Etna.
Alert to every aspect of the global wine market, de
Grazia adopted organic vineyard practices but care-
fully hued his cellar work to international industry
standards.

This same eco-friendly marketing but deter-
minedly market-oriented approach characterizes
the Baron Franchetti's work at his nearby Tenuta
Passopisciaro. Franchetti had already made a name
for himself when he launched a wine estate *ex nihilo*

on his family's vast holdings in the Col d'Orcia valley of Tuscany, an area where the grapevine had never been cultivated. For his Tenuta Trinoro, he had trucks bring in hundreds of tons of soil from a legitimate winegrowing region to create a "humus *ex nihilo*" and a wine *post nihilo* with internationally fashionable Bordeaux grape varieties. With the help of Bordeaux enologists, he immediately marketed the wine at two hundred euros a bottle and earned the favor of Robert Parker, who in the early 1990s was the undisputable czar of the international marketplace. The British Parker-wannabe, Jancis Robinson, jumped on the bandwagon too, swooning over his "movie star looks" in one paragraph, while intoning breathlessly in another that "Franchetti is like a youthful Yves Saint Laurent, complete with impressive height, heavy specs, mop of tow hair..."

Franchetti then moved on to Etna around the turn of the twenty-first century, setting up shop eight kilometers from de Grazia and four from Cornelissen.

Though all three are kindred spirits, what distinguishes Cornelissen from his neighbors was his decision to embrace the natural wine movement. A decision that quickly brought him handsome rewards, turning him into an avatar-star of natural wine hipsters from Paris to New York. He cast himself as a Sicilian wine renegade, incarnating the

natural authenticity of Etna, although even after ten years he still spoke no Sicilian and has a limited grasp of Italian, the second language for locals.

But given his significant marketing skills developed from years of speculating on wine as a luxury product, he's very fluent in the language of branding and the perverse coherence of the marketplace. On his Web site, he writes:

> *Man will never be able to understand nature's full complexity and interactions. We therefore choose to concentrate on observing and learning the movements of Mother Earth in her various energetic and cosmic passages and prefer to follow her indications as to what to do, instead of deciding and imposing ourselves. Consequently this has taken us to avoiding all possible interventions on the land we cultivate, including any treatments, whether chemical, organic or biodynamic, as these are all a mere reflection of the inability of man to accept nature as she is and will be. The divine ability to understand the "Whole" was obviously not given to man as we are only a part of this complex and not God himself.*

The implication being…

He goes on: "Our products are the result of this philosophy and our hands and team. Wines and olive oils which reflect ultimate territorial identity

and mineral depth carry the name Magma® and MunJebel®."

I certainly have never encountered the registered trademark sign on any natural winegrower's Web site or promotional materials. But Cornelissen takes this logic to a deliciously contemporary level of (unintended) irony:

> *Making such products without compromise in quality and profoundly authentic to territory, with low yield and continuous investing in quality with respect for the environment, adds up to a certain cost. Our Grand Vin Magma® and our MunJebel® single vineyard crus are wines with an inevitably high price tag and therefore we take pride in producing and offering at a great value for money our classic MunJebel® Bianco and Rosso estate wines. This is a social politics of price.*

In 2017, a lucky beneficiary in Italy of this "social politics of price" could buy the "great value for money" Cornelissen "estate" wine intended to improve social relations for the 99 percent for a mere fifty-three euros a bottle. In which case, it's understandable that the 1 percent in Italy will feel gratified to uphold their end of the social compact by spending 180 euros for the Magma®.

Given my skepticism of the man, it could seem gratuitous to add that the Cornelissen wines embody all of the defects that critics of natural wine attribute to the entire movement. But it's also true that I tasted a number of bottles, urged on me by the kind of Paris and New York natural wine hipsters that drove Lee Campbell from the wine world, before I knew anything about the winemaker. They always struck me as painful to taste. Oxidized beyond the afterlife, with a mean-spirited acidity, overextracted in the case of Magma, diluted in the case of the Munjebel...a kind of blindman's wine buff. They made me think of someone claiming to be an heir to Cassavetes but really just doing an unironic remake of Andy Warhol's infamous film about the Empire State Building, which consists of a single, fixed shot of the building lasting eight hours and five minutes.

® indeed.

*Twenty-Two*

# The New "Ruropolitanism"

DOUG WREGG IN ENGLAND embodies another expression of the new cosmopolitanism. Born in New York of British and American parents, Wregg moved back to England with his family when he was seven. He went to Oxford University and studied English literature, his great passion. He wrote and taught for several years but felt restless. A first contact with restaurants led him to discover that he loved the notion of hospitality, and when he made his first wine list, he somehow felt it had a mysterious affinity with literature. "I discovered my teaching gene late in life," says Wregg. "I love to share ideas, and wine is the starting point for conversations about politics, art, music, literature, and ethics. But most of all, I love telling stories, and wine is the sum total of all the stories that can be told."

In 1996, Wregg joined Les Caves de Pyrene, a wine importer founded a few years earlier by Eric Narioo, who started with two friends selling wine—mostly from Narioo's native region of Gascony—out of the back of a van. In 2004, says Wregg,

> *We were sitting in a Parisian wine bar. We were offered a couple of glasses of wine, including a white from Olivier Cousin in Anjou. It was an epiphany. Like in a Hollywood movie. We looked at each other and felt, "Cue the music!" The rest, for us, is history: an exploding love affair with natural wine, with terroir, provenance. We now work with around two hundred or so natural growers, importing them into the UK. Some are fully-formed, others are in transition. It's critical not to be sectarian and ideological also. Leave the door open so farmers are encouraged to discover new paths.*

Les Caves de Pyrene employs thirty people and has sales of over 25 million euros a year in the UK, local distribution affiliates in Italy and Spain, and numerous wine bars and restaurants in London. Now shareholder and director of marketing, Wregg says: "Natural wine markets itself, so I don't have to do any dirty work. We don't parade an agenda, although people may associate us with the natural

wine thing. We sell to the corner pub and Michelin three-star restaurants, knowing the wine can change hearts and minds by its own power of persuasion."

Most of all, Wregg sees Les Caves de Pyrene as a kind of Un-United Nations, a UK hub for an international flow of ideas and concrete actions to rethink what people know about farming, food, culture. They represent growers from France and Italy, of course, but they also have German, Austrian, Spanish, Portuguese, Greek, Slovenian, Croatian, Georgian, Australian, American, Chilean, Argentinian, and South African winemakers on their ever-expanding list. Says Wregg:

> Natural wine, being an idea as well as a practicality and livelihood, has no borders. Although there are hot spots (the Loire especially), you'll find independent-minded, curious vignerons in every part of the world. Sometimes, their creativity is stifled by a desire to please the market, or they are crushed by the dead hand of bureaucracy. But because people are traveling more and communicating regularly and tasting with an open mind, there is an active ferment of ideas that transcends country and region. Of course the wine fairs are responsible for growers coming together, exchanging ideas and tasting each other's wines. The fairs are the cogs that create the idea of movement. For me I'm not sure about a wine

*movement. I see natural wine as a natural synthesis,
an inevitable direction for anyone who wants to re-
think the world in an ethical and practical way.*

While more than half of Narioo and Wregg's list
of growers are French and Italian, with the Loire,
the Rhône, and the Languedoc dominating, each
area of the world is of interest to them.

In South America, a natural wine scene has yet
to develop, but Wregg is convinced the precondi-
tions for making great wine are there. After decades
of abuse by French and American multinationals,
in Chile especially they're rediscovering their own
culture. Many small growers are now seeking out
their own ungrafted rootstocks from vineyards free
from the phylloxera disease, rediscovering the origi-
nal regions where vines were planted by the Spanish
missionaries—Itata, for instance—as well as the use
of tinajas, terra-cotta clay pots that every peasant
farmer had once upon a time to make his wine. One
of Wregg's prize discoveries is Enrique Villalobos,
a noted Chilean sculptor who lives—of course—in
an area known for centuries as the Valley of the Art-
ists. Villalobos has some land in the forest in Colch-
agua near his house. A vineyard was planted there
around eighty years ago and has since grown wild
with the vines mutating into *Vitis sylvestris*, the vine
that winds up the trees. Wregg explains:

*There are not only trees but bushes and thickets. You'll find bunches of grapes amongst the sloes and blackberries, curled in nests on the very forest floor. It is wild and dispersed. No controls are used, no chemicals are sprayed, and the vineyard, if we can call it that, exists in its sylvan surroundings. There are some wild horses that canter through the woods and occasionally nibble the shoots. At harvest time a bunch of his friends come together, don gloves, take out ladders, and harvest this wild bounty. The house, which is a studio, also functions as a make-shift winery. The fermentation is part of discarded old sculpture—everything is an extension of what he does with his hands, his eyes, his friendships.*

For Wregg, the Georgian wine scene, "the spiritual home of natural wine because the probable origin of all wine," is also amazing, with its own tradition of *qvevri*, with an embrace by young Georgians who have fled Tbilisi to make the countryside active, only to fuel an explosion of wine bars back in the country's capital.

Australia for Wregg is equally intriguing: "They have the most dynamic natural wine scene with growers selling directly to wine bars and restos. It is part of the artisan boom. Good, sustainable, and fun. Wine is a vehicle for pleasure and the growers talk about 'smashing a bottle.'"

Narioo and Wregg travel the globe, visiting the growers of course but also visiting the urban centers where the wine is consumed, just as the growers themselves do. "One thing I have noticed is that these growers are incredibly literate, intelligent, and resourceful people," says Wregg.

*Being a farmer and a winemaker you need a grasp of history, geography, geology, botany, microbiology, as well being a carpenter, a plumber, and a cleaner! Renaissance people! Backbreaking work, dedication to the cause, focus on tiny details—that's the day job—and then you have to deal with boring practicalities and silly bureaucracy. I never cease to be impressed. The consolation is the work in the vines, to be in nature, and to be at one with nature at times. The more you do that the more you understand that you are transient and that the real mission is to be a steward of the vineyard and the environment. This socio-ethical consideration is the driving force of the best of the natural wine growers. No one's out to make a quick buck. As one grower said to me: "I don't care about getting bigger or better. I have a nice life and a young son. That's enough for me now."*

Wregg's blog on the Caves de Pyrene Web site is the most interesting thing written in English on natural wine. It's a fantastic irony that technically

what should be an agent of pure marketing and deceit is inverted in the natural wine world into the embodiment of liberty and poetry, everything that we could expect from the most fiercely independent journalist, another subtle but deeply radical form of inversion, even insurrection.

*Twenty-Three*

# Agri-culture

WHATEVER THE MOTIVATIONS, what is certain is that the new natural wine farmer often has as deep an understanding of urban culture as of agriculture. In fact the balance between the two is something sought out by many. If they start as farmers, like Thierry Puzelat, the natural wine world opens up numerous possibilities to cultivate an urban, even cosmopolitan culture. On the other hand if they start out as urban dwellers, like the former globetrotting photographer Emile Hérédia, they plunge into local, rural life and the necessary manual labor with absolute dedication. In the world of conventional wine on the other hand, there are countless estate owners, especially in prestigious regions like Napa and Bordeaux, who play the weekend Marie Antoinette at the Trianon but remain culturally determined by city life. Or those who may be third-generation

farmers, who, because of the competitive nature of the industrial-chemical wine world, won't have as much access to cooperative cultural exchanges.

One of the most revolutionary aspects of the natural winegrowers' movement is the recognition that the culture of the countryside—agriculture—will always predominate. The artisanal agricultural gesture demands a concrete know-how, which is indeed a radical posture in a world increasingly dictated by the virtual, the digital, and the disincarnated. Most of us now live in a world lacking in materiality. In this disincarnated society, a return to the artisanal, to the manual (in the metaphoric and literal sense), poses urgent questions for all classes of artists and artisans.

The questions it asks are not anodyne, because they revolve around the question of ecology. And by ecology, I don't mean, What can we do to improve the environment? but rather, What can we do to avoid the extinction of the human race, the extinction of ten thousand years of civilization, ten thousand years of agriculture?

Pablo Servigne, agronomist and coauthor of the book *Comment tout peut s'effondrer* (How Everything Can Collapse), explained in an interview for the independent French Web site Reporterre: "Certain ancient civilizations collapsed economically and politically. Several centuries later they'd be reborn.

But there are also civilizations that collapsed for ecological reasons. Because the collapse of the environment always provokes a collapse of the corresponding civilization. And in those instances, the civilization isn't reborn because the environment has been exhausted."

Civilization and environment. Agriculture and culture. For several centuries we've forgotten (or often artificially separated) the link between these two twinned notions. How was it possible for the world of culture to become deracinated, dematerialized, disincarnated, and be turned into a terrain for intellectual and financial speculation, stripped of its roots in the earth, from which the initial cultural gestures sprang? As the cliché would have it, if you ask the question, What is culture? you won't get the same response from an artist and a farmer.

According to the cliché, for the former it would be the combination of all the things to read, to listen to, to see that enrich our minds. For the latter, it would simply be the fruit of his labor from the earth. To each his field, imaginary or material.

In the contemporary imagination, the areas of agriculture and culture are absolutely distinct. On the one hand, we erase the intellectual and cultural dimension of agriculture and reduce it to a purely economic and alimentary question (especially in a country like the United States or Australia). On the

other, we persist in the myth of intrinsic intellectual value, even as the cultural field becomes equally reduced to an economic equation. Agriculture has been reduced to commercial considerations, to statistics, and to pseudoscientific questions, while the human aspect and the relation between man and nature, between the spirit and the body, has been severed. In the contemporary world, we insist above all on the cleaving of the two "cultures." One nourishes the body, the other the spirit. They are (consciously!) uncoupled (pace Gwyneth Paltrow) with a hierarchy of importance wedged between the two activities.

We forget that the cave paintings of thirty thousand years ago evoked the hunt and the gathering of fruits and nuts as a way to commemorate the past but also as a depiction of a wished-for future: art as magical invocation. We've forgotten that it's agriculture—sedentism and faith in the future— that enabled the birth of human civilization. Where one cultivates the land, one buries the dead, one marries and settles, prospers, learns to govern and to share in the harvest. The great geographer and anarchist Élisée Reclus said in 1905 that "man is nature become conscious of itself."

But the twentieth century is distinguished above all by the conviction—as present in democracies as in dictatorships—that man has entirely subjugated nature, twisting it to his needs and desires. The

so-called postwar miracle in Japan and Germany, their astonishingly swift passage from dictatorship to democracy, their instantaneous economic metamorphosis from devastation to economic hegemony, can be explained in part by the intimate understanding that preexisted their conflicts with their democratic adversaries. Nature was conceived as a field of play for the human imagination, where man could hold a totalitarian sway over nature. Hitler's Nazi Germany and Roosevelt's democratic America both were committed to the universal twentieth-century belief in industrial hegemony *über alles*.

The more that artists and cultural players sidled up to economic and political power, the more their view of nature became contaminated by the industrial eye. This is equally, tragically true for most of the ecological discourses of the last fifty years, where the impending environmental catastrophe has compelled politicians to speak about it. But nature doesn't listen to speechifying. She reacts physically to the treatment that she's accorded. Here only material action counts.

OF COURSE words are also embodied and have discernible roots. They contain the traces of the wounds inflicted on them. For this reason there is a lexicological root that can tell the story of this

tragic rupture between the culture of the soil and the culture of the mind. The traces stretch back to Latin and the Romance languages, to the end of the seventeenth century, to the moment when the city became the center of political, economic, and cultural life. It's the emergence of urban life as a social center in Western countries that marks the process of uprooting. The critical transformation occurred between 1650 and 1700, when in France, for instance, out of a population of 20 million, only 3.5 million lived in cities. The kingdom of France was still overwhelmingly rural even though it was in the cities, in cafés, salons, and bookshops that culture in the modern sense began to assert itself. Hand in hand with the social aspect went the economic. It was in cities that markets were developed, along with shops for artists and artisans and financial, governmental, and judicial institutions. And it was in cities that the prices for agricultural activities were decided. Cities became the places for exchanges of all kinds. It was where the ascending class known as the bourgeoisie emerged, a class that leaned on culture and urban life the way the aristocracy had depended on the land and agriculture.

However, just as artists and artisans are closer to each other than we might think today in our disincarnated world, the words "culture" and "agriculture" were also.

*Twenty-Four*

~⊗~

# At the Root of Culture

WE USE THE WORD "culture" to mean so many different things that it's become completely hazy: to be cultured; a dialogue between cultures; African culture; underground culture. We say that Coca-Cola and Ernest Hemingway are products of American culture; that Burgundy wine and Flaubert are the flower of French culture. We say that a field of corn in Mexico is culture. Or the totality of the social habits of the Dogons in Africa. For bacteriologists, culture is the bacteria grown in petri dishes. We could even say that "everything is culture," as it became fashionable to say "everything is language."

So what are the historical roots of the word itself? From the beginning, "culture" had a double link to the land. It meant the place of rest for the dead and the vital source for the living. For archaeologists and historians, culture begins with these

two traces of civilization found beneath the earth: funerary objects and agrarian tools.

At its origin, *cultura* in Latin meant the "care one gives the land." Until the seventeenth century, the Romance-language forms of the Latin *cultura* meant exclusively working the land. The verb *colere* meant "to take care of," also in a figurative sense. Cicero, Roman statesman and man of letters, in his Tusculan Disputations from 45 BC, wrote: "as a field, though fertile, cannot yield a harvest without cultivation, no more can the mind yield thoughts without learning; thus each is feeble without the other. But philosophy is the culture of the soul. It draws out vices by the root, prepares the mind to receive seed, and commits to it, and, so to speak, sows in it, what, when grown, may bear the most abundant fruit."

But this was an exceptional flight of poetical fancy. *Cultura* in Latin was almost always invoked in its agricultural sense. In the Middle Ages, *colture* replaced the Latin word. Charlemagne invoked it as a designation for all cultivated lands. During the Renaissance, because of the humanist impulse that placed books and education at the center of a cultivated life, *colture* began to be used more insistently for its metaphorical meaning. But it was not until the seventeenth century that the sense of cultivating one's intellectual and spiritual faculties became commonly used. In the famous Richelet dictionary,

one of the oldest of the French language, published in Geneva in 1680 but banned in France, the word *culture* makes two appearances. The first entry describes "the art of cultivating the land," and the second "the efforts one makes to perfect and polish the arts, sciences, and the mind."

The mutation of *culture* in the farmer's sense into *culture* in the urban sense coincided in France with the unification of the country and the language under Louis XIV. And of course, as seen in a previous chapter, this was the era when the artist evolved from artisan into intellectual. The culture of the mind, the arts, literature, the sciences, constituted an imaginary territory that demanded to be tilled. The evolution of the dictionary itself becomes a useful way to trace its contours.

Since 1635 the Académie française had been charged with the mission of defining the proper use of language and establishing its official vocabulary. But the savvy academic Antoine Furetière beat the academy to the punch, insolently publishing his dictionary in 1690 in Amsterdam, four years before the official academy version. His definition of the word *culture* is brief: "the care one takes to render land fertile and arable." He doesn't mention its figurative sense, but that can be found in a note just above under the verb *cultivar*, to cultivate: "one says figuratively in regard to moral matters that it is necessary

to cultivate the minds of the young." As late as 1690, preeminence is still given to the agricultural sense of culture. But the progression from the cultivation of the earth toward the spirit is under way.

In the second edition of the academy's dictionary in 1718, the first to classify words strictly in alphabetical order and no longer organized by a root or family, the word "culture" retains its primary agrarian meaning, but the direct link to the word "agriculture" disappears. The latter is displaced to the beginning of the dictionary under the letter $A$. The word "culture" now stands alone with its twin meanings, one concrete and anchored in the soil, the other abstract and planted in the mind. In the official vocabulary of the new centralizing, technically inclined power, the two dimensions of the word will inexorably separate. Culture as agriculture is gradually replaced by culture in the mind. By rearranging word order alphabetically rather than by their thematic and etymological roots, it's as if the dictionary itself becomes deracinated, recognizing a cultural migration from the earth toward an immaterial, putatively rational world.

The farmer at the beginning of the eighteenth century migrates toward the city, exchanging the labor of his land for the labor of his mind. However, like the monarchical power itself, the word *culture* becomes frozen before the French Revolution. In the

two subsequent versions of the Académie française's dictionary, from 1740 and 1762, the definition remains unchanged. The tectonic movements of the Enlightenment hadn't yet affected the official definition of the royal institution, which remained a rock of immobility. Official culture was unmoved. But even the *Encyclopédie*, the most culturally influential publication of the Enlightenment, compiled between 1751 and 1772 by the philosopher Denis Diderot among others, had a peculiar definition of *culture*.

The only article that corresponds to "culture" in the entire landmark humanist tome concerns the culture of the earth! But this comes with a fairly devastating caveat.

Entitled "culture of the land" and published in 1751, the article is fourteen pages long. What's most striking is the very modern argument of agriculture as a fundamentally commercial, export enterprise. The culture of the mind is the fundamental object of the entire encyclopedia, and Diderot missed few opportunities to affirm his critical and emancipatory beliefs. So it's odd that he chose to associate the word "culture" with international commerce.

Perhaps this is a sign of the *Encyclopédie*'s ambiguity: at once a major work of humanist civilization and a commercial enterprise undertaken by booksellers for the new clients of the bourgeoisie. The article on culture was written by a certain François

Véron Duverger de Forbonnais, known as an economist and financier, a specialist in the international commodities market.

This usurpation of the word "culture" by a self-interested financier was a sign of destiny, both for agriculture and culture in general.

In the 1798 dictionary, following the French Revolution, the previous definition, "the means for making the land more fertile," is replaced by the simple "labor of the land." This phrase is then followed by "to improve its productivity," both concepts that express modernity's technical-economic bias. There is also the notion that "countries of significant culture" means "where the land is worked with horses."

So it's worth considering that in the 1835 dictionary of the Académie, the modern mutation of the rural world toward a purely economic enterprise is confirmed. "Important culture" now means "what was considered, in another era, to be executed with horses, today means the exploitation of a vast tract of land by means of a large capital investment, following the advice of agronomists." The tradition of "another era" is now opposed by a "today." The agrarian world was transformed under the July Monarchy (1830–1848), a liberal constitutional reign under Louis Philippe that sought to significantly increase agricultural output to favor large aristocratic landowners. In this new

definition, capital and the scientific know-how of agronomist-technicians become the masters of the land to whom farmers must submit. The definition traces the contours of modern agriculture by making culture an action in which man asserts his control of the land, displacing peasant experience in favor of scientific preeminence.

At this time, the dialectic of nature and culture also imposed itself on philosophy as the motor of history. For Hegel most notably, history evolved from the "man of nature" toward the construction of the state: a political entity dominated by culture. In his *Propedeutica Filosofica*, written around 1810, he writes, "the state of nature is a state of brutality, violence and injustice. Man must leave that state behind and create a society that becomes a State, the only place where the rule of law can create a reality."

At this time, what belongs to nature is that which demands the least amount of work, suggesting a simple organic life ruled by a poverty of spirit and a certain primitiveness. This concept of course betrays a particular view of nature. She is to be bettered. To cultivate her is not a harmonious act but one that requires her to be constrained and dominated. The modern world begins to cut itself off from nature and the intuitive, empirical, historically rooted knowledge of the peasant-farmer, turning it into an internal enemy.

In the progressive, capitalist vision of the nine-teenth century, intellectual culture becomes a pri-mary weapon, allowing it to subjugate nature. The body, the flesh, life without order, innate desires, are all elements to be overcome. Nature takes the place of the devil and animality that of evil itself. Much has been written about sexual repression in the eighteenth and nineteenth centuries with the establishment of capitalist bourgeois society. There were innumerable treatises of the time on the phys-iological misdeed of onanism and the improbable devices designed to prevent young men from mas-turbating. In the nineteenth century, it was above all a question of controlling nature. Nature became a question strictly of capital at the moment where natural resources began to be exploited as the pri-mary motor for industrialization.

Not coincidentally, it was at this time that in-tellectual culture became the new religion of the emerging democracies. It became an asset itself. The new clothes for the new man of science: rational and above nature. In the new educational system for this new man, it was the acquisition of "a broad culture" that would distinguish the best of the new. During the nineteenth century, the book industry and the press developed rapidly, alongside the emancipation of the artist, freed from the patronage of the ancien

régime thanks to the development of the art market and the bohemian life that glorified even his deprivations. In this way a rather perverse profile emerged.

Culture also became the means by which the bourgeoisie could distinguish itself from the people, even as they themselves grew more cultivated because of the expanding reach of schools. Culture began to play the role that bloodlines did for aristocrats. Culture served as a kind of foundation for a new aristocracy, based on university degrees and their transmission by new bloodlines. If one is born bourgeois one is born with culture, a priori. The sense of legitimacy, of superiority, of being "the chosen," was heretofore transmitted by degree and type of culture. A distinction emerged between the arts themselves. Those that descended from a so-called classical period—tragedy, opera, classical music, official painting, religious edifices—were attributes of an aristocracy appropriated by the bourgeoisie. Then there was so-called popular culture, sustained by the nascent cultural industry: the novel, comedy, operetta, popular song, the illustrated newspaper, and eventually photography and cinema.

Nature, exalted by Romantic artists in a kind of anticipated nostalgia exactly at the moment in which its material value was being downgraded, gradually

disappeared from the preoccupations of painters, writers, and other guardians of the new temples.

In the 1877 dictionary of the Académie, the progressive élan of the century was confirmed by the definition of culture as the cultivation of the spirit. But the academicians also continued to define culture in its anachronistic sense of the cultivation of land, ascribing its origins to the Middle Ages. In some sense this was a legacy of the Romantics, who sought to glorify the medieval period, but in an artificial conception that turned medieval culture into a museum piece.

The ultimate transformation of the official definition of the word "culture" occurred in the twentieth century. In the 1935 version, the technical prowess of agronomists was clearly emphasized. Cultivation of the land consisted of "employing the procedures and the arable instruments judged most efficient by agronomists." Motorization and machines progressively replaced people and horses. Henry Bauchet produced one of the first tractors, in 1909. One can also see that the word was used to express man's scientific manipulation of life itself: "In Bacteriological terms, *Microbial Culture* is the development of specific microbes under favorable conditions." Culture has definitively triumphed over nature, at least according to the dictionary. It describes man's mastery of even the most minuscule expression of life.

But a third meaning also emerged at the time: culture as civilization. Already imagined in the nineteenth century by Madame de Staël, who mistranslated the German word *Kultur,* it returned in 1930 in Freud's book *Das Unbehagen in der Kultur* (*Civilization and Its Discontents*). In the dictionary, however, the word preserved a sense of unity: one word with multiple meanings. The dictionary invokes it "figuratively" to describe the secondary meaning of the culture of the mind, as well as to describe the third meaning of civilization. It's as if this third definition is a kind of museumification of culture itself. We identify far-off cultures in order to preserve the memory of them at the moment of their mass extinction.

In the current version of the dictionary, a work-in-progress since 1994, the Académie française distinguishes three separate meanings for culture. They are given equal status. There's culture in the agricultural sense and, by extension, the bacteriological; the urban and intellectual meaning of culture; and then culture in the anthropological sense. These are the three contemporary meanings of a single word, three separate understandings of culture.

Not exactly a trinity.

And in fact the *Oxford Living Dictionaries* now offers a fourth dimension to the English word "culture." The primary definition links the word to the

arts. The second to the "ideas, customs and social behavior of a particular people." The third refers to its biological meaning. We have to wait for a fourth, laconic mention of "the cultivation of plants."

A clear afterthought in Anglo-Saxon *culture*.

# Cultura

BY CLEAVING the word "culture" and its meaning in two, even in three, we've transformed what for a farmer has always been one and the same activity.

For some it still is.

Giovanna Tiezzi belongs to the fifth generation of Tiezzis at Pacina. Neither noblemen nor peasants but a succession of enlightened activists, the Tiezzis have lived on the land they work near Siena on the southern border of the Chianti since the mid-nineteenth century. In addition to growing spelt, chickpeas, lentils, and olive oil, they share an extensive vegetable garden that feeds the half dozen families that live on the Pacina estate, friends and relatives of her parents, most of whom settled there during the 1960s. Giovanna's mother, Lucia Carli, is a poet and former professor of biology at the University of Siena. Her late father, Enzo Tiezzi,

was a passionate organic farmer. But he was also a world-renowned professor of physics and chemistry at Siena and author of the landmark book *Tempi storici tempi biologici* (Historical Time, Biological Time, inexplicably never translated into English), a prophetic meditation on the catastrophic disequilibrium between the march of nature and the march of civilization. Tiezzi is also a folk hero in Italy; the leader of the antinuclear movement, he succeeded through a 1987 national referendum in permanently blocking nuclear power in Italy.

His daughter Giovanna began her professional life as a dancer in a modern dance troupe, but the lure of the farm proved more compelling. In 1987, she became the first person in her family to bottle Pacina's wine under their own label. With her husband, Stefano Borsa, she quickly turned Pacina into a beacon of the natural wine movement in Tuscany, along with their neighbor Giovanna Morgante at Le Boncie. The most authentic expressions of the Chianti Colli Senesi terroir that I know of, Le Boncie and Pacina are both systematically refused official DOC territorial recognition. By 2014, Giovanna and Stefano (a lapsed agronomist from the industry-friendly University of Milan) decided to stop even submitting their Chianti to the local commissions. But this Chianti-that-can-no-longer-bear-its-name, refused recognition at home, has become

a beloved Chianti icon in Japan, Scandinavia, France, Belgium, Latin America, and North America. The Pacina wines, including their ex-Chianti, the lighter "Il Secondo," the biting Canaiolo, their dense, amphora-aged "Pachna," the bracing white, and the rosés, are sought out by those thirsty for the rare expressions of Tuscan authenticity. Their refusal by the official commissions is understandable when the norm for Tuscan wines is the treacly, Disneyfied concoction of international enologists, themselves paid by absentee industrialists and local aristocrats who jumped on the globalized bandwagon, or by jet-setting landlords, including numerous Hollywood producers and directors.

Pacina, which means "Bacchus" in Etruscan, revels in a different cultural connection. While its village of Castelnuovo Berardenga sits on the southern frontier of the Chianti (a region recognized since medieval times), it marks a northern boundary of the much more ancient Etruscan civilization, which flourished from roughly the eighth to the third century BC. With an enchanted culture whose origins and many contours remain mysterious, the Etruscans' independent but federated city-states were concentrated between modern-day Tuscany and central Lazio. The little we know about them suggests that their civilization was devoted above all to agriculture, art, mining, and the export across the

Mediterranean of the riches of their earth and their craftsmanship. They had little appetite for wars, and women seem to have naturally occupied a more prominent place in Etruscan society than any other ancient civilization. So it's not surprising that the bellicose and imperialist Romans needed little time to eradicate most traces of the culturally more dedicated Etruscans.

When Giovanna welcomes friends or visitors to Pacina, before taking them to visit the fields, the orchards, or the vines, let alone the cellar, she's eager to speak first about the earth and the human role as *tramite*, or (roughly) midwife. She might glance in the direction of Siena's towers, visible on the horizon fifteen kilometers away. Then Giovanna asks her visitors if they know Ambrogio Lorenzetti's fresco in Siena's medieval town hall. Painted in 1338, it was commissioned by the nine town councilors meant to run the city in a democratic fashion. The fresco, an allegory of Good Government and Bad Government, was conceived as both talisman and inspiration, so that the councilors might make good choices and as protection from the authoritarian threat of Siena's power brokers. This sprawling sequence of images greeted the medieval politicians just as it greets the hordes of tourists bused in today: each equally indifferent

(if each in their own fashion). In the first cycle Lorenzetti illustrates the effects of bad government. Then, when the viewer turns around, he's invited to rediscover the good. The images of good government themselves are equally divided between the prosperous city and the well-cultivated countryside, each fulfilling its function. Giovanna, who likes to imagine the view of the fertile fields as the vista from Pacina, sees a contemporary purpose for the eight-hundred-year-old images. When her children Maria and Carlo were small, she'd often take them into Siena to have an ice cream and then contemplate the Lorenzetti fresco cycle as a way of rooting them in the land that they might one day look after. "These images are cultural transmission," says Giovanna with a quiet delight that evokes the dulcet tones and lines of the images themselves. "They're culture of the earth, culture of the imagination. Culture of the past, culture of the future." Her determination to cultivate her land with a sense of "good government" also suggests how Lorenzetti's images are less ossified relics of the past than active spurs to action. Giovanna's feeling for Lorenzetti also suggests how the purpose of any cultural engagement is to make humans fecund so that they in turn can make fertile both the earth and civil society.

# The Nature (or Culture) of the Natural

If we can accept that the agricultural act is fully cultural in all the meanings of the term, then it becomes useful to add further planes to the (necessarily Cubist) portrait of natural wine. So-called conventional wine, as we've seen, has only been the convention for the last fifty of the eight thousand years of its history. This neoproduct is wine that has been largely denatured. It shouldn't really be called wine. "An alcoholic beverage from grape juice" would be truer. If 99 percent of the world's wines are, at bottom, not really wine, what constitutes the 1 percent (to invert the Occupy paradigm)?

Natural wine is not Rousseauist or Thoreauist, even if it embodies the civil disobedience of the latter. It's not a nostalgic gesture, born from some pastoral fantasy of the past. It's not a Luddite movement that rejects modernity and technology per se. It is, however, a wine that seeks to anchor itself intelligently—critically and amorously—in the past so that it can question, innovate, even break the rules for the present (and future). In this way, wine finds a natural place alongside all cultural expressions: painting, architecture, literature, cinema.

In *agri*culture.

Giovanna Tiezzi herself sees her work as "essentially someone who prepares the fruit." But the big

difference with organic farmers or those who limit their biodynamic activity to the vines is in the work that's done in the cellar. And this is what requires the greatest audacity. The better "conventional" winegrowers and many organic or biodynamic producers conceive of their wine as a *product of* terroir. Natural winegrowers see it as a *vector for* terroir. Instead of imposing themselves on the picked fruit, they seek to efface themselves behind it.

In CINEMA, the desire to share transparent emotion and the humility (or the audacity) to be an agent of circumstance rather than the desire to be its creator, is revealed in the relationship between an actor and a director. Take Elia Kazan and Marlon Brando, for instance. In *On the Waterfront* there's a magical alchemy between Brando, the actor within the frame, and Kazan, the framer of the circumstance. Especially in any scene where Brando is alone or is filmed separately, the distance the director places the camera (that is, the audience) from the actor, the stark quality of the light, and the palpable intensity of the actor become symbiotic. Brando strains to "speak" with every tissue in his body, and Kazan "listens" so intently with every cinematic instrument at his disposal, that we vibrate with them.

And paradoxically all artifice seems to disappear.

Whenever Brando is onscreen, you have the feeling that you've just heard Kazan whisper—or shout—"Action, Marlon." The magic of cinema is that sixty years later that moment of grace vibrates with the same thrilling immediacy. Brando's ability to access his interior life—an ability we condescendingly associate with children and animals in their "natural" state—in fact requires the finest sense of craft. Every actor of worth has lived a moment when the confluence of director, character, script, and setting allow him to reveal himself fully, to become a pure vector (not a streetcar!) of desire.

Desire, terroir. Culture, agriculture.

Just as Kazan and Brando in the justly celebrated *On the Waterfront* have kept the tensions of McCarthyite America of the 1950s palpable today (in part of course because of Kazan's fraught personal history), Arthur Penn and Gene Hackman in the little-known masterpiece *Night Moves* continue to envelop us in the lassitude of 1970s post-Vietnam America. Penn was a great believer in the "transparent camera position" as opposed, say, to the coked-up contortions of Martin Scorsese's self-consciously frenetic movement. He was the right director to frame the anomie of the mid-1970s. In Gene Hackman he found the perfect co-agent for the sardonic, ostensibly cynical but fundamentally still utopian spirit of the time. Like Kazan with

Brando before them, Penn and Hackman inhabit the same space, internal and external, the one merging with the other.

During my one-day shoot with Arthur Penn for a documentary series on directing (*Searching for Arthur*, 1997), Penn spoke at length about Kazan's approach with actors, his ability to coax out their desire, almost their need, to reveal themselves as completely as possible. "Kazan would take the actor aside, put his hands on his shoulder, whisper into his ear, bring him close." Penn went on to explain that Kazan was able to convey that the emotion of the place they were shooting was as important as any character. With the lighting and the camera position intimately entwined with the actor, the *topos*, the soul of a place, its "terroir," could be fully revealed.

It goes without saying that for a humanist like Penn, there are three thousand ways to arrive at an expression of filmic topography, of cinematic terroir. Each new configuration of director, actor, script, and physical context will find its true expression according to personality configurations, culture, style, desire. Just as with wine.

Early in the shoot day with Penn (he gave me from breakfast until sundown), I was sitting next to him in the back of a New York taxi, the lens of my camera a foot from his nose. Visibly uncomfortable, he said, "It's still a mystery to me how actors

develop emotion in front of the lens." I looked at him, astonished. He, Arthur Penn, one of the greatest directors of some of the greatest actors in the history of cinema? Who prized out singular performances from Gene Hackman, Dustin Hoffman, Jack Nicholson, Faye Dunaway, Warren Beatty, Marlon Brando, Jane Fonda, Robert Redford, Paul Newman?

According to Penn (excessively modest), 80 percent of a director's job is in casting the right actors. But having spent many years now with natural farmers and winegrowers, I'm convinced that directing is very close to their work as fine-grained observers, as joyous midwives of the life around them.

In choosing the actors and the set, a director establishes the conditions for the terroir. In order not so much *to direct* as *to be* with the subjects (actors, light, and decor) that are filmed.

Of course there are countless great directors whose approach is radically opposed to this notion of subtle symbiosis. Baroque stylists like Fellini, Kubrick, Max Ophüls, and Hitchcock invented sui generis every detail of their world and did everything possible to eliminate "spontaneous life," and yet managed to create profound reflections on the nature of what is human. But the list of those who might subscribe to some notion of natural terroirism is probably longer, including as heterogeneous a

bunch as John Cassavetes, Robert Bresson, Roberto Rossellini, Rainer Fassbinder, Pasolini, Bergman, Ettore Scola, Ray (Satyajit and Nicholas!), Renoir, Jia Zhangke, even Harmony Korine in *Gummo*. The list is *ad* (almost) *infinitum*.

At the very least, I'm quite sure that directing can't be summed up by what's been taught for decades at film schools, what's been espoused by most film critics over the last forty years and still dominates their language (and therefore the dreams of ambitious filmmakers). The formal language of the camera, the self-consciously proclaimed aesthetic, the plastic image as an end in itself, has as little to do with film as its plot or a dime-store description of the character's psychology.

We seem to have reduced cinema to flashy camerawork, contorted plots, and CliffsNotes for Freud 101. Or the highbrow Janus: exalting the endless silence from the endlessly stationary camera.

The soul of directing can't be a formal or mechanistic engagement. It has to be a question of being fully present, of establishing an ineffable bond between the image and the terroir of the shoot: the place, the actors, the human and topographic life that it photographs. We too—filmmakers—are capable of searching out the organic life of a subsoil, of digging down in search of a certain minerality.

*Twenty-Six*

⤝⤞

# Searching for
# (Natural) Direction

THIS FEELING OF MINERALITY, of touching something substantial and subterranean in relation to my craft, occurred by chance. I felt it keenly during the accidental filming and then the editing of *Natural Resistance* (2015), as modest (and accidental) a film as could be imagined.

I've spent my career going back and forth between fiction and documentary. But with the arrival of quality digital around the turn of the century, even the distinction between filming and not filming became much more fluid. A few summers ago I went with my children from Rome, where we live, to visit some winegrower friends near Siena. I had arranged a weekend get-together between several of them and Gian Luca Farinelli, the director of the Cineteca di Bologna (the national film archive in Italy), at the house of Giovanna Tiezzi. We were

planning a festival in Bologna entitled "Days of Illegality" to celebrate acts of civil disobedience among farmers across Italy. The purpose would be to highlight how shepherds, cheesemakers, dairy farmers, prosciutto and salami artisans, pig farmers, growers of cereals, and vegetable gardeners, as well as winemakers, found themselves increasingly unable to carry on centuries-old practices because regulations from the EU in Brussels were now bending the agricultural policy to the most homogenizing industrial standards.

Sitting beneath a thousand-year-old oak tree in the magical garden of Pacina, a converted eleventh-century monastery Giovanna and her extended family and friends live in, the last thing on my mind was filming anything. But as I listened to Farinelli, a radical spirit in the world of official filmdom; Corrado Dottori, ex-economist turned radical farmer in the Marche; Stefano Bellotti, a Pasolinian poet of the vines from the Piedmont; and Giovanna and her husband Stefano, a reluctant rebel, I realized my three children were probably too young to appreciate how refreshingly subversive, lucid, but deeply optimistic the conversation was. I went to my room and brought down my camera without thinking about the consequences. I had no intention of *directing* anybody. Instead I placed myself, camera in hand, like an actor within someone else's mise-en-scène.

The spontaneous fermentation between farmers, winegrowers, and film institute director in that particular garden on that summer day allowed for a natural movement where the director-filmer became an actor. And vice versa. The vitality of these exchanges around the lunch table transformed my spontaneous act of filming into a gradual recognition of a more intentional mise-en-scène. I had the feeling, though, that whatever sense of craft I had was at the service of someone else, something else. There was a feeling of transparency between what I was listening to, what I was feeling, and what I was conveying through the camera that I held (for better and for worse!). The easy intimacy, joviality, but also urgency of the people in that context seemed to fertilize the filmed images. It felt so alive, I went to visit the other winegrowers at their farms that week, so that the context for my kids, for me, for others could be expanded.

When I returned to my studio in Rome to edit these few days of images, gathered like wildflowers at Pacina in Tuscany, in the Marche, Emilia, and Piedmont, I didn't know what to expect. I certainly didn't have a feature-length film in mind. In fact, to edit a film I normally take close to a year, sometimes more. But after three months at the editing table, an eighty-minute meditation on agriculture and cinema had materialized. The work of constructing the

film felt as spontaneously cheerful, but also as urgent to me, as the process of filming. I was as surprised as if it had not been my hand that had guided the camera's movements or the (figurative) cutting and pasting of the images at the editing table.

I sent it off to some distributors and festivals expecting that it couldn't find a place on the big screen. But somehow it slipped inside the Berlin film festival and was picked up for theatrical release. Already in 2014, the presence of a marginal documentary—not to mention any independent film really—on the big screen seemed a thing of the past. Spectators had already moved on decisively from the shared, public experience of an hour plus narrative, seen—even dreamed—in the dark on an all-engulfing screen. We know that the average spectator for independent/auteur/cultural cinema has been steadily aging for the last fifteen years while the overall attendance has shriveled. We know that filmic narrative is now largely "consumed" on telephones and computers, on a tiny screen with drastically reduced potential for visual complexity, absorbed as a private, individual act.

Cinema as both a public and *cultural* spectacle (outside of the Hollywood blockbuster) is already an anachronism. But for someone of my generation, the magic remains in the metamorphosis of images captured small by a camera but destined to expand beyond life-size on the screen. This alchemical

transformation has defined cinema from its origins in the last decade of the nineteenth century up through the beginning of the twenty-first. It doesn't make what is done today inferior (although there's much to be discussed about limiting a film's language to close-ups and graphic images legible on a tiny screen) but it marks as significant a disruption (if not rupture) as the effect of photography's arrival on painting.

It's one thing to conceive images for people sitting in the dark next to strangers, absorbing without distraction larger-than-life moving pictures in an environment at once dreamlike and specifically communal and hence political. It's another to create images for a palm-sized screen that will be consumed with double irony: as pure individual choice, but utterly contaminated by countless other images—the surrounding subway car, a kitchen counter as you multitask, lying in bed next to a companion viewing their own interrupted and interruptible image stream.

This societal transformation (the ironyless "smartphone," computer streaming from the Internet while the computer holds dozens of other "windows" open and even visible) has already drastically altered how even big-screen-intended filmmakers compose within a frame and how they construct an audiovisual narrative.

What has, however, remained constant is the filmic dependence on movement. The word "cinema" itself comes from the Greek *kinesis*, or motion. Movement has lain at the heart of cinema from the first Lumière films of moving crowds and trains seen from a fixed tripod to what should now be called simply an *audiovisual gesture*, including the frenetic, space-defying drone contortions of commercial spectacles.

It was Orson Welles (him again!) who said that what "separates the men from the boys" among directors is the ability to pull off a successful tracking shot. This dime-store machismo associated with the (all-too-phallic) camera was not accidental. Before the lightweight cameras of the 1960s that allowed for handheld camera movement (generally actually perched on a shoulder) and before the digital-mechanistic innovations of the last thirty years that have made any movement imaginable possible, to move the camera itself required prodigious forces (not to mention time and money). The tracking or dolly shot, in which a camera atop a wheeled vehicle was moved along guide tracks by powerfully built, highly skilled artisans—called dolly grips—required significant planning, hours of preparation, and hours for the execution of a single shot. But the scale of the operation was commensurate with the

scale of the ambition and the scale of the final images perceived by an audience.

Before I arrived at a more humble (mature?) notion of what constitutes mise-en-scène, I was under the Wellesian spell. But perhaps more than Welles's gargantuan feats of spatial redefinition (in depth, breadth, and height), I was enchanted by the lyrical flights of motion whimsy of the great European master Max Ophüls, a Mitteleuropa Jew whose career spanned the Germany of the 1930s, America of the 1940s, and France of the 1950s. Ophüls's perpetual visual fluidity, little kinetic gems that stud his films, was always movement that mirrored his characters' charm and delight in discovering the world around them. Far from the Wellesian imperative of movement as a macho domination of space and assertion of ego, Ophüls's balletic, kinetic camera is a source of enchantment and a revelation of space as character, especially in his masterpieces *Le Plaisir, La Ronde,* and *The Earrings of Madame de...*

But Welles's crack about a successful dolly shot as a marker of adulthood lingered in the back of my head as I prepared my second fiction film, *Signs & Wonders.* It felt like a rite of passage to try to master the camera mounted on wheels, pushed on a track. Doubtless the choice of Giorgos Arvanitis as director of photography was as inspired by his long association with the master filmmaker Theo Angelopoulos as by

the setting of Greece for the film. Angelopoulos was the prolific creator of the longest-lasting, most complex, and serpentine tracking shots in the history of cinema. Especially in the last half of his career, which stretched from the 1960s to his death while filming in 2012 (hit by a motorcycle on an Athens-Piraeus highway), his baroque obsession with the limits of narrative movement were often impossibly self-conscious and tortuous. But the *kinetics* of *Kinema* found a sublime purity in his 1975 masterpiece *The Travelling Players*. In a style worthy of Bernini, he "condensed" fifty years of twentieth-century Greek history into four hours of mesmerizing ten-minute-long tracking shots.

Throughout the filming of *Signs & Wonders* I concocted dolly after dolly with Arvanitis. But my anxiety grew as the movements became ever more tortuous, ever more unconnected to the intensity of feeling I was searching for. During the editing of the film, I systematically eliminated as many of these artificial conceits as possible. It might well have been proof that I failed Orson Welles's test of manhood, or it simply might have meant that it was as unnatural for me to compose film language with conventional tracking shots as it would be to have written this book in iambic pentameter. (Yikes!...it could get worse...)

———

HOWEVER...in the spirit of the natural winegrow-
ers, I don't consider any of my positions ideologi-
cally determined (which could be nothing more
than proof of deep hypocrisy, of course). So in my
second-to-last film, *Rio Sex Comedy*, the prologue is
defined by a very long, very complex tracking shot.
To introduce Charlotte Rampling's character, a
British plastic surgeon in Rio, we accidentally stum-
bled on a four-hundred-foot tracking shot that lasts
two minutes. Had I learned nothing from *Signs &
Wonders*? At the very least I can say that this tracking
shot was diametrically opposed to the ornate, self-
conscious shots that I had fabricated with Arvanitis
and his dozens of assistants in Athens. In fact, the en-
tire shoot of *Signs & Wonders* felt oppressive, because
the film's relatively large budget meant that there
would always be fifty or sixty people on set, making
it difficult for me to find the desired intimacy and
immediacy with the film's protagonists, played by
Stellan Skarsgård and Charlotte Rampling.

So after the liberating experience of *Mondovino*,
a documentary that I shot alternately by myself and
with the help of a single friend scouring the globe,
and after subsequently meeting many natural wine-
makers, I knew that I was most interested in acts of
spontaneity and surprise for the new film in Brazil.

*Rio Sex Comedy* was conceived from the start as
an incubator for improvisation. With several close

actor friends, including Charlotte Rampling, Fisher Stevens, Irène Jacob, Burgundian winegrower-actor Jean-Marc Roulot, and later Bill Pullman, we decided to form a cooperative in which everyone became a coproducer, receiving shares in the film, identical salaries for all the principals, and a commitment to performing their work as artisanally and autonomously as possible. For the actors, this meant doing their own wardrobe, hair, and makeup, while the technicians relied less on specialized assistants than is customary. In this way we were able to establish a sense of egalitarianism with the minuscule squad (rarely more than a crew of eight on set as opposed to the sixty or so people on *Signs & Wonders* and countless other films). The actors were free to interact spontaneously with the surrounding "documentary" life of Rio that we all wanted to seep into the film. We were also able to shoot for five months instead of the standard month and a half, giving ourselves the luxury of time that even few Hollywood blockbusters have, at a total cost lower than a single one of their shoot days.

It was in these circumstances then that I found myself caught up in a serpentine traveling shot that I nonetheless believed didn't betray my evolving notion of "natural" aesthetics. One of the principal locations was Santa Casa in downtown Rio, the oldest hospital in the Americas. It was here that

many scenes were staged between Charlotte and the real-life founder of modern plastic surgery, Ivo Pitanguy, mixing the lower-income patients seeking cosmetic surgery with actors in scenes that were semi-scripted but open to the surreal hazards of real life. On one particular shoot day we happened to finish very early. I was tempted to give everyone a half day off but I was reminded that the liberty we were searching for was precisely in making use of "free time," an almost unheard-of luxury for filmmakers. I asked Charlotte and Lubo Bakchev, the young Bulgarian-French cinematographer, if they wanted to improvise some shots that might serve as an opening credit sequence, taking advantage of our earned free time. They immediately said, "Of course." Lubo, who had shot several grueling, fascinating films for the Tunisian filmmaker Abdellatif Kechiche, was the rare cameraman who listens as much as he looks with his instrument.

I'd been eyeing an enchanted "oriental" garden in the courtyard of a wing of the colonial hospital: one of Rio's many improbable contradictions. Given that Charlotte's character in the film is a whimsical and subversive plastic surgeon who dissuades her patients from going under the knife, it seemed like a fertile ground to launch her into the film. But to arrive there you had to pass from the chaotic streets

of downtown Rio through a bustling reception hall and then into the garden. I suggested to Charlotte and Lubo that we try to invent a shot that could link the passage from reality (ours and the others') to whimsy, allowing the unscripted passersby to dictate our rhythm.

Dressed in a fantastic flowing white robe that suggested something doctorly but that we'd chosen from her own wardrobe back in Paris, Charlotte said, "Why not?" Lubo returned her smile with a nod and strapped on his Steadicam vest with an arm and a gyroscope to which the camera is attached. Given that we were in a no-man's-land in many senses, this contraption would allow us some of the spontaneity of documentary shoots, but at the same time provide a more graceful, dollylike movement if strapped onto the right cameraman. Above all, it would leave Charlotte and Lubo free to dance among the crowds with autonomy, once I'd sketched out the route. In fact, as I followed on the video assist (occasionally I yielded to that hypocrisy too!), it became clear that Lubo was painting the space with his camera in an intuitive dance with Charlotte. The Robocop and the enchanted maiden (as enchanted and maidenlike at sixty as anyone a quarter her age) somehow swept through the halls of the working hospital not exactly unnoticed, but

unencumbered. They seemed to glide through the space, perhaps buoyed by the improbable shoot of the morning or the devil-may-care attitude that they were working without time or organizational or financial pressures. Charlotte climbed the exterior grand staircase like the daughter of the British military man that she is and then slipped through the outer hallway into the main lobby like a gleeful spy. Lubo followed at first at a discreet distance but gradually he swept closer to her as she changed the cadence of her step, more in tune with Rio's slouching rhythm. Sidestepping the patients, doctors, nurses, and peddlers, they headed for the garden, with its double-sided staircase descending on opposite sides. As Lubo got near Charlotte, she accelerated her step and descended the left staircase. At the last second, he shifted and went down the right staircase, creating an unexpected opening of the filmed space in a vertiginous countermovement. I followed behind, a spectator drawn to this ever more hypnotic dance, half an eye on the monitor and half on the actress, conscious that in this instance, the camera can express as much emotion as the actor's movement. The beauty and simplicity of their actions, as well as the surreal spectacle unfolding in the middle of a working Rio de Janeiro hospital, seemed improbably natural. Both to the makers of the fiction and to those living their lives around us.

Like all great actors—whose principal grace is their ability to respond immediately with every fiber to the surprises—Charlotte sensed the waltz was on. And took it to the next level. At first there were little flitting movements of her feet. Then, as if listening to some silent music provoked by Lubo and his camera, she began to sway and dance in earnest to an invented, enchanted rhythm. Lubo, the filmer-listener, was able during the next minute (an eternity for a traveling shot) not only to accompany Charlotte's spontaneous flight of dancing fancy but to find an unshowy but equally vital visual response to her call.

That they finished together in an ironic two-step around a statue of the Virgin Mary in the center of the garden seemed somehow logical.

We did at least five takes and I eventually edited several together, but it was the first take by far that dominates, because it contained the magic of discovery, almost uninhibited by the human hand. Or at least uninhibited by the director.

If I'm proud of this shot, it's not the pride of the creator, because it's only glancingly my own work. Rather, I feel closer to Giovanna Tiezzi's conception of authorship, refusing the word "winemaker," preferring instead to see herself as a kind of midwife.

———

EVERY DIRECTOR of course has his own conception of what constitutes mise-en-scène, the craft of directing, just as each winegrower has his or her own personal response to the land, the plant, and the cellar.

Certainly there are common principles among natural winegrowers, but not a single natural wine resembles another. For me, there's more diversity within the 1 percent of the world's natural wines than there is among the 99 percent of the others.

As we've explored in previous chapters, a wine's vitality depends on a natural fermentation provoked by the complex yeast population spontaneously present. The moment of fermentation (of any kind) is extremely delicate. High-risk. If the ambiance in the cellar (or on the set) is artificial, manipulated, fake, then it's unlikely the grapes will reveal the deeper aromas of the terroir.

What will an actor be able to reveal of himself if the ambiance on set is subject to power games, excess ego, excess money, excess reliance on technology? Though of course not everybody films like John Cassavetes, who did everything possible to make the actor's emotional experience as visceral as possible, who sought to let each actor on his sets share their deepest feelings and fears in a spirit of total complicity.

Stanley Kubrick, another towering genius in the history of cinema, is a complete counterexample.

His modus operandi consisted of humiliating each actor he worked with, making them feel as miserable and alienated as possible. His cruelty was legendary.

I remember spending a few days with the Croatian actor Rade Šerbedžija in 1998 when we were considering working together on *Signs & Wonders*. He'd just finished a half year shooting *Eyes Wide Shut*, Kubrick's last film before his death. I remember the look on Rade's face as he told of harrowing experiences on the set (eyes wide open) that he and Tom Cruise were equally subject to (which I guess is a form of democracy). For a scene with barely a word of dialogue and simple actions, Kubrick had made them do seventy-five takes, seventy-five repetitions of the same action. Without ever explaining what wasn't right with the earlier takes. On most films, two to five takes are standard, with some directors pushing the occasional angle in a scene to nine or ten. After that, most actors will rebel. Seventy-five takes—especially for a non-critical scene—is unheard of. Cruel and unusual punishment. Rade said Kubrick often directed from his dressing room, speaking to them on a loudspeaker (in stark contrast to the Kazan-Penn-Cassavetes practice of keeping everything as tactile as possible). Kubrick would drop a laconic "Another take, please" over the intercom. According to Rade, neither he nor Cruise could tell the difference between the second and the seventy-fifth take.

While one can question the ethics of his behavior, Kubrick has managed to use this alienating method of directing to create works of a profoundly disquieting humanity, from *A Clockwork Orange* to *Barry Lyndon* to *The Shining*. *Eyes Wide Shut* is a masterful meditation on late twentieth-century existential unease, making Antonioni's midcentury ruminations on the same theme feel gentle and folkloric in comparison.

This also explains Kubrick's perverse choice of actors for whom he had an undisguised contempt, from Ryan O'Neal in *Barry Lyndon* to Tom Cruise in his last film. Ironically, Kubrick's Sadean methods produced an effect of unmasking, revealing hidden areas of the psyche that the warm and intimate style of Kazan, Penn, or Cassavetes also sought.

So, in radically opposed styles they each arrived at a revelation of the unconscious nature of the actor. One through an undeniably grotesque abuse of his power. The others through the sometimes no less treacherous and manipulative technique of seduction and tenderness.

In both ways—in any way—spontaneous fermentation is possible.

><

# The Grail of Authenticity

THE WORD "AUTHENTICITY" long ago fell out of fashion. It has been pillaged by all the most treacherous political forces. Some have used it as a reactionary bludgeon, in the defense of an odious notion of purity. For others authenticity is simply an obstacle to economic development that relies on mass reproduction and the marketing and mendacious valuation of a product. Without any inherent profit value, authenticity has been a dead weight in industrial and postindustrial societies, where finance reigns supreme. How could a banker who speculates on fictitious derivatives possibly ask himself the question about the authenticity of his nonproducts?

A society devoted to the consumption of objects and foodstuffs that are increasingly artificial, as far removed from our biological or spiritual needs as possible—but now embedded in our psychological

ones—has no place for authenticity. Unless of course it's invoked as a marketing strategy.

What was the final nail in the coffin of this Homeric ideal of authenticity (primitive in appearance but like most notions sung in the eighth-seventh-century BC poems, at the heart of Western civilization)? Both the nail and its hammer have been blithely provided by the clueless double agents of postmodernism, in their taste for intellectual gamesmanship, in their insistence on form as sole substance, in their relentless desubstantiation of all things.

GIAN LUCA FARINELLI, director of the Italian national cinematheque in Bologna, told Giovanna Tiezzi that "the most radical quality in today's society is sincerity."

But during the filming of *Natural Resistance*, Farinelli also pointed out the pitfalls of attaching oneself too vigorously to any single definition of authenticity. While discussing with Giovanna why her wines at Pacina are refused the DOC certification of "authentic Chianti," even though they're among the last Chiantis with a tangible trace of their real history, he warned that "history is never fixed. There are no absolute cultural truths because culture is in a perpetual state of change."

Certain tribes were able to preserve their cultural gestures over centuries, even millennia, when they had limited contact with any outsiders: the less exposure, the more intact the language, reflexes, behavior. But in the West, there's nothing but a long history of contamination and cross-pollination. As Thomas Hylland Eriksen points out in his book *Overheating: An Anthropology of Accelerated Change*, a rueful rumination on the intersection of globalization, national identity, and ecological collapse, the notion of the loss of authenticity in anthropology was already a concern of Bronisław Malinowski over a century ago.

So any notion of authenticity is extremely thorny. It could even be called an intrinsic oxymoron. It can be used as a nostalgic evocation of a mythical past or as a vector of sustainable progress. Like many people of my age, I feel like a witness to the end of the last traces of the recognizably authentic: a preoccupation shared by every generation for at least the last ten thousand years! Indeed, every generation has decried the loss of authenticity. Columella, in his first-century AD treatise on agriculture, reports how even peasants of his time bemoaned the indelible loss of the climatic conditions of their youth.

But there is a critical aspect that distinguishes an early twenty-first-century lament from any other. The rate of change has itself changed at an

exponential rate since the beginning of the Industrial Revolution, itself now exponentially redoubled since the dawn (or eclipse) of the digital one. The disappearance of nutritional value from foodstuffs is not a nostalgic illusion.

THE WINES made in Burgundy two hundred years before the birth of Jesus, the wines made by the Romans in subsequent centuries, and the wines said to have enchanted Charlemagne up through those made by the dukes of Burgundy in the Middle Ages certainly were all very different from one another. And the medieval beverage cultivated by Cistercian monks, through the celebrated wine made for the princes of Conti in the seventeenth century, through to the legendary Romanée-Conti made by Aubert de Villaine today, are also undoubtedly distinct in style, flavor, texture, cultural meaning. No one could say precisely what the differences might be, but what we can be sure of is that the transformations occurred over centuries. There had been an evolutionary curve in the taste and cultural conception of the same wine that had quietly accompanied the arcs of men's lives over several millennia. Time itself was inscribed in the wine just as wine inscribed itself in time. "Cultural time" accompanied the time of a lifespan. One wasn't born with

one set of perceived truths to die with a complete set of opposing ones. With a slower evolution, one lifespan was rarely enough to exhaust the wisdom of a craft.

In our era, a violent rupture has been created, bringing fundamental changes not across three or four generations but repeatedly in a single one. In the beginning or middle of an apprenticeship. We live in a technological world where children now teach adults, flipping the historical *and* biological order of transmission. And it seems more than likely that phenomenon will only intensify, as Giovanna Tiezzi's father, Enzo Tiezzi, professor of chemistry and physics, foresaw in his description of the collision between the biological time of the planet and its creatures (including humans) and the historical time imposed by human will.

## Authenticity and Ethics

With natural wine, as with all cultural gestures, it's not enough to speak of the sincerity of a gesture. Even if we accept that sincerity itself has now become a radical quality. Because sincerity concerns only the person accomplishing the gesture. It can be measured only against itself. One can be sincere in all things and at the same time completely mistaken

and unjust. On the other hand, if one is sincere and one takes into account something which exists outside the self, that constitutes the "other"—say, nature for a winegrower or the reality of what is filmed for a filmmaker—and if one integrates that with one's own sincerity, then the question is no longer moral but ethical. It becomes an encounter with the other within oneself. An ethical gesture by its nature fuses intellectual elaboration and a spontaneous sincerity, because the ethical quality of a gesture is generated by the fusion of a social context and a personal intention. Ethics presuppose an encounter between subjective sincerity and a collective or "objective" reality that is shared by many.

One can't make a wine with only the self. One cannot create an authentic wine sui generis, in one's own image, like a painting by Caspar David Friedrich, for instance. No wine can exist without a respect for an alterity, an otherness within. One can't make a film by oneself (although the phenomenon of selfies is an ethics-defying flirtation with just that!). Gritty documentary or baroque fiction, a film extracts its substance from filmed "reality."

It becomes important therefore to distinguish between a moral authenticity and an ethical one. A moral authenticity would lead us to make an ideological wine, based on the assumption of a "universal truth" and the application of a formula. In

that case we wouldn't be far from the notion of "purity," from religious dogma, always a dangerous position.

There's no question that some natural winemakers among those who espouse a return to "authenticity" are engaged in this kind of self-defeating moral mission. They affirm that a wine can't be natural unless it is 100 percent free of any added sulfites. They wish to impose strict rules that guarantee the absolute purity—virginity really—of natural wine. Even if it means losing sincerity and losing a personal relationship to one's own taste. Preferring dogma to personal choice.

In cinema, the parallel with the Scandinavian movement Dogma 95 (no matter the intended irony) is clear. Founded by Danish showman Lars von Trier in 1995, it obliged its signatories (including Thomas Vinterberg, who later gravitated to Hollywood) to pursue the notion of cinematic purity. The list of outlawed actions during filming and editing to ensure an anti-Hollywood "authenticity" was long. Though only variably respected, many of the films generated tangibly counterfeit images, where the "real" was nothing more than an aesthetic posture. There is one film, though, that I adored from the time it came out and that seemed a daring commentary on the movement itself. *The Idiots* for me is Lars von Trier's most convincing film, because it's

the only one where I feel he's not hiding something (well, actually almost everything). The film shows us a group of marginals, bohemians, troubadours in a way, who create a series of outrageous provocations in a small town, lying, cheating, conning, using their own capacity for fraud to induce others, the innocents, to reveal their "truths."

Intrigued by the potentially autobiographical implications of the film, I asked our mutual friend, the actor Stellan Skarsgård, to ask Von Trier if the film was fundamentally about himself. Six months later I got a call: "Hi, it's Stellan. I'm in the Copenhagen airport. I just spent a half hour in a taxi with Lars. I asked him your question." There was a pause. "And so?" I asked. "Well, he didn't say anything. But he didn't stop laughing for five minutes."

Unlike a "moral" wine, a wine that is the fruit of an *ethical* authenticity cannot, by its nature, be ideological, or constrained by dogma. It might include low doses of sulfur if a winemaker considers it necessary, in the pursuit of a balance between his personal convictions and concern for the health and aesthetics of others. While a moral posture exonerates the subject from self-reflection by imposing a purity of behavior, an ethical one invites him to question concrete reality, to engage with "the other," not by deathly certitudes but by more vivifying interrogations.

By respecting the other, a winegrower necessarily develops his own subjectivity, inviting the drinker to do the same.

In the deconstructionist revolution as practiced by intellectuals and artists surfing on the wave of French theory that started more than forty years ago, concrete reality has been consistently derided as a pure illusion. The "other" was simply denied. As for the bankers, their abandonment of common reality in the construction of conceptual finance, "algorithms *über alles*" in order to enrich themselves, necessarily crushed all others, creating misery for millions of people in every country in the world, real-life victims of their virtual speculations.

Finance and the plastic arts both have speculated on themselves. But this phenomenon extends to many disciplines which have fallen back on themselves, on a self-reflexive mission that is equally derivative, abstract, and deconstructed.

In the world of industrial wine (99 percent of existing wines today), it artificially reproduces the artisanal gesture. This is visible in the posture of the great enologists who have imagined themselves the masters of nature. With their scientific power, technology, and chemical arsenal, they have created a beverage, a speculative derivative of wine. What is left in the bottle after all those interventions and

exclusions is nothing more than the "me" that made it. The self, bottled. A liquid selfie.

Instead of the industrial discourse of wine that only speaks about itself *as* wine, an object in and of itself, natural wine doesn't propose a discourse about wine but about human relations and man's relation to nature. It's not wine that speaks about wine but wine that speaks about its "other": nature.

⋈

# Entropy and Its Discontents

WHOEVER has no solid scientific training—the vast majority of us—is entirely at the mercy of the mechanisms that allow the dominant ideology—the theology of science—to control our lives. In the productivist-consumerist societies, corporations (national, multinational, transnational) have replaced states. Science and technology are the motors of their power. That power is concrete and empiric in the production of goods and services, symbolic in the moral ascendance that science has taken over all ontological questions. Equally dangerous is the extreme compartmentalization among scientists, a "divide and conquer" culture that defines every aspect of our world. In this way scientists themselves, even those with the noblest intentions, are unable to defend themselves from the manipulation of their work if they're not armed with a rigorous

philosophical, historical, and aesthetic training that can allow them to place their ambitions and their specific scientific research in a larger cultural context.

When *Natural Resistance* was presented in Milan movie theaters, several of the winegrowers from the film joined me for a public discussion at the agronomic school at the University of Milan with Professor Lucio Brancadoro and several of his colleagues. The debate that unfolded, before the watchful eyes of a hundred or so students at what is considered Italy's leading center for agronomic studies, felt more like a thirteenth-century theological debate than a scientific seminar. On the one hand there were the dogmatic defenders of the faith—or at least the institutional incarnation of its power—and on the other were the self-doubting humanists trying to question all dogmas. My reading of who was who was clear. But doubtless for many students, the fanatics were the natural winegrowers and their clueless cinematic ally. What is certain is that the academic defenders of purported scientific objectivity treated Stefano Bellotti, Corrado Dottori, and Stefano Borsa with a contempt and a ridicule that I found shocking. Brancadoro and Osvaldo Failla encouraged the students to laugh at "the sorcerers and voodooists and their biodynamic cult." In a scene that I saw repeated from Pisa to Parma to

Ancona during the film's release in Italy, the professors launched a frontal attack on the growers, never doubting that chemical agriculture is the only solution for all of the world's alimentary problems. They denied any link between cancer and pesticides and any danger in the use of the herbicide glyphosate (legalized by the agrochemical-industry-friendly European Union despite some member country bans). Failla even asserted that global warming represents no possible threat for the planet. Their open mockery of the three natural farmers on the stage before them made it clear to the students that the debate was between a return to ignorant peasant superstition versus scientific reason and progress.

But Corrado Dottori remained remarkably cool. Having graduated from the most prestigious business school in Italy, Milan's Bocconi, he was well prepared to joust in this urban arena. He turned to the students and asked them simply, "How many of you here have studied the history and philosophy of science?" A long silence followed as he waited for even one raised hand. Then he added, "How many of you have been asked to question scientific methods by studying philosophers of science like Karl Popper? Please raise your hand." Another long, motionless silence.

I asked Professor Failla later about the source of financing for most of the university studies in

agronomy. He hesitated. Then he turned nervously to the students (who likely had never been led to ask that question) and then back to me, conscious that I was now filming the event (I later turned it into a thirty-minute short called *Desistenza a Milano*, or, roughly, "Giving up in Milan"). "Is the financing mostly from the government?" I asked. "Well, no...I couldn't say that. For a long time now, there's been little public money available," he mumbled, not looking me in the eye, in contrast to his previous bravado. "Where does it come from then?" He began to fidget and then let out oh-so-quietly: "The private sector." "The private sector? Who exactly?" I asked. I wondered if the students in the back rows heard the names: "Bayer, Monsanto, Novartis..."

ENZO TIEZZI, the free-thinking chemist and physician at the University of Siena previously cited in this book (and father-in-law of Stefano Borsa, who had attended Milan's school of agronomy only to repent a few years later when he fell in love with Giovanna), was well aware of this problem. Over twenty-five years ago he wrote his scientific, civic, and humanist masterpiece, *Tempi storici tempi biologici* (Historical Time, Biological Time). In the book he warned against the dangers of ultraspecialization, simply stating that the loss of diversification leads

inevitably to entropy: "superspecialization also sig-
nifies the loss of the interdisciplinary culture, the
fragmentation of knowledge."

Born in 1938, he came from a scientific culture
that stretched back to the Greeks, a culture that in-
sisted that it was as important for scientists to know
Homer and Dante as the laws of thermodynamics.
In exploring the potentially mortal gulf between
the actions of humans and the movements of nature,
Tiezzi asks us to consider that "all human actions
are subject to the iron law known as the Second
Principle of Thermodynamics or the law of entropy,
which establishes that all energy inexorably moves
from a form of usable energy to an unusable one and
that all human activities (especially those that create
order and organization) inexorably produce disorder,
crises, pollution, and, in the final analysis, the deca-
dence of the surrounding environment. The appro-
priate application of this law determines the quality
of our lives or the destruction of the planet."

Tiezzi continues: "The Industrial Revolution has
accelerated this process. Man has the power either to
accelerate even further the process of degradation
(in the search for profits, consumption, hegemony)
leading to the death of the planet in several decades
or centuries, or to slow down these processes to nat-
ural rhythms that will allow several million years
more of life for humanity and nature." Tiezzi goes

on to define one of the principal arguments of this book: "from a biological standpoint, we can certainly affirm that increasing the complexity of all relations and increasing genetic diversity signifies an increase in the stability of an ecosystem. Biological complexity is synonymous with stability. The technological capacities of man have created an artificial system. The potential modifications of nature are enormous. Generally these modifications translate as the destruction of biological species and of our genetic patrimony. The destruction of biological complexity makes the world vulnerable in all respects."

From this notion, Tiezzi elaborates his view of the two competing time frames:

*Humanist cultures (Marxist or capitalist) lack a fundamental parameter in their historical analyses: biological time. Both are "static" and extremely limited in their ability to project the future. Biological time is what we use to measure biological evolution, and its unit of measurement of the past is on the order of millions of years. Billions of years separate us from the origin of the earth; hundreds of millions from the appearance of algae, bacteria, and trilobytes, arthropods or fish; three million years since the appearance of man. But biological time is also what we need to measure the future of man, and the rupture of*

*biological equilibriums is now inducing variations on a planetary level in such a brief time frame that they are accelerating the geological clock. Transformations which used to occur over millions of years now can occur (because of the induced disequilibriums) over several decades. The subsequent variations for human and social equilibriums correspond to an acceleration of millions of years of history. That is: the biological and historical scales have become inverted, given that the documented history of man in relation to the history of the earth is infinitesimally small, like a static flash in biological culture.*

Tiezzi concludes, "for the first time a historian is bereft of the units of measure of the past and of the future that are needed to let us know what might happen to the human race."

This phrase has haunted me since I was given the book by his daughter, the winegrower Giovanna Tiezzi, two years after his death. What he has to say about historians, could it also be true of artists? Especially given that his daughter has become a natural winegrower, it's led me to thoroughly reconsider the cultural *and* revolutionary role of farmers in our society.

# Happy Ending

NAOMI KLEIN, in her important book *This Changes Everything*, published in 2014, explores the intersection between capital, the instrumentalization of science, and the potential apocalypse of global warming, writing that "the globalization of agricultural systems over recent decades is likely to have been one the most important causes of overall increase in greenhouse gas emissions," and has "far less to do with the debates about 'food miles' associated with imported versus local produce than with the way in which the trade system, by granting companies like Monsanto and Cargill their regulatory wish list—from unfettered market access to aggressive patent protection to the maintenance of their rich subsidies—has helped to entrench and expand the energy-intensive, higher-emission model of industrial agriculture around the world. This,

in turn, is a major explanation for why the global food system now accounts for between 19 and 29 percent of world greenhouse gas emissions." Three years after the book's publication, many climate scientists have revised that figure upward to at least 33 percent.

Given that viticulture has been in the avant-garde of agriculture for millennia, it would be a mistake to underestimate the significance of attacks by the agrochemical industry against the natural wine culture of rebellion. Today, the artisanal natural winegrowers—independent agents of both cultural tradition and nonindustrial innovation, a fecund and free modernity—are attacked by governmental institutions like the AOC in France, the DOC in Italy, and the FDA in the United States. They are under assault like the cheesemakers and cereal, vegetable, fruit, and livestock farmers who practice artisanal natural farming. Every day there are farmers whose ancestral savoir faire is confiscated or declared illegal. The case of José Munnix in Belgium is typical. After thirty years of activity, he was forced to close his cheesemaking operation in the town of Herve in May 2015. The entirety of his production, two thousand cheeses, was seized by the authorities. What was his crime? He continued to make cheese from unpasteurized milk, the way cheese from Herve had always been made, a key

element that had brought it renown. The war by pseudo-sanitary institutions throughout Europe and North America is violent. Under lobbying pressure from the largest industry operators, they're not content just to dominate the market but feel clearly impelled to eradicate even token alternatives.

In the case of natural winegrowers, they are compelled to defy norms established by industrial monoculture and industrial sanitary needs. In Italy, Stefano Bellotti in one year alone (2013) was levied with fines that totaled a ruinous 150,000 euros—nearly a third of his gross revenue—for everything from planting homeopathic peach trees among his vines, to a minuscule typographical error on a wine label, to a failure to produce an entirely sterile environment in part of his winery (the result of which—had he conformed—would have killed any chance of indigenous yeasts provoking a natural fermentation).

In France, Emmanuel Giboulot, a highly respected winegrower in Burgundy, was taken to court for refusing to use a toxic chemical insecticide on vines that he had painstakingly protected biodynamically for thirty years. Using isolated outbreaks of the vine disease golden flavescence as a pretext, the regional authorities demanded that every Burgundian winegrower treat his vines with a chemical insecticide. Many organic and biodynamic growers

purchased the chemical but then simply didn't use it, knowing that proof of purchase was sufficient protection from prosecution. But Giboulot was so outraged by the senseless decree that he decided to make a public stand. He was quickly charged by the regional government. The prosecutor asked for six months' jail time and a thirty-thousand-euro fine. But thanks to a public outcry that produced close to a million signatures worldwide and numerous newspaper articles describing the absurdity of Giboulot's plight, the prosecutor reduced his demands. Giboulot was convicted in early 2014, but he took his case to the court of appeals in Dijon and was fully acquitted in November of the same year, thanks to the independent superior court magistrates.

But even this didn't stop the authorities the following spring, when they prosecuted Thibault Liger-Belair for the identical reason they'd gone after Giboulot. Liger-Belair was also acquitted, but notice was served that refuseniks would be harassed. Olivier Cousin in the Loire was also prosecuted and fined the symbolic sum of one euro by regional judges for insisting on including the region of origin of his sublime and authentic Anjou. The case was in fact brought by the AOC, the very body meant to protect authenticity, but determined only to defend the industrial-chemical travesties that are marketed as legitimate.

Theirry Puzelat, a friend of Cousin's and colleague from farther east in the Loire, explains it this way: "because of all the media attention in the last few years, natural wine now pisses off a lot of official, powerful folks. They feel compelled to attack the legitimacy and authenticity of natural wine because it represents a clear threat to their illegitimacy. Judicial examples will be made!"

In the desire to protect natural winegrowers, the influential French blogger and writer Antonin Iommi-Amunategui has published a *Manifeste pour le vin naturel* (Manifesto for Natural Wine). He argues that "an official natural wine is necessary so that the rest of the agricultural food chain and society at large can perceive the shock of the new and seriously question their practices." He adds that "the battle for the official recognition of natural wine is in fact a key for unlocking other things because, as the Comité Invisible write in *To Our Friends*, 'all insurrection, no matter how local, contains the seeds of a global one.'"*

But in defining natural wine as a product, in focusing on its composition and techniques, he remains in an idiom that the agro-alimentary industry understands and can easily misappropriate. The marketing of a token amount of industrial perversions of

---

* Author's translation.

biodynamic or "no sulfite" wine from massive industrial producers like Zonin in Italy (five thousand bottles out of 50 million) or Gérard Bertrand in France is proof enough. Loire Valley pioneer Thierry Puzelat proposes to displace the argument from the product to the methods of production:

> I was completely against a strict label or precise parameters along the lines of organic farming because I know that can be recuperated quickly by the world of supermarkets and industrial copycats. Because Mr. Carrefour will always be able to imitate the definition of any product. So I think natural wine should be inscribed within the gesture of peasant, artisanal farming. By all means demand rigorous controls over ingredients (or lack thereof) and certain techniques. But that's not enough. There should be a social, political, and economic context which describes the nature of a family-run farm of limited (nonindustrial) dimensions. That said, there are few agricultural products that will allow a family to live decently cultivating a small or even medium-sized farm. With wine however, we've proved that you can survive, even thrive, with dignity on a small scale, with as few as five hectares. That can become a beacon for a different model of farming, the scale adjusted to each kind of agricultural activity. It's the only future possible anyway: putting an end to vast and concentrated

*monocultural plantations and dividing land use more equitably. To limit the size of a farm, to give value to the social aspect of a family farm instead of a technique, to be able to certify the peasant, familial, artisanal origin of the product are all ways in which we can do away with the cult of the speculatory "product" and focus instead on the purely social gesture anchored in a specific culture. It's this that no industry can ever reproduce.*

I don't think any filmmaker, writer, researcher, teacher, artisan, artist, or anyone who believes in the need for cultural vitality—who wishes for freedom from consumer fetishism—could fail to find value in Puzelat's words.

Natural winegrowers have had to confront the so-called conventional world of wine, made toxic by the cult of the product and its unfettered addiction to chemicals and to the pursuit of power. They have been denounced by the most powerful and industry-friendly wine critics in every culture. From Robert Parker in America, who wrote plainly that "natural wine is a fraud," to the French Parker-wannabe Michel Bettane, who has been equally vitriolic in his denunciations of the perceived threat to his long-cultivated status as (chemical) wine guru, to the Italian coconspirator of the Berlusconi-era homogenization of Italian wine, the

*Gambero Rosso* guide. Where natural wine proposes a discussion about the ethical, cultural, historical context of wine, leaving subjective aesthetics as an afterthought, an alternative, more democratic blogosphere has certainly been established.

However, it's worth noting that as some of these dissident, free-spirited bloggers have accrued greater notoriety within the natural wine world, there are unsettling signs that a few voices are turning just as narcissistic, self-aggrandizing, and commercially opportunistic as their industrial-chemical brethren.

What is certainly the most significant safeguard against the creeping me-ism of the critics' discourse is the fact that the natural winegrowers themselves go around the world speaking articulately about their work themselves, and many of them have blogs in which they find no need for pseudo-journalistic "wine writer" filters. Corrado Dottori not only maintains a much-followed online diary called "La Distesa," but he's written one of the most moving books about wine, *Non è il vino dell'enologo* (Not an Enologist's Wine), for an Italian publisher who has also brought out his first novel, *La musica vuota* (The Empty Music). Many natural winegrowers are as articulate about the context of their work as the work itself.

The egalitarian tactics of Occupy Wall Street and Los Indignados in Spain—in which they sought

to defy conventional hierarchies, diminishing antagonisms and *protagonisms*—have, alas, remained a utopian ideal. They and other movements have failed to find a concrete, real-world realization of their ideals.

Natural winegrowers, however, suggest a vital counterexample, patiently building a global structure that is empirical, ethical, and celebratory. Above all they've demonstrated that their precise pragmatism can be expanded not just to all agricultural activities but to the culture at large, in its deepest, most magical and reparatory meanings.

The natural wine movement has also proven a success even by the barbaric parameters of the consumer society. In a decade, Paris has gone from two natural wine bars to over 350 listed on a single Web site. Between 2004 and 2016, Japan went from one importer of organic wines with a few tentative natural entries to over twenty importers who bring in exclusively natural wine. London, New York, and elsewhere follow suit. A decade ago, natural wine was either unheard of or suspect to most people who drank wine. Today there are tens of thousands of importers, distributors, wineshop owners, and restaurateurs across the globe that dedicate their urban lives to passing on the fresh news from the countryside. Many of them are reconverted artisans from purely urban cultural fields.

Of course there are frauds, hucksters, people in it—winegrowers like wine floggers—doing it out of opportunism or cynicism, but what is amazing to me is that these con men and (fewer) con women seem comparatively scarce when considering every other human activity. Still, the corruption of loftier goals is never far from any human endeavor. Especially if one considers the situation in New York, for example. While a winegrower in the Jura region of France might decide to set the sale value of his wine at, say, ten dollars, by the time it reaches many a Williamsburg hipster wine bar, it might cost ten times that. Who's to blame? Everybody (except for the farmer)...but the question to ask in that case is less about natural wine I think, than about the obscenity of what it means to do business and share culture in New York City in the second decade of the twenty-first century.

But if one leaves aside (or actively tries to puncture!) the bubble of the contemporary American megalopolis, there is ample reason to take heart. That a global community has sprung up and thrived that fuses urban with rural, pursues at least the ideal of our better instincts—biological, animal, ancestral, but also political, communitarian, cultural, and ethical—and dares to defy convention with joy and simplicity, should be a source of inspiration and optimism for all who are outraged by the status quo.

Without a radical (that is, rooted) response in all cultural activities, there can be no profound change to the society we live in. And therefore no hope for the long-term survival of the species. How is it possible anymore for anyone to think otherwise? Even the hyper-privileged (by virtue of either their talent, their birth, or their circumstances), those who currently milk the system for their (pasteurized) gain, can't escape the knowledge that they are the principal agents of our collective suicide.

In each cultural sphere, it has become necessary to invent not just new forms but new systems of production, exchange, and rewards in an expression of completely equitable commerce. In each field—publishing, film, plastic arts, teaching, journalism, music, dance—there could be a complete renewal, exercised with the same courage and ethical backbone as in the natural wine world.

Given the obscenity of exploding global inequality and the consequent threat of ecological apocalypse—and its corollary detail of the disappearance of all traces of human civilization—it's easy to feel defeated. What should be heartening, however, is that even within a society where the odds are so stacked against any idealistic venture, natural winegrowers provide a gleeful, unbombastic counterexample.

The premise of this book is that our profoundly deruralized society has forgotten a simple truth; that it's not coincidental that ten thousand years of human civilization have run concurrently with ten thousand years of agricultural activity. And no matter how barbarous much of our history is, with the exception of a tiny fraction of that time scale, there has been some form of equilibrium between the two.

In the subsoil of our devastated contemporary chemical landscape—nature's archive of our collective history now deprived of its mineral memory—it could seem quixotic that these natural winegrowers continue to plant their minuscule but dynamic and deep-rooting seeds.

They confront a society that seeks only what is efficient in its conversion to profit, what is disposable and replaceable, what is artificial, where science is disconnected from wisdom and conscience. A society as dedicated to eradicating life as propagating it.

They have confronted their own world of agriculture, a land crushed as if in a totalitarian regime by the transnational megaliths practicing the law of the strong, the principal agents for the murderous abuse of scientific ethics. They have confronted their own craft, the world of wine, transfigured by the mechanisms of big agro on the one hand and

disfigured by the cultural lies of the consumer society of the spectacle on the other.

And yet in a joyous and pacific but unquestionably insurrectional fashion, they fight. They struggle so that agriculture can once again become culture, what it had been until the era of chemical warfare, speculatory financial orgies, and the anthropocentric arrogance of man as "artist."

Natural winegrowers of course are ecologists in their relationship to *nature*, but they are equally ecologists in their consideration of *culture*. And this should give us all at least a fragment of hope for the future of the two sisters, culture and nature: twinned in our youth, twinned, let's hope, in our future.

# Acknowledgments

Great thanks to Judith Gurewich, whose unflappable conviction and infectious good cheer have made a much-improved English edition of this book possible. I'm also indebted to all the winegrowers cited in this book and many of the filmmakers. The research, companionship, and continuous sparring with Olivier Beuvelet for the original version were invaluable. Many thanks to Juan Pelizzatti and Matteo Acmè for their simultaneous work on the Spanish edition and their cover design, and to Alexandra Poreda in the US, Ilaria Bussoni in Italy, and Deborah Kahn-Sriber and Manuel Carcassonne in France for their editing prowess.

I'd also like to thank the late Stefano Bellotti, inspired poet of the earth, who changed many lives and many plots of land for the better, including mine.

# Winegrowers Cited

Amoreau, Jean-Pierre. *Château Le Puy*, Saint Cibard, France (157, 158).

Aubert, Elodie. *Le Clos des Cimes*, Mérindol-les-Oliviers, France (152–153).

Barber, Caleb. *See* Heekin, Deirdre.

Bellotti, Stefano. *Cascina degli Ulivi*, Novi Ligure, Italy (157, 160, 179, 180, 247, 274, 282).

Borsa, Stefano. *See* Tiezzi, Giovanna.

Breton, Guy. *Domaine Guy Breton*, Villié-Morgon, France (169).

Cornelissen, Frank. *Azienda agricola Frank Cornelissen*, Solicchiata, Etna, Sicily, Italy (203–209).

Courtois, Claude. *Les Cailloux du Paradis*, Soings-en-Sologne, France (63, 169).

Croft, Vasco. *Aphros Wine*, Arcos de Valdevez, Portugal (157, 159).

Dard, René-Jean. *See* Ribo, François.

de Grazia, Marco. *Tenuta delle Terre Nere*, Randazzo, Etna, Sicily, Italy (205, 206).

# Directors Cited

# Films Cited

*Alice in the Cities* (Wenders)
*The American Friend* (Wenders)
*Andrei Rublev* (Tarkovsky)
*Barry Lyndon* (Kubrick)
*Bonnie and Clyde* (Penn)
*Citizen Kane* (Welles)
*The Earrings of Madame de…* (Ophüls)
*8½* (Fellini)
*The End of Violence* (Wenders)
*Eyes Wide Shut* (Kubrick)
*The Godfather* (Coppola)
*The Idiots* (von Trier)
*Kings of the Road* (Wenders)
*La Dolce Vita* (Fellini)
*La Ronde* (Ophüls)
*La Strada* (Fellini)
*Le Plaisir* (Ophüls)
*Little Big Man* (Penn)
*Luci della varietà* (Fellini)
*MASH* (Altman)

*The Mirror* (Tarkovsky)
*Mondovino* (Nossiter)
*Natural Resistance* (Nossiter)
*Night Moves* (Penn)
*The Nights of Cabiria* (Fellini)
*Nostalghia* (Tarkovsky)
*On the Waterfront* (Kazan)
*Paris, Texas* (Wenders)
*Pulp Fiction* (Tarantino)
*Reservoir Dogs* (Tarantino)
*Resident Alien* (Nossiter)
*Rio Sex Comedy* (Nossiter)
*The Sacrifice* (Tarkovsky)
*The Salt of the Earth* (Wenders)
*Searching for Arthur* (Nossiter)
*Signs & Wonders* (Nossiter)
*The State of Things* (Wenders)
*Sunday* (Nossiter)
*Taxi Driver* (Scorsese)
*The Travelling Players* (Angelopoulos)
*Until the End of the World* (Wenders)
*Wings of Desire* (Wenders)

# Select Bibliography

Assouly, Olivier. *L'organisation criminelle de la faim*. Arles: Actes Sud, 2013.

Bloom, Harold. *The Anxiety of Influence: A Theory of Poetry*, 2nd ed. New York: Oxford University Press, 1997.

Bourguignon, Claude and Lydia. *Le sol, la terre et les champs*, rev. ed. Paris: Sang de la Terre, 2008.

Browaeys, Louise, and Henri de Pazzis. *La part de la terre: L'agriculture comme art*. Paris: Delachaux et Nietslé, 2014.

Chauvet, Jules. *L'esthétique du vin*. Paris: Jean-Paul Rocher, 2008.

Cicero. *Tusculan Disputations*. Translated by J. E. King. Loeb Classical Library 141. Cambridge, MA: Harvard University Press, 1927. Excerpts from this work were translated by the author from the French edition.

Comité invisible. *À nos amis*. Paris: La Fabrique, 2014.

———. *L'insurrection qui vient*. Paris: La Fabrique, 2007.

Debord, Guy. *La société du spectacle*. Paris: Gallimard, 1992.

———. *Panégyrique*. Paris: Gallimard, 1993.

*Dictionnaire de l'Académie française, dédié au Roi*. 2d ed. Paris: Coignard, 1718.

*Dictionnaire de l'Académie française*. 3rd ed. Paris: Coignard, 1740.

*Dictionnaire de l'Académie française*. 4th ed. Paris: Veuve de Bernard Brunet, 1762.

*Dictionnaire de l'Académie française, revu, augmenté et corrigé par l'Académie elle-même*. 5th ed. Paris: J. J. Smits, 1798.

*Dictionnaire de l'Académie française*. 6th ed. Paris: Firmin Didot, 1835.

*Dictionnaire de l'Académie française*. 7th ed. Paris: Firmin Didot, 1878.

*Dictionnaire de l'Académie française*. 8th ed. Electronic version on the Web site of the Académie: http://atilf.atilf.fr/academie.htm.

*Encyclopédie ou Dictionnaire raisonné des arts, des sciences et des métiers*. Vol. 4. 1st ed. Paris: Le Breton, David, Briasson et Durand, 1751.

Furetière, Antoine. *Dictionnaire universel contenant généralement tous les mots françois*. Amsterdam, 1690.

Hedges, Chris. *Wages of Rebellion: The Moral Imperative of Revolt*. New York: Nation Books, 2015.

Hegel, Georg Wilhelm Friedrich. *The Philosophical Propaedeutic*. Edited by Michael George and Andrew Vincent. Translated by A. V. Miller. Oxford, UK: B. Blackwell, 1986. Excerpts from this work were translated by the author from the French edition.

Heinich, Nathalie, *Du peintre à l'artiste: Artisans et académiciens à l'âge classique*. Paris: Minuit, 1993.

———. *L'élite artiste: Excellence et singularité en régime démocratique*. Paris: Gallimard, 2005.

Iommi-Amunategui, Antonin. *Manifeste pour le vin naturel*. Paris: Les Éditions de l'Épure, 2015.

Joly, Nicolas. *Le vin du ciel à la terre*. Paris: Sang de la Terre, 1997.

Klein, Naomi. *This Changes Everything: Capitalism vs. the Climate*. New York: Simon & Schuster, 2014.

Lapaque, Sébastien. *Chez Marcel Lapierre*. Paris: Stock, 2004.

Le Gris, Michel. *Dionysos crucifié: Essai sur le goût du vin à l'heure de sa production industrielle*. Paris, Éditions Syllepse, 1999.

Mével, Matthieu. *L'acteur singulier*. Arles: Actes Sud, 2015.

Morel, François. *Le vin au naturel*. Paris: Sang de la Terre, 2013.

Morin, Edgar. "L'encyclique *Laudato si* est peut-être l'acte d'un appel pour une nouvelle civilisation," *Le Croix*, June 23, 2015.

Mougey, Amélie. "Pourquoi une pomme des années 1950 équivaut à 100 pommes d'aujourd'hui," *Terraeco, Le goût assassiné*, no. 66, avril 2015.

Nicolino, Fabrice. *Un empoisonnement universel: Comment les produits chimiques ont envahi la planète*. Paris: Les liens qui libèrent, 2014.

Nicolino, Fabrice, and François Veillerette. *Pesticides: Révélations sur un scandale français*. Paris: Fayard, 2007.

Pommier, Édouard. *Comment l'art devient l'Art dans l'Italie de la Renaissance*. Paris: Gallimard, 2007.

Reclus, Élisée. *Les grands textes*. Choisis et présentés par Christopher Brun. Paris: Flammarion, 2014.

Richelet, César Pierre. *Dictionnaire françois contenant les mots et les choses*. Genève: Jean Herman Widerhold, 1680.

Servigne, Pablo, and Raphaël Stevens. *Comment tout peut s'effondrer: Petit manuel de collapsologie à l'usage des générations présentes*. Paris: Éditions de Seuil, 2015.

Steiner, Rudolf, and Ehrenfried E. Pfeiffer. *Agriculture: Spiritual Foundations for the Renewal of Agriculture*. Great

Barrington, MA: SteinerBooks, 1993. Excerpts from this work were translated by the author from the French edition.

Tardieu, Vincent. *Vive l'agro-révolution française!* Paris: Belin, 2012.

Tiezzi, Enzo. *Tempi storici tempi biologici.* Milan: Garzanti, 1992.

Torga, Miguel. *L'universel, c'est le local moins les murs.* Translated by Claire Cayron. Bordeaux: William Blake, 1986.

Viala, Alain. *Naissance de l'écrivain.* Paris: Minuit, 1985.

JONATHAN NOSSITER is a prize-winning director of seven feature films including *Mondovino* (nominated for the Palme d'Or at Cannes), *Sunday* (Best Film winner at the Sundance Film Festival), and the upcoming *Last Words*, with Nick Nolte and Charlotte Rampling. His previous book, *Liquid Memory* (World Gourmand Award winner), recounts his time making wine lists for restaurants in New York, Rio, São Paulo, and Rome. Born in the US, he grew up in Europe and Asia and now lives on a fruit and vegetable farm in Italy with his three children.